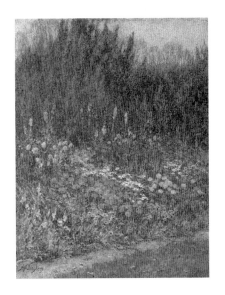

ROYAL WATERCOLOUR SOCIETY
WATERCOLOUR MASTERS - THEN & NOW

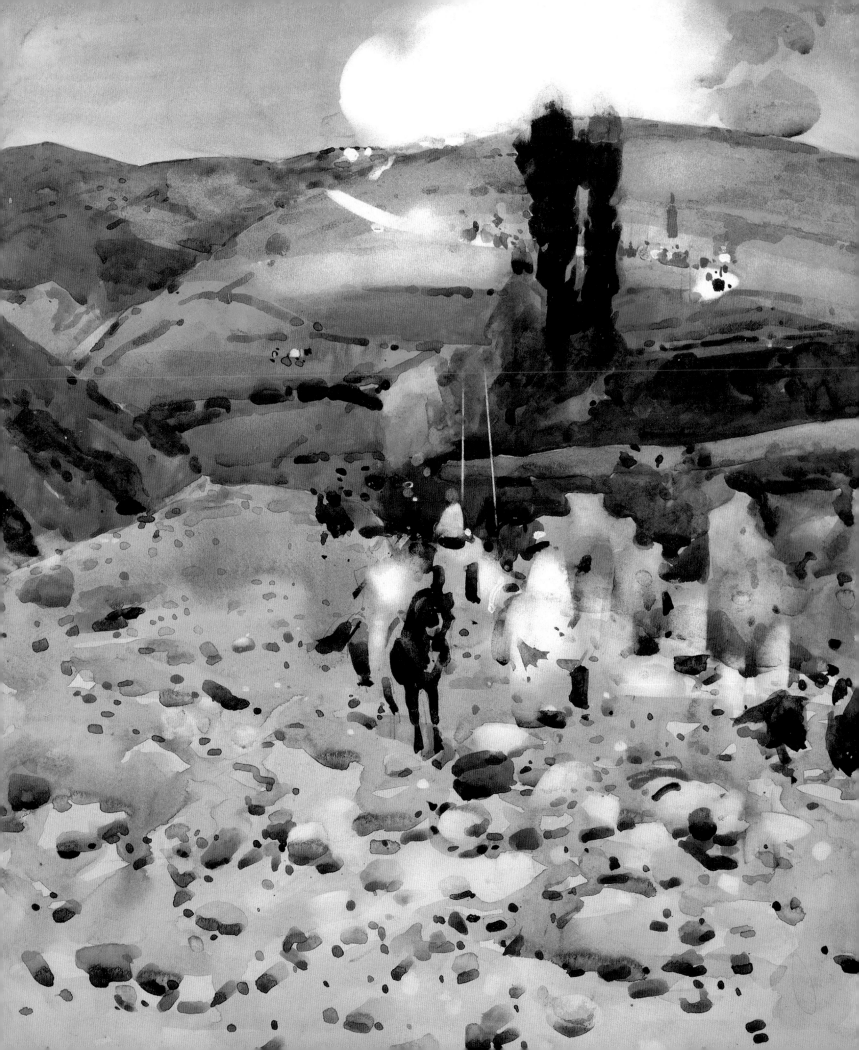

ROYAL WATERCOLOUR SOCIETY
WATERCOLOUR MASTERS - THEN & NOW

FOREWORD BY HRH THE PRINCE OF WALES

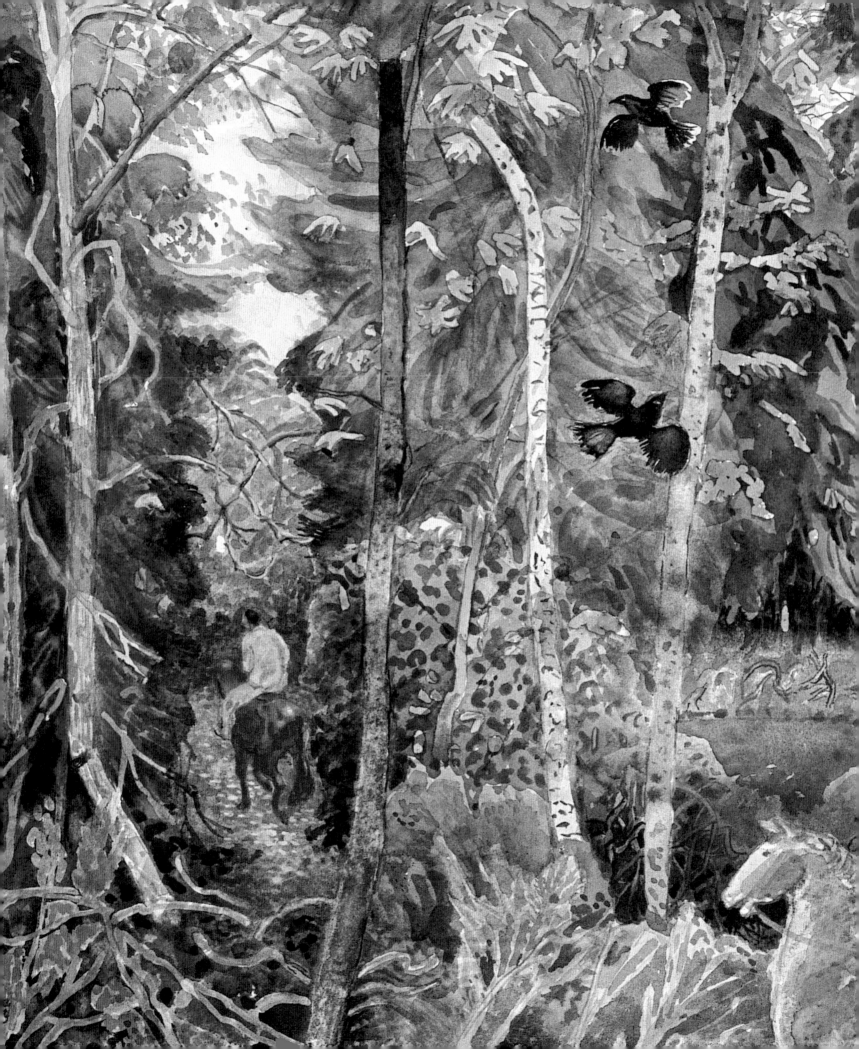

CONTENTS

Half title: **HELEN ALLINGHAM**, *A Bit of Autumn Border*, watercolour and bodycolour, 20.5 x 15.3 cm (8.1 x 6.1 in)
Frontispiece: **ARTHUR MELVILLE**, *Arabs Returning from Burning a Village*, watercolour and graphite, 57.5 x 47 cm (22.75 x 18.5 in)
Left: **JUNE BERRY**, *Riders in the Forest*, watercolour, 50 x 61 cm (19.5 x 24 in)
Following page: **ARTHUR RACKHAM**, *Abbaye d'Ardennes, Caen*, watercolour and bodycolour, 32 x 23 cm (12.5 x 9 in)

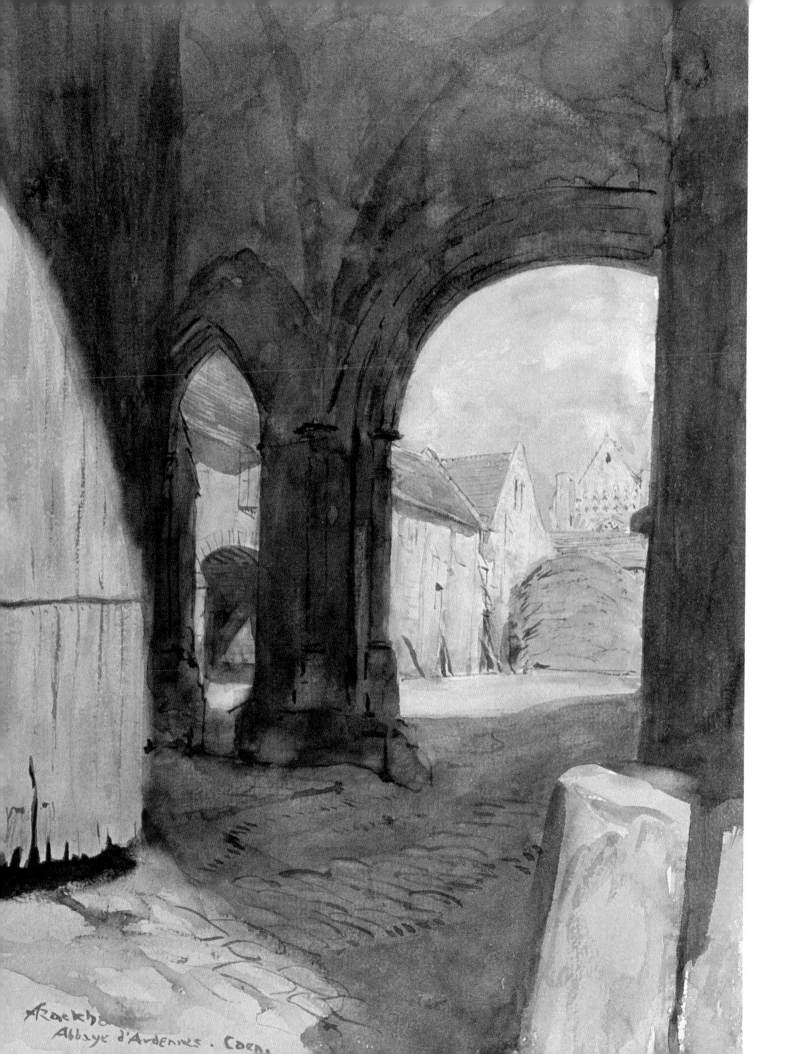

A Rackham
Abbaye d'Ardennes. Caen.

Watercolour is the most quintessentially British of media; its attractions for me lie in the fluidity and immediacy of the material. To watch a master of the medium, as are all of the artists whose work is shown in this book, is to marvel at the deceptive ease with which an image, full of light and movement, emerges. Those of us who have struggled to use watercolour to our own satisfaction know just how deceptive that apparent ease can be. I remember so well, when I was just beginning to venture into the world of watercolour - probably over thirty years ago now – that I asked Ted Seago, the renowned Norfolk painter, to give me a lesson. "I can't teach", he said, "but I can demonstrate". And he did just that – from his memory he conjured up, as if by magic, an image of a Thames barge floating in an estuary under a dramatic sky. It was at that point that I felt like giving up for there is no doubt that watercolour is an extraordinarily difficult medium.

The first exhibition to be held by the Royal Watercolour Society occurred in 1805; it is the oldest watercolour society in the world, and is second only to the Royal Academy of Arts in its importance as an art society. The two hundred years of the Society's history superbly reflect the history of excellence in the medium, and this book emphasises the strengths of that tradition. By drawing from the wonderful archive of the Society's Diploma Collection for their inspiration, today's Members have reinforced the continuity of excellence and ability. These personal essays by contemporary artists talking about their art and the extent to which they are influenced by the works in the Diploma Collection, bring to this book great charm and honesty when many books about art are often cool and analytical.

For instance, the wonderful painting by Arthur Rackham shown on the opposite page was chosen because of the extraordinary way in which he used tonal values, an element of artistic understanding used by many watercolourists. It is fascinating to see an artist known for his very particular style of illustration - of which there is another fine example in the RWS Diploma Collection – demonstrate his control over the medium to create a beautiful topographical work like this.

At a time when conceptual art appears at the forefront of Media attention and artistic endeavour, sadly at the expense of drawing and painting, it is enormously refreshing to see skill and its practice combining to embrace and further this wonderful medium. It seems appropriate that the royalties from this book should go towards the charitable and educational aims of the Society. For those, like myself, who love the art of watercolour, this book is a revelation created by true masters of the art: it also reinforces the pleasure and privilege I feel in being an Honorary Member of the Society.

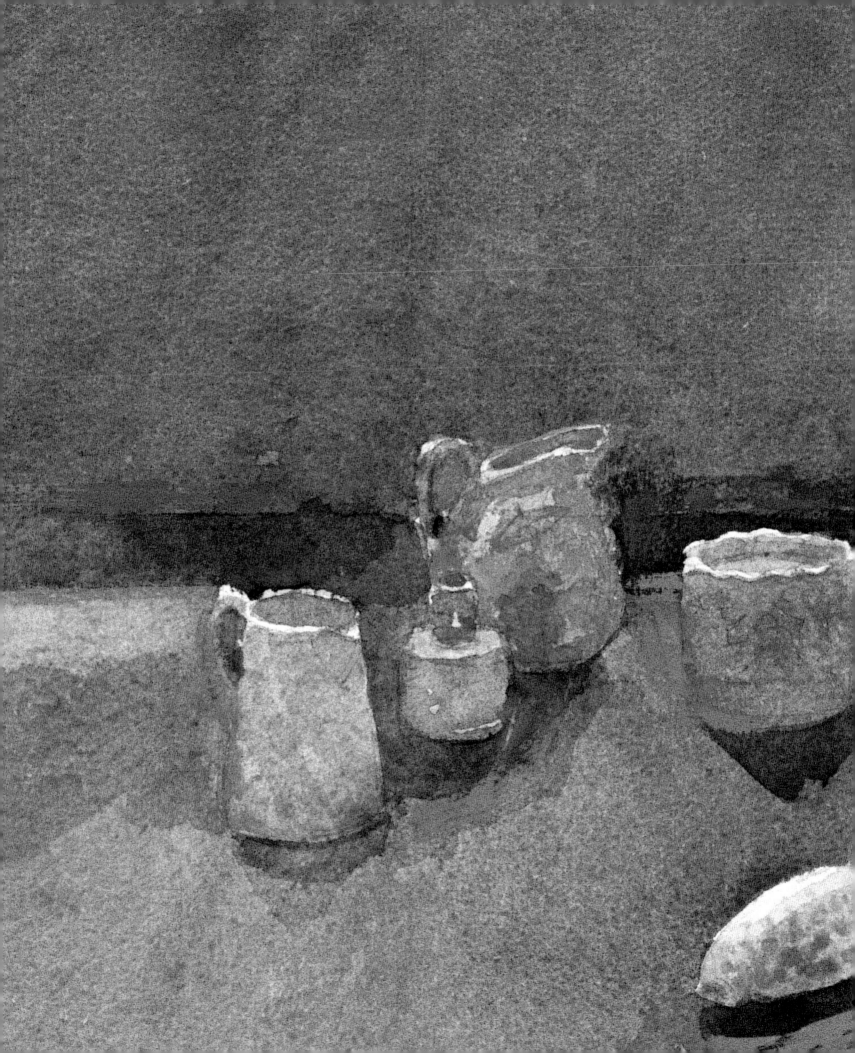

COLOUR

William Blake said, 'Energy is eternal delight', and, as a painter, I would add that colour is its conduit.

No artist used colour, and, in particular, watercolour so skilfully, so boldly, so joyously, so inventively as our own J M W Turner (1775–1851). So much is this so that his genius introduced overtly all the abstract principles that have always been the underlay of good art. With his diaphanous brilliance of colour he achieved mood and atmosphere in terms of coloured light. He sought basically to achieve expression via the forceful orchestration of pure colour, making pictorial works that were not mere formal imitations but also reconciled the abstract with the particular.

The history of painting is, after all, the story of colour. A juxtaposition of colours can captivate us, usually the warm tones fill us with joy, while the cool ones can induce sober meditation or dolorous thought. Here one is reminded of Mark Rothko's final major set of works made not long before his suicide. Their dark intensity of colour provides a background, a sort of mysterious iconic 'imagery' hidden in their depths, poetic and serene. We are drawn in and try to understand his journey, the dark night of the soul.

Clearly, artists hold sway. Colour is a tool, a weapon, a balm. Its rejuvenating properties make fine physic and, upon recognizing this, one can go along with Bob Dylan and say 'But I was so much older then, I'm younger than that now'.

SONIA LAWSON RA, RWS, HON. RWA

Left: **CHRISTA GAA**, *Still Life with Pottery Duck* (detail), watercolour, 41.2 x 30.5 cm (16.25 x 12 in)

ANNIE WILLIAMS
CHRISTA GAA (1937–1991): *Still Life with Pottery Duck*

Christa Gaa is an artist who, among others, has influenced my work and given me inspiration. I have certainly been more excited about painting still life since seeing her paintings. I love her use of rich, subtle colours, which glow from her work and appear to flow effortlessly across the paper. Her subject matter is simple everyday objects she has collected, to some of which she probably had an emotional attachment. I know she felt it was very important to love the subject matter and I too have to feel some excitement about what is in front of me, and to enjoy the challenge it poses.

 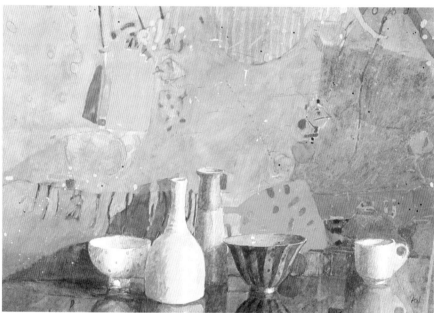

After seeing her work I found myself using more layers of watercolour wash and trying to strengthen my colours. Like Christa Gaa, I start my paintings with watercolour and finish by using gouache. In this picture she used lots of deep earth colours, but in close tones, which I love. Like her, I have a collection of small and intimate objects; in my case they are mostly pots, which have reappeared in several paintings.

For me the quality and direction of light can play an important part in creating an atmosphere and shadows become very much part of the composition. Christa often used lighting from above, which highlighted her ellipses, while the rest of the objects would melt into the background. I prefer my light source to come from the side because it gives me greater use of play with shadows.

Her work has a lovely sense of calmness about it – I do strive for that. I also enjoy the use of pattern in my backgrounds and foregrounds, using such things as fabrics or newspapers, but I have to be careful it does not become too busy.

Above left: **CHRISTA GAA**, *Still Life with Pottery Duck*, watercolour, 41.2 x 30.5 cm (16.25 x 12 in)
Above right: **ANNIE WILLIAMS**, *Pots and Stripes*, 2005, watercolour and gouache, 37 x 46 cm (14.6 x 18.1 in)
Opposite: **ANNIE WILLIAMS**, *Patchwork*, 2004, watercolour and gouache, 35 x 33 cm (13.8 x 13 in)

ID OTHER S

Art

Patchwork..postscrip

Me

oir

thinking

iW.

MARY JACKSON
CHRISTA GAA (1937–1991): *Still Life with Pottery Duck*

Christa's passion for painting ran deep: day-to-day objects, which she selected for her still-life paintings were transformed into magical works of art on her canvas. The uniqueness of Christa's painting attracted me to try and say something about her approach and to look closely at mine. If I could take a leaf out of her book, I would be a better watercolourist.

Christa was exploring all the time; she was using different shapes: square, round, sharp-edged, soft, patterned, weaving them together to form her composition. The placing of the objects always looked natural, and the use of the negative shapes helped to set up the arrangements. She seemed to have a wonderful imagination and colour sense.

Colour was her forte: in her choice of colour her work seemed to express contemplation and stillness; there seemed to be a broodiness, moody and reflective.

Her colour was rich and seductive, and for each painting she would make a different selection. It might be browns leading to mauves, warm ochres to deep reds, or, as in the case of this early still life, the serenity of blues, cool and warm using reflective light to lift the painting enhanced by the edges of the objects catching the highlights. The deep, rich quality of the brown-mauve tablecloth in the foreground is echoed in the shadows moving to the back of the table, and this binds the whole painting together. The simplicity is breathtaking.

I asked Ken Howard, her husband, about her approach. Apparently, she started at 10am, after all the housework was complete and the dog had been exercised, then settled down to painting and usually completed a work in one session, with no interruptions or breaks, finishing around 9pm. The change of light didn't bother her.

To begin with she drew in lightly, added watercolour followed by gouache and finished sometimes with chalk: rules were to be broken! Ken would sometimes say, 'But Chrissie, why don't you paint what's in front of you?' and Chrissie's reply would be, 'Oh Ken, but I have!'

I've always admired Christa's approach and wanted to experiment in her style; these paintings are brave initial attempts and have inspired me to continue and, maybe, change my direction.

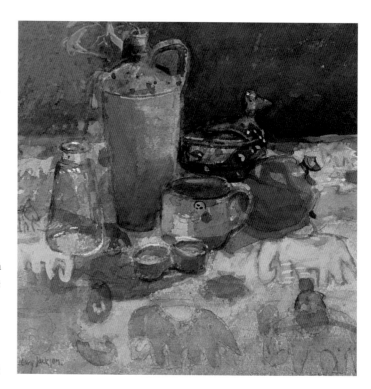

Opposite, left: **CHRISTA GAA**, *Still Life with Pottery Duck*, watercolour, 41.2 x 30.5 cm (16.25 x 12 in)

Opposite, right: **MARY JACKSON**, *Homage to Christa*, watercolour, 25 x 24 cm (10 x 9.5 in)

Above: **MARY JACKSON**, *Japanese Pot*, watercolour, 24 x 25 cm (9.5 x 10 in)

SIMON PIERSE
ARTHUR MELVILLE (1858–1904): *Arabs Returning from Burning a Village*

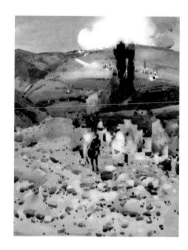

What struck me about this painting when I first saw it was the extraordinary freshness of its execution and the way that Melville had used large – almost tachiste – blots of flat colour. It looks unfinished in a way, but the structure is all there and reveals how the artist relied on firm drawing to underpin a very free technique. It was only afterwards that I read the title and was slightly taken aback by its hint of violence. I wonder whether this is an event that the artist witnessed or perhaps just imagined.

In my homage to Melville I laid down colours and then flooded the paper with Chinese white – as he often did – and scrubbed away at the surface in an attempt to convey the dazzle of desert light and to imply a sense of movement. Melville was adept at catching the scorching midday heat of southern Spain or North Africa, and I wanted to put something of that into my own watercolours of central Australia and New Mexico.

Returning from the Telegraph Station, Alice Springs draws obliquely on the memory of a journey to the Northern Territory with my wife over ten years ago. One afternoon we walked in the soporific heat back from the historic telegraph station of Alice Springs, along the dried up Todd River bed, our eyes almost shut tight against the blinding desert light. It was a moment when I felt a sudden sense of revelation in passing

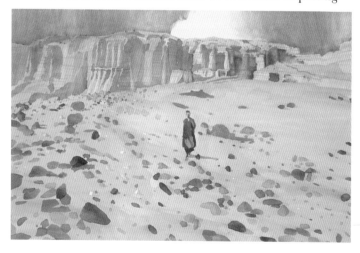

through an ancient landscape, a sense of being far less permanent than the rocks and trees around me. It is not a topographical painting, although the particular spot that I painted is certainly identifiable. Nor is it a painting that could have been done on location; I find that the thirsty desert air of central Australia drinks my watercolours off the palette before I have a chance to apply them in large washes. I prefer instead to make drawings and take photographs as an aide-mémoire to something that is felt as well as seen.

Travelling in New Mexico a few years ago I visited some of the places that had inspired American artist Georgia O'Keeffe (1887–1986). The White Place or Plaza Blanca, near O'Keeffe's home in Abiquiu, is a strangely eroded landscape of white sediment cliffs and towers topped by capstones. It is a primeval place and one where I had a strong sensation of the imprint of O'Keeffe's presence still upon it. In *Georgia O'Keeffe returning from White Place* I imagined the artist wandering back to her studio to paint after a walk through the bleached canyons of Plaza Blanca. My painting is an attempt at capturing this spirit of place as well as another opportunity to try out Melville's technique. I first applied a ground of Chinese white mixed with some Naples yellow. Once this slightly chalky layer had dried, I painted the stones on top, which caused the edges of them to bleed slightly, creating a series of almost abstract blots that can be read either as marks on the surface or as elements in the landscape.

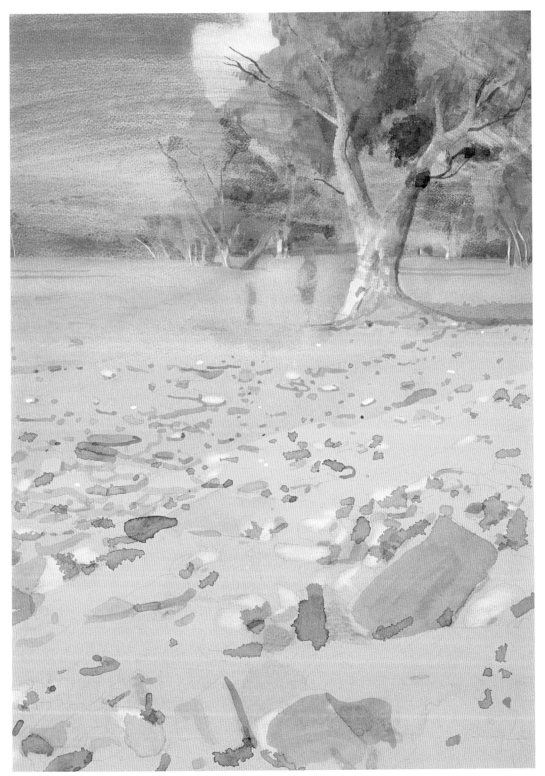

Opposite, left: **SIMON PIERSE**, *Georgia O'Keeffe returning from White Place*, 2004, watercolour, 51 x 71 cm (20 x 28 in)
Opposite, right: **ARTHUR MELVILLE**, *Arabs Returning from Burning a Village*, watercolour and graphite, 57.5 x 47 cm (22.75 x 18.5 in)
Left: **SIMON PIERSE**, *Returning from the Telegraph Station, Alice Springs*, 2003, watercolour, 71 x 51 cm (28 x 20 in)

GREGORY ALEXANDER
ARTHUR MELVILLE (1858–1904): *Arabs Returning from Burning a Village*

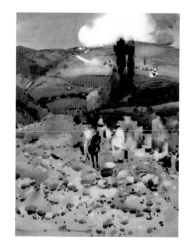

I have liked this painting since I first came across it in Michael Spender's book, *The Glory of Watercolour*. A wonderful detail is reproduced actual size and shows how broad and abstract this work really is. I particularly like the ambiguity of the figures in the centre. It's easy to see there are people on horseback and that they are wearing white – but a great deal is left to one's imagination. This, I believe, is a particularly modern work – the broad use of the medium and calligraphic mark-making in the foreground are all delightful – and probably quite avant-garde for its time.

My own response hinged on my own experience. Whilst looking at the painting I was immediately transported to the dry and rocky landscapes of the Mediterranean. Furthermore, the dark shapes of the horses reminded me particularly of Greece, its working donkeys and its village people dressed in black, trundling along in the heat. I particularly wanted to pick up on the ambiguity of the subject that Melville achieved in his work, and accomplish a similar stylistic application of the medium – with its calligraphic marks and impressionistic style.

In the end I think my work is much more figurative than I intended – and I would like to attempt a completely abstract work in response to Melville's piece as well. However, I hope it is possible to see how I arrived at this painting from Melville's starting point.

Above, left: **ARTHUR MELVILLE**, *Arabs Returning from Burning a Village*, watercolour and graphite, 57.5 x 47 cm (22.75 x 18.5 in)
Above, right: **GREGORY ALEXANDER**, *Village Life, Greece*, 2004, watercolour on Arches paper, 58 x 76cm (22.8 x 30 in)
Opposite: **JUNE BERRY**, *Riders in the Forest*, watercolour, 50 x 61 cm (19.5 x 24 in)

JUNE BERRY
ARTHUR MELVILLE (1858–1904): *Arabs Returning from Burning a Village*

I was instantly drawn to Arthur Melville's painting by its rich, intense colour. Studying it more closely, it wasn't just the colour but the very loose style of painting and those characteristic blobby patches either of white or some strong dark colour that excited me. Some areas appear sponged out to the same degree that others are saturated with powerful colour – a technique described by a contemporary critic as 'blottesque and stainy' and as composed of 'dabs, blurs and splashes of paint' by the art critic of the *Daily Chronicle*. To my eye the painting has a very modern appearance compared with works by the group of painters Melville was associated with – the Glasgow Boys.

After studying in Paris and travelling and painting in the Middle East for a couple of years, Melville returned to Scotland and soon after moved to London. Here he began to develop what became his late watercolour technique.

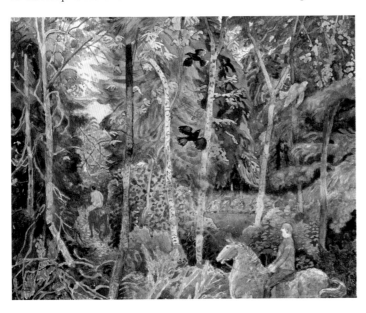

He worked on saturated paper, sometimes on the floor with pools of colour and vigorous brush marks, sponging out superfluous detail. Sometimes he flooded the background in with umber to establish the tone and when it was almost dry, added full bright patches of colour. He invented a unique method of preparing his paper by saturating it over and over again with Chinese white, finally rinsing it to leave a specially prepared surface. When I tried this procedure I found it made sponging out very easy, leaving a brilliant white, but the preparation was a tedious process.

My paintings in response to *Arabs Returning from Burning a Village* are obviously not concerned with the subject matter, but with following Melville's technique, working on very wet paper, using various stages of drying to add further layers of colour, sponging out unnecessary detail and using these sponged-out areas tonally as part of the composition.

It has always been my way of working to paint in the studio from memory, using drawings made on the spot and photographic reference to make more or less invented compositions, so I was interested to learn that Melville accumulated a huge store of sketches and drawings on his travels in Egypt and Turkey which he continued to use as reference for finished paintings created in the studio almost until his early death twenty years later. Some paintings were worked up accurately from sketches and others were semi-imaginary from memory.

Melville was interested, as I am, in the ideas of the symbolists, particularly Whistler, and their doctrine, as defined by Gauguin, that drama and memory are ultimately more important than observation of the 'real' world as practised by the Impressionists.

Returning to Melville's technique, someone said to me 'what you're talking about sounds really simple', but as anyone who has tried it will know, it is a great challenge to control big brushfuls of colour dropped onto soaking wet paper, and it can be such a pleasurable achievement when it works out well.

KAROLINA LARUSDOTTIR ROBERTS
ARTHUR MELVILLE (1858–1904): *Arabs Returning from Burning a Village*

When I think of the RWS and all the wonderful works I have seen there over the years, there are many that are as alive with me and as fresh as the day I first saw them. It is strange how some paintings seem to have a long-lasting impact over and above the others.

The painting I have chosen out of the Diploma Collection is Arthur Melville's *Arabs Returning from Burning a Village*, (1922). I still remember seeing it for the first time. Its fluidity of composition, the stunning simplicity of colours and the bright light makes this a very memorable painting. Without being too obvious, the people seem to blend into the landscape almost as if they were part of it. It looks light and airy and the brushstrokes seem deceptively easy but it comes together to make one of my favourite paintings. The essence is captured, not the detail. The figures merge into the scenery, hardly distinguishable as figures but undeniably so. The boldness and simplicity of the application of the watercolour adds to the effectiveness of the painting.

So much is understood about the landscape, as much from the information given as from the absence of detail – the heat in the ground, the dry air, the midday sun, lack of shelter and the sense of distance and space. Within the dry rock, there is a small area of green, which should provide a sense of rest and refreshment, but then we realise this is the area under attack and we can feel the villager's isolation.

The ambiguity of the painting appeals. I am given a certain amount of information but my mind and imagination must also work to make its own conclusion. The most obvious parallels between Melville's painting and my own is of course the subject matter of people in landscape. This has always been an interest of mine, perhaps growing up in Iceland makes this easy to understand. As an Icelander, the landscape is all pervading. Every aspect of life in Iceland is affected by the land and the extreme weather conditions.

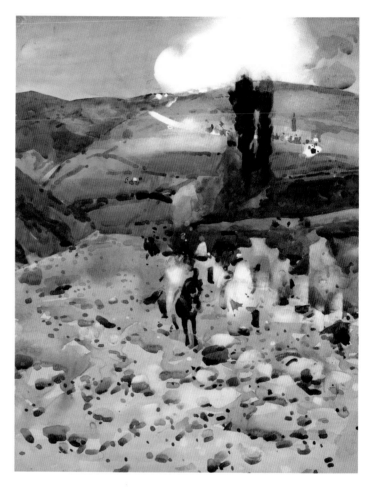

The figures in both paintings have a very special relationship with the landscape. They understand it, they live with it, on it and from it and they also understand its dangers.

Above: **ARTHUR MELVILLE**, *Arabs Returning from Burning a Village*, watercolour and graphite, 57.5 x 47 cm (22.75 x 18.5 in)
Opposite: **KAROLINA LARUSDOTTIR ROBERTS**, *Stephen's Birthday*, 2005, watercolour, 50 x 70 cm (19.7 x 27.6 in)

TOM COATES
JOHN SINGER SARGENT (1856–1925): *Bed of a Glacier Torrent*

It must be said that the John Singer Sargent in the RWS collection is not the greatest painting of the artist we all admire. He once described his work as being merely snapshots, but he is being rather flippant; it tells us, however, about the modesty of the man who was always in demand for his portraits. Sargent's varied collections of watercolours show off his techniques to the full, with uses of warm and cold colours in opposite ways. When people use a cold colour for shadows, he cheeks us by using a hot one or a mixture, blending colours together, counteracting brightness with a pure, unadulterated spectrum of rainbow pureness.

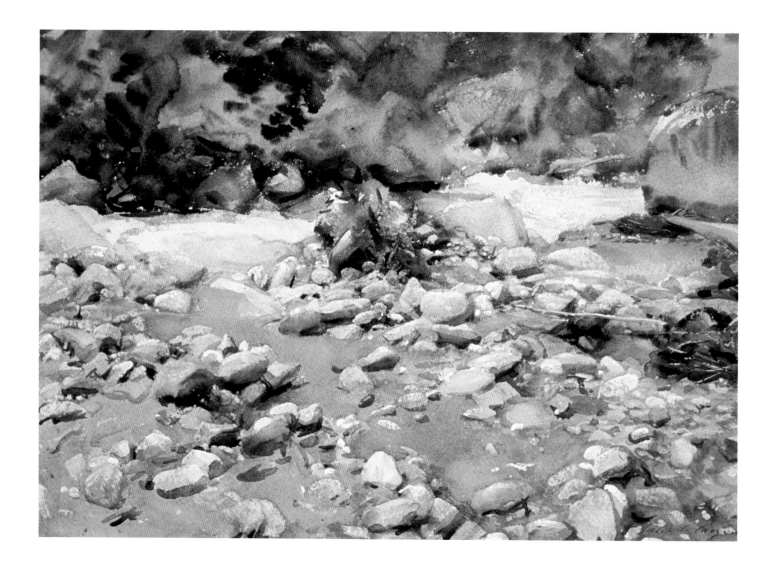

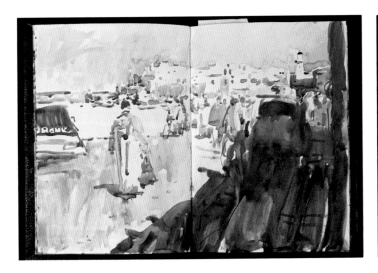 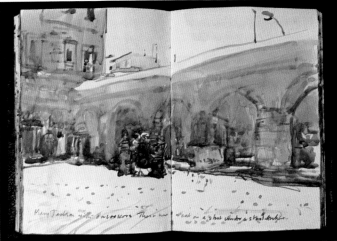

Having broken away from the confinement of portraiture, the wide subject matter shows Sargent as a tour-de-force, as does his collection of watercolours at the Imperial War Museum. They all show his flair for working with fast, loose strokes.

There are many quotes on Sargent by writers, poets and most of all patrons of high esteem. As Evan Charteris wrote in 1927: 'To live with Sargent's watercolours, is to live with sunshine captured and held with the lustre of a bright legible world the refluent shade and the ambient ardours of the noon'.

The countless journeys that Sargent made with friends is something we have in common. The sketchbook page shows Mary Jackson, who always collects children around her with her warmth and generosity. It was done during a trip to

Morocco, and the multi-coloured background gives the theatre of a backdrop.

Another page from the Moroccan sketchbook shows a rapid attack on the subject with quick, loose strokes and the shadows exploding into dark browns with a mixture of blues.

It takes a lifetime of practice to be a painter, but a short time to attack a subject with the flair of a Sargent. To try to mimic him is a dangerous thing, but he helps us to enjoy the exploration of the watercolour medium. To become excited by another technique can only be open to an experienced practitioner, whether he be an oil painter, or even a sculptor.

You don't find watercolour, it finds you: it's used to enhance a sketchbook page, but it's a wonderful individual medium that finds the strengths and weaknesses of the artist.

Opposite: **JOHN SINGER SARGENT RA**, *Bed of a Glacier Torrent*, watercolour and bodycolour, 35.5 x 50.7 cm (14 x 20 in)

Above left: **TOM COATES**, *Fish Market, Essaouira, Morocco*, watercolour, 24 x 33 cm (9.5 x 13 in)

Above right: **TOM COATES**, *Mary Jackson with Onlookers, Essaouira, Morocco*, watercolour, 24 x 33 cm (9.5 x 13 in)

CLAIRE DALBY
WILLIAM HENRY HUNT (1790–1864): *Jug with Rose and Other Flowers and Chaffinch Nest*

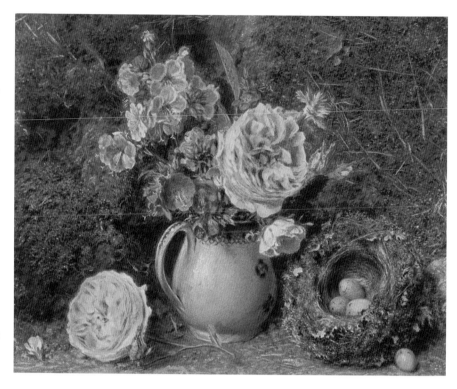

The only time I ever found a bird's nest right by my feet for the taking was some years ago in a Scottish city car park, many yards from any tree. Naturally I picked it up. However, after admiring its construction, instead of filling it with pebbles or chocolate eggs (it was, unsurprisingly, empty) and painting it, I gave it to a friend.

William Henry Hunt was renowned for his remarkably detailed still lifes featuring birds' nests. In this painting light gently filters down from the left: no harsh highlights or shadows detract from the colours and textures.

The nest particularly attracted me. It is tilted to show the contrast between the silky hairs of the lining and the soft, mossy fuzziness of the exterior. It is ornamented with scraps of lichen, which shares its subtle colour with the eggs within, and also with the jug and the shadows of the white flowers. Just enough detail is actually delineated: the eye and mind fill in the undefined areas with moss and down.

My still life was painted in late winter, and I decided to concentrate on the idea of the nest as a container. My 'nest' is a man-made bowl and instead of mosses, it has a strand of plant motifs 'woven' around it. The rather abundant 'eggs' are supplied by bunches of grapes and the 'flowers' are printed on a favourite old Indian cloth which replaces Hunt's informal soil surface. Daylight comes from a north window.

My first interest was in the contrast between the individuality of the grapes and the geometrical regularity of the bowl, between the translucency and muted, bloomy shine of the fruits and the hard brightness of the china.

My other main interest was in all the colours of the 'green' grapes (from pinkish and blueish highlights to some near-red shadows). To explore their variety, I chose a high viewpoint (rather than tilting the 'nest') and kept the cloth and background subdued.

Above: **WILLIAM HENRY HUNT**, *Jug with Rose and Other Flowers and Chaffinch Nest*, watercolour and bodycolour, 23.2 x 28.4 cm (9.2 x 11.3 in)
Opposite: **CLAIRE DALBY**, *Seedless Grapes*, 1988, watercolour and bodycolour on tinted paper, 24 x 23 cm (9.5 x 9.1 in)

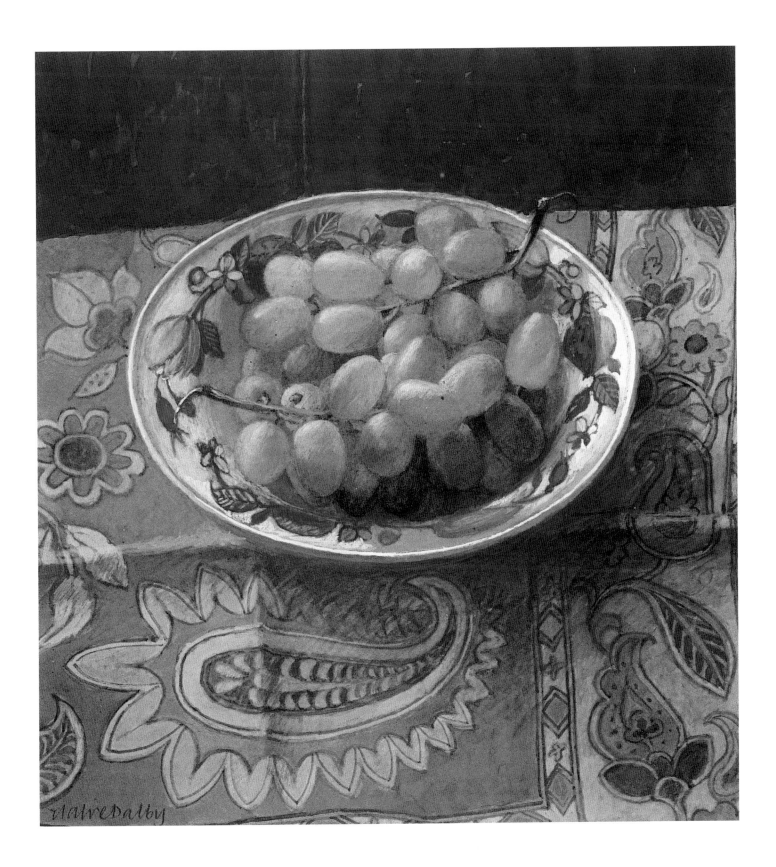

CATHERINE DUCKER

WILLIAM HENRY HUNT (1790–1864): *Jug with Rose and Other Flowers and Chaffinch Nest*

This image by Hunt immediately strikes me as created by someone who loves nature; even though it was painted in a studio, the nest and flowers are set against a natural background. This is unusual and is an element I like. The artist has chosen a subject in which I am very interested: the fragility of nature and the beauty of nature as a provider.

Nature provides both life with the egg, and beauty with the flowers. The artist portrays beautifully a selection of garden flowers, which have an element of wildness in them, with one rose outside the vase. As with the flowers, in the bird's nest one egg is broken and one egg lies outside the nest.

The painting is beautifully sensitive in its chosen objects and composition. Although my own work appears more minimal, the colours chosen and marks I use have the same meaning to me: they are essential to represent my love of the land and the connection I have with elements of the landscape. Hunt's painting is clear and unmuddled. It is a busy subject, and yet your eye can see the simplicity of the overall concept.

My paintings are a spontaneous response to experiences I have in the landscape. Moments of excitement, moments of bonding with nature, abstract colours from an experience made from working quietly undisturbed in my studio.

Recent works have been inspired by travels to Africa where I encountered magical people who work with the sea. Other paintings have come from a winter of riding at home and connecting with the land through horses.

Currently I grow lots of organic food to sell. Being around the soil daily and the growth of very beautiful plants which nourish us, and give us the fuel to live, inspires me and it comes out through my painting in an uncontrolled manner.

I have always grown lots of flowers and occasionally these pop up in my art; they give us so much pleasure in the house with their scent and undemanding presence that I want to paint their beauty when the moment takes me.

I only paint when I feel happy. That doesn't mean that by the end of the painting I'm still happy, and nor do I want to paint every day. I go through lots of emotions, but it is essential that I feel connected to what I'm doing. I feel I have a lifetime of painting ahead and this is just the start of the journey.

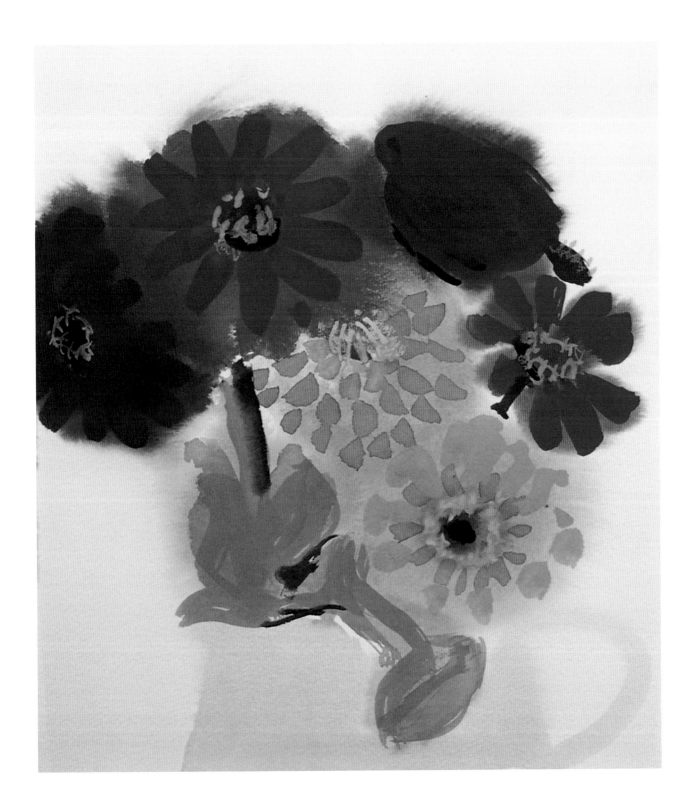

Opposite, left: **WILLIAM HENRY HUNT**, *Jug with Rose and Other Flowers and Chaffinch Nest*, watercolour and bodycolour, 23.2 x 28.4 cm (9.2 x 11.3 in)

Opposite, right: **CATHERINE DUCKER**, *Ride by the River*, watercolour, 40 x 60 cm (15.7 x 23.6 in)

Above: **CATHERINE DUCKER**, *Zinnias*, watercolour 60 x 40 cm (23.6 x 15.7 in)

DAVID WHITAKER
ALFRED WILLIAM HUNT (1830–1896): *Welsh Flood*

Alfred William Hunt's *Welsh Flood* is a real find for me. The greenish browns of the sodden earth – compressed as it is between heavy grey clouds above and the agitated water below – express the uncontrollable force of nature. Faint, central, and low in the sky, the sun appears behind the heaviest clouds whilst away in the distance to the far

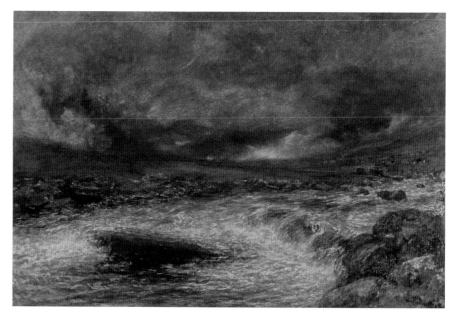

right, cattle are grazing. They, and the village beyond them, go almost unnoticed in the wake of the river as it rushes from right to left. In the foreground the turbulent water meets with some unidentifiable object, which appears to be resisting the powerful surge. As I see it, the connection with my own work is in the dynamics of the composition: the push and pull of one force against another.

I feel this painting must have mirrored a crisis of some kind in Hunt's life, which makes the subject all the more poignant. I try to do something similar: I often compose images which match my present feelings with feelings formed from past experience. Sometimes I will create images from my imagination which may be a forecast of things to come. At other times, I will make a transcription of a particular work of art. If I were to make a painting from *Welsh Flood* my colour would be tertiary, with flecks of secondaries and primaries trying to survive as the storm stirs everything up.

My palette consists of seven colours. I use two yellows – one cold, one warm – cadmium red, magenta, viridian and two blues – one reddish and one greenish. With these colours I can express endless possibilities of natural phenomena.

Hunt has used black in this painting, a colour I very rarely use because it has such a depressing influence on other colours. However, subjects form their own processes and were I to make a similar painting in response, I might reintroduce black as an essential element.

Above: **ALFRED WILLIAM HUNT**, *Welsh Flood*, watercolour and bodycolour, 36.8 x 53.5 cm (14.5 x 21.1 in)
Opposite: **DAVID WHITAKER**, *Northern Lights*, 2004, watercolour, 46 x 61 cm (18 x 24 in)

ANTHONY EYTON
ALFRED WILLIAM HUNT (1830–1896): *Welsh Flood*

My picture is of a small Welsh waterfall emerging from a wood, its lightness and force shown up by the surrounding black rocks. When I started, the sun was out. The weather changed to being cloudy, so the dynamic became different, and the picture became more stern.

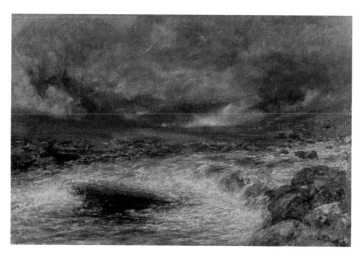

It is only recently that I have come across Alfred William Hunt's work. The subject is also of water on the move. It is called *Welsh Flood*, painted in 1870, in open country with an emphasis on the waters turbulence, the rocks painted in extreme detail, the whole scene imbued with a great sense of weather and atmosphere. Hunt was a friend of Ruskin, and a great admirer of Turner and David Cox.

I think we can often take comfort from, and perhaps even envy artists of opposite temperament. In Hunt's case, his opposing qualities are his concentration and focus on a particular subject and his attention to detail. In common,

we both have an insistence on literalness, that is it is the subject or truth to appearances that dictate. There is also common ground in space, weather and light.

In the 1870s there was a buzz in the air and the example of Turner to lead to much experimenting with the medium. Hunt was no exception. In the *Welsh Flood* he resorted to scraping out, scratching, sponging and other enlivening processes. Most of the picture must have been done en plein air but I suspect he brought it to a conclusion in the studio, though his main desire must have been to relive the experience.

Hunt's working methods have been vividly described by his daughter Violet. 'He did at least two tramps a day, one in the morning light and one on an evening subject. Morning and evening were subdivided in as much as he often put away the morning sketch for a new 'effect' at midday.' I can identify with this adaption to a new subject or change of light, but would add that the method could mean that each picture becomes a long haul, and need 're-entering' each day.

Violet continues, 'My father's manual dexterity was remarkable enough. With those long nervous bird-like fingers he could propel or arrest his brush within the merest fraction of an inch in any given direction and 'place' a dab of colour here or there with the force of a hammer or the lightness of a bird's wing.'

Above: **ALFRED WILLIAM HUNT**, *Welsh Flood*, watercolour and bodycolour, 36.8 x 53.5 cm (14.5 x 21.1 in)
Opposite: **ANTHONY EYTON**, *Waterfall in a Wood, North Wales, 1990*, watercolour, 77 x 55 cm (30.5 x 21.7 in)

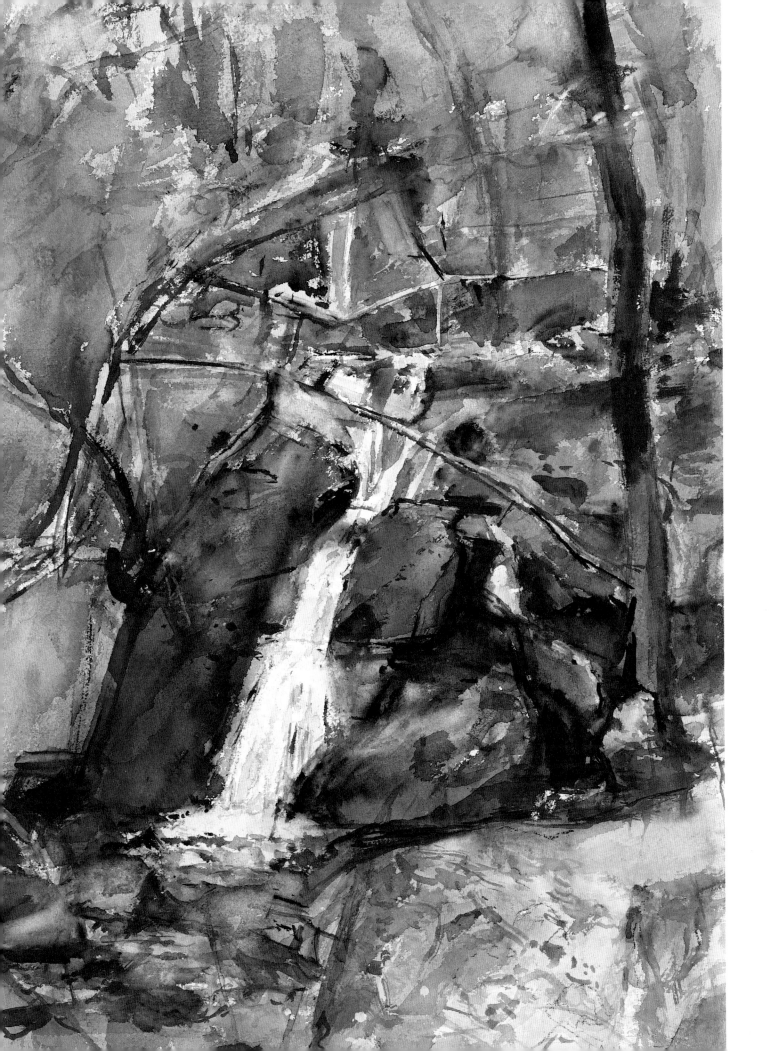

TREVOR FRANKLAND

JOSEPH EDWARD SOUTHALL (1861–1944): *A Cornish Haven*

I was attracted to this painting not only because of its strong composition but also by the subject matter. The image of a sailing ship probably returning from foreign parts has for me a strong association with past times and the Grand Tour revisited. The influence of the Continent on English art and architecture during the eighteenth century was extensive.

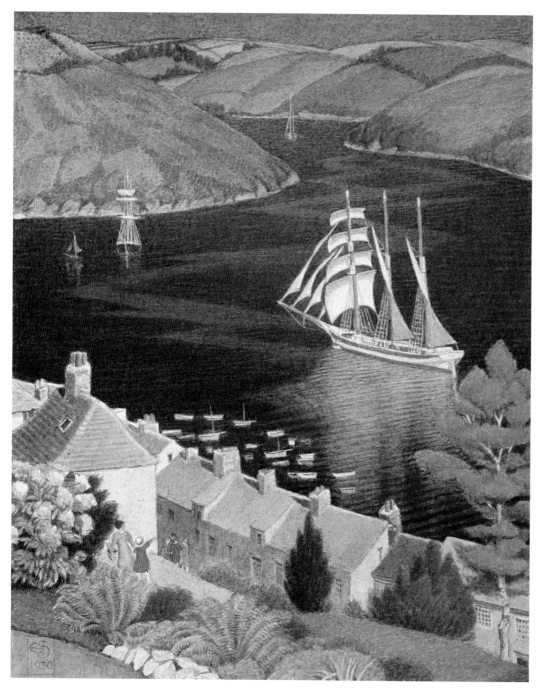

Left: **JOSEPH EDWARD SOUTHALL**, *A Cornish Haven*, watercolour, 30.3 x 24.3 cm (12 x 9.6 in)
Opposite: **TRVEVOR FRANKLAND**, *The Grand Tour Revisited*, 2005, watercolour, acrylic and carbon pencil, 56 x 82 cm (22 x 32.2 in)

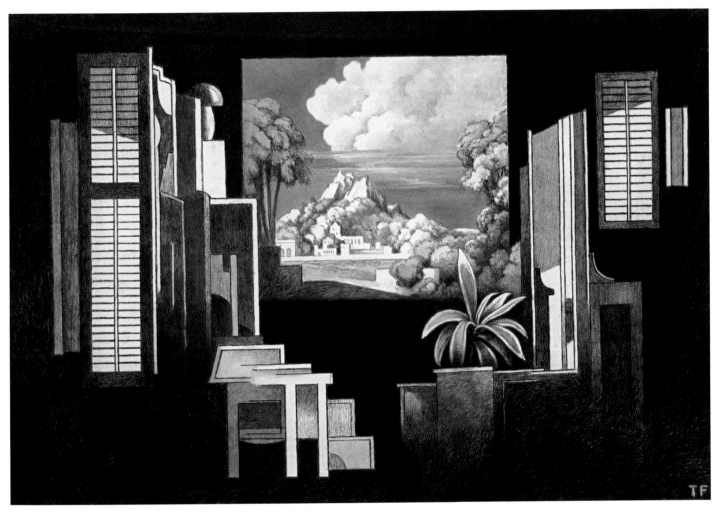

The Grand Tour played an important role in this context by helping to introduce major changes in the works created by artists as well as architects. If the buildings of Andrea Palladio had a major influence on English architects, then the French artist Claude Lorrain certainly had a major influence on English landscape painter J M W Turner, whose early ambition was to emulate this French artist.

My painting is a combination of an invented classical Italian landscape with semi-abstract architectural shapes so as to emphasise the link between the past and present. The ideas that generally govern the way I work can be best described as being based on the persistence of the past in the present, a combination of inner and outer worlds.

Appropriate forms have to be found for what are elusive images and I find that collage is an ideal way to give substance to them. Formal structures require descriptive detail, so the images I create are a combination of geometrical or architectural forms with objects, whole or fragmented to provide detail.

I also scan assembled fragments into a printer so that I can use the same images in a different context. The variety of compositions I then create gives me a better chance of giving pictorial form to my ideas which, to achieve the results I am seeking, sometimes require an element of ambiguity. A conté drawing is made from the chosen image to which I add colour. The final watercolour is based on this drawing using a limited palette and a heavyweight Waterford paper.

ANN WEGMÜLLER
JOSEPH EDWARD SOUTHALL (1861–1944): *A Cornish Haven*

When I first saw the painting *A Cornish Haven*, I liked it immediately but it took me sometime to work out why. At first it reminded me of places I knew, of summer activities, walking along coastal roads, looking at boats and the hills beyond. A few weeks later I had a second look at his painting and realised that what attracted me was what always attracts me to the work of others: the colours. In the case of Southall's painting it was the warm, light colours of the land and the dark, cool colours of the sea.

As a direct response to this, my first painting was about the warm, colourful rocks beside the beach, boats to look at and one *Sailing Out*. The closer you get to the water, though, the cooler the colour temperature becomes.

In the second painting, I took this warm/cool theme further, introducing the *Shore Road* with houses in the sun, gardens and pathways. The houses are looking out to the warm hills and the dark sea. The boats are not so important in this painting and are only suggested. The subject matter has changed in my painting. It is about the land at the water's edge. As it is a warm painting, I laid down a wash of yellow-ochre and built the painting up from there: the dark ultramarine of the sea acted as a counterpoint.

My third painting cools down the summer atmosphere and brings to it a different time of year and a different mood. It is a different place entirely. The two shapes of houses represent the human element. The boats have gone, leaving the marks of an empty pier on the bottom right-hand corner. The blues are warmer here and the sand pink. The sea is a darker, colder blue, broken up by landmasses and rocks nearer the shore. There is only a small passage from the open sea to this haven.

My painting is about the might of the sea and the small signs of human activity near the shore. The houses and the people in them are *Looking Out To Sea*.

The mood of the painting is dictated by the dark ultramarine taken over the whole paper, with as little as possible of a cobalt blue added nearer the houses. The subject has changed again from Southall's original work of a pleasant summer sea to a colder bleaker view of the sea by the people who live from it.

Above, left: **JOSEPH EDWARD SOUTHALL**, *A Cornish Haven*, watercolour, 30.3 x 24.3 cm (12 x 9.6 in)
Above, centre: **ANN WEGMÜLLER**, *Looking Out to Sea*, gouache, 75 x 55 cm 29.5 x 21.5 in)
Above, right: **ANN WEGMÜLLER**, *Shore Road*, gouache, 55 x 49 cm (21.5 x 19 in)

Above: **ANN WEGMÜLLER**, *Sailing Out*, gouache, 40 x 36 cm (16 x 14 in)

JANET GOLPHIN
HELEN ALLINGHAM (1848–1926): *A Bit of Autumn Border*

The rich, warm glow of colour captivates and enthralls the viewer. The colour of the flower border by twilight becomes the overriding element in an otherwise simple composition. There is no need for detail. It is a sight universally recognized and the familiarity already registered within the memory enables the viewer to complete the picture.

At first glimpse *A Bit of Autumn Border* has the impression of a beautiful embroidered piece of fabric placed over other layers. Looking at the painting upside down or sideways on, the abstract qualities work together beautifully, the distant trees could be foliage at a waters edge. The actual subject is immaterial, it is how we interpret the basic composition and how colour captures our attention and feeds the senses with bejewelled, glowing warmth.

Amaryllis with Wall Hanging demonstrates a similar simplicity of composition with no beginning or end, but an illusion of an ongoing scene beyond the picture's edges. Areas of the painting are unfinished and detail is missing. There are vertical, horizontal and slightly diagonal lines, which again work in every direction.

The darkest areas in my painting emulate the darkened foliage in Allingham's work in as much as they enhance the abundance of colour bringing it forward. Though gold-leaf has been used, it is subdued with washes of watery paint projecting rich colour forward and an illusionary understanding of an embroidered wallhanging.

In essence, the black and contrasting gold amongst the overall intense colour produces a three-dimensional vision, devoid of any necessity for detail, which again is completed by the viewer's own memory of similarity filling in the gaps. Multiple layers of richly coloured paint intensify the depth of colour, enhanced by other elements.

Both paintings are uplifting and that is the correlation between the two: the difference in subject is immaterial. The female sensuality in both paintings reflects the attitudes towards sensuality within the two ages.

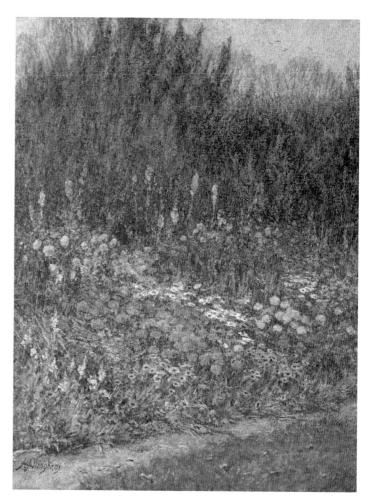

Above: **HELEN ALLINGHAM**, *A Bit of Autumn Border*, watercolour and bodycolour, 20.5 x 15.3 cm (8.1 x 6.1 in)
Opposite: **JANET GOLPHIN**, *Amaryllis with Wall Hanging*, 2005, mixed media, 81 x 91 cm (32 x 36 in)

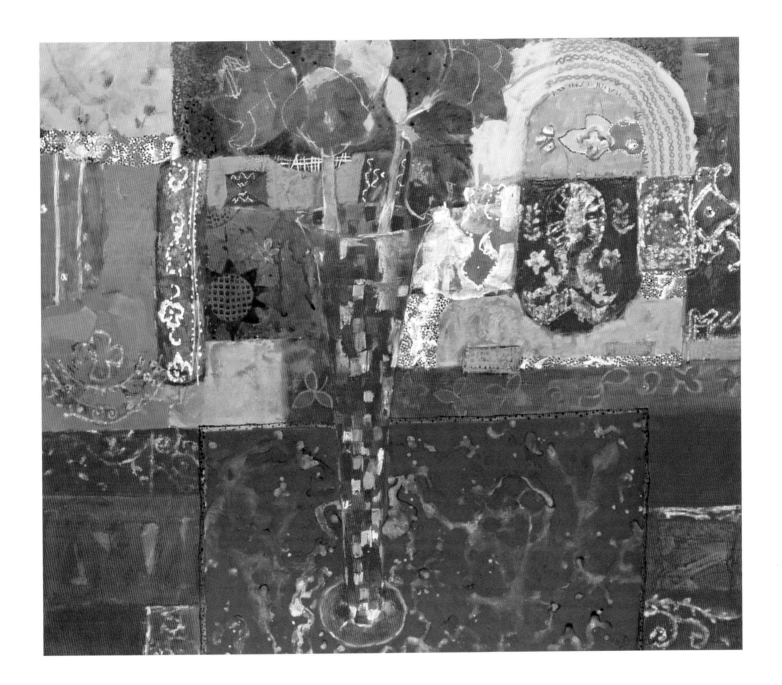

ISLA HACKNEY
CECIL ARTHUR HUNT (1873–1965): *Dents des Bouquetins, Arolla*

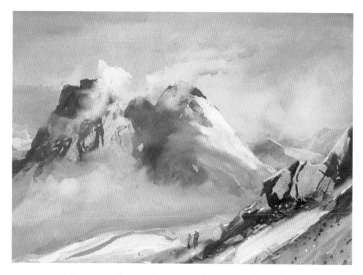

'*For consider, first, the difference produced in the whole tone of landscape colour by the introductions of purple, violet, and deep ultramarine blue, which we owe to mountains.*' (John Ruskin)

Since JMW Turner's journey through the Alps to Italy in 1819, mountainous landscapes with remote and misted peaks and other typically 'sublime' subjects had become a source of inspiration for generations of artists to follow. Writing his book *Modern Painters* in defence of Turner's greatness, John Ruskin's thoughts on the role of colour in landscape are still of interest today. Referring to mountains, he says:

'*Large unbroken spaces of pure violet and purple are introduced in their distances; and even near, by films of cloud passing over the darkness of ravines or forests, blues are produced of the most subtle tenderness.*' (Ruskin, *Modern Painters*, Vol. IV, 1856)

When I look at Cecil Arthur Hunt's awe-inspiring scene of Alpine peaks I find that my eye is drawn into its pools of pure, vibrant blue. Hunt's bold washes of colour at the centre of his composition invite us to share with him a sensation of physical and spiritual oneness with the natural world. This is not simply an attractive depiction of mountainous terrain, it is an imaginative interpretation of natural phenomena.

Hunt sought to align himself with nature's underlying forces, reminding us of both the timeless and transient aspects of nature. Tracking the changeable weather conditions, his travellers stand tremulous at the edge of a glacier.

Intense sunlight strikes the mountains as an aqueous mist encircles them, and great swathes of grey-blue cloud fill the valley. As onlookers also, our own focus shifts as the artist deftly brushes in areas of translucent colour, allowing it to merge with broader washes of more opaque bodycolour while Chinese white is used to reassert the monumental form of the snow-covered slopes.

Like Hunt, I hope to involve the viewer in the immensity of the scene, recalling also the construction of the image as pigment on paper. Taking the Scottish mountains and glens as my inspiration, I work with freely applied colour. I began *Melting Snow* with spontaneous, random mark-making. The painting's central motif seems to hover in front of its surroundings – a space or void awaiting a subject – while vigorously brushed colours set up an endless oscillation between fragmentary detail and the unified whole. Blue and purple shadows and bright white traces in the snow pick out the mountain ridge as the elements threaten to envelop it.

Above: **CECIL ARTHUR HUNT**, *Dents des Bouquetins, Arolla*, bodycolour over graphite, 26.7 x 36.2 cm (10.5 x 14.3 in)
Opposite: **ISLA HACKNEY**, *Melting Snow*, 2004, acrylic, 75 x 90 cm (30 x 36 in)

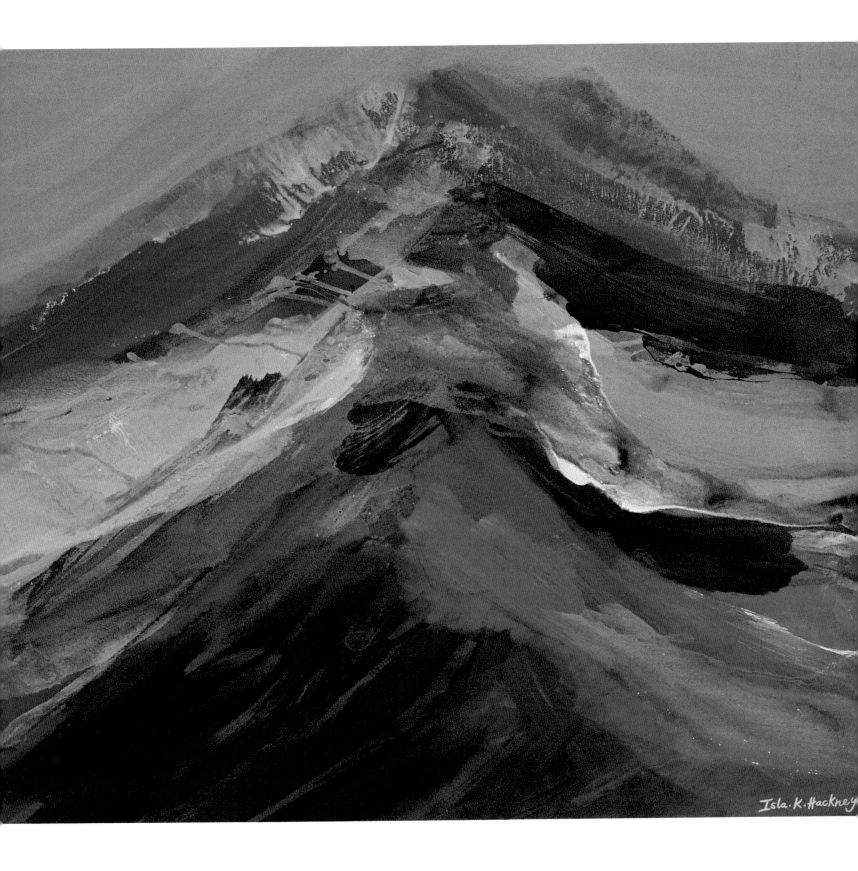

Isla.K.Hackney

PAUL NEWLAND
FRANCIS OLIVER FINCH (1802–1862): *Ruins of an Ancient City*

'Of course, he'd have seemed very conservative even then!' said the archivist when I went in search of material on Francis Oliver Finch in the Society's archive.

I had first caught sight of this picture (the first I had ever seen by Finch) on the cover of a catalogue for a show of works from the Diploma Collection held in 1987 (two years before I became an Associate). The image seemed enigmatic, wistful and completely intriguing. It was as if last respects were being paid to those European artists of the seventeenth century (Claude, Poussin *et al.*) who had had so profound an effect on the way the English manipulated the landscape of their country. Estates had been designed, gardens gardened and, most enduringly perhaps, England and Wales recorded under their influence. But no more…

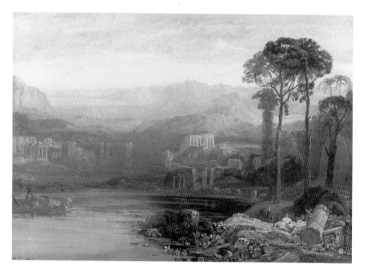

I started to paint this transcription from the reproduction, but when I went to draw from the original I found that the view was more extensive and the colour far cooler, more northern in fact, than in the reproduction. I also found that although the theme was so congenial to me, pictorial elements on the right side were not. I decided to transplant into the composition a little piece of landscape in Umbria, which I had once known quite well – my own little recollection of 'the south' – to complement the picture's theme. It also seemed important to make the gesture, at least, of adjusting the colour – into a sort of 'Finchian' key. The result is a bit of a patchwork of ideas, which requires a good deal of adjustment to bring about unity: a unity not yet achieved. Many parts of the picture are still quite thin wash, but others are more dense, with gouache being introduced.

Above: **FRANCIS OLIVER FINCH**, *Ruins of an Ancient City*, watercolour, 55.3 x 75.5 cm (21.8 x 29.7 in)
Opposite: **PAUL NEWLAND**, *Regarding the Ruins*, 2003–4, watercolour and gouache, 51 x 61 cm (20 x 24 in), with preparatory sketches below

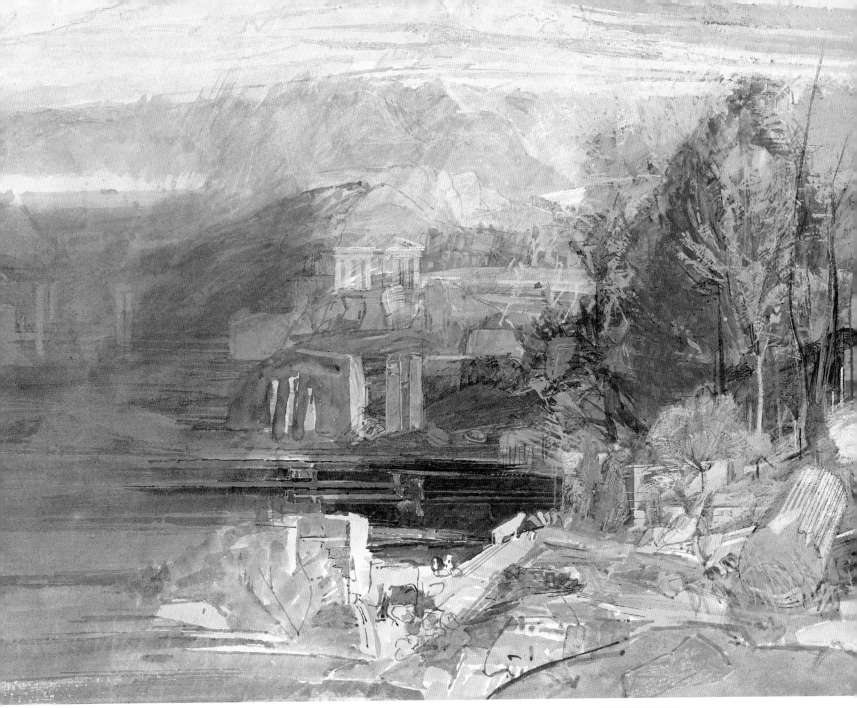

NEIL PITTAWAY
FRANCIS OLIVER FINCH (1802–1862): *Ruins of an Ancient City*

My ideas are often inspired by historical narrative subjects from the eighteenth, nineteenth and early twentieth centuries, so that the inspiration to produce new works based on the RWS painting collection was a natural progression. I particularly like the idea of borrowing visually from the past and letting the subject evolve gradually to form a modern and stimulating concept for the spectator.

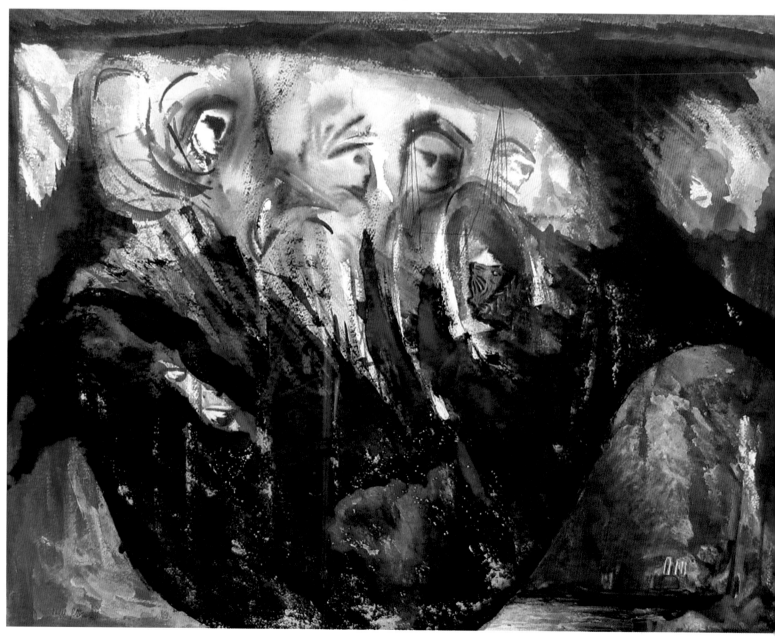

The transcription method of working is a bit like piecing together a large jigsaw. First, one researches and observes closely the chosen painting, observing every aspect of the work, both theoretical and practical, drawing out the essence of what the artist was trying to say, then reinterpreting it to create a totally refreshing vision, that is very much in the present day. This is what I have tried to do with my interpretation of Francis Oliver Finch's painting. By transporting it into an imaginative world that is real and unreal, old and new flow in parallel worlds to create a space that is devoid of real time. The subjects are strong and full

of emotion but distant as if a third party that is not present is working out the missing elements.

God-like figures that represent images from Greek mythology fall heavily over a fragile modern age. The modern age and globalization are inextricably linked to a bygone age of a classical empire, now in ruins. The ideal of romanticism in the classical landscape of Oliver Finch remains to be enjoyed and celebrated to this day.

The strength and application of colour determines the tempo of the picture and creates a backbone that supports and defines its character. Colour also expresses the general overall mood of the picture. The glazing methods I use highlight this further and create an image that is complex both technically and conceptually.

In my transcription, called *Changing Worlds* I have used colour to bind parallel concepts together to form a world that is enlivened and rich. I have chosen rich Turneresque colours for the classical landscape based directly on Francis Oliver Finch's work.

I use colour symbolically to represent a golden age, a world that is no longer real, but exists in the imagination of the human spirit and mind. Through using colour that is clean and machine-like I create another rich but far removed world, a world of new enlightenment, of globalization and scientific exploration.

Opposite, above: **FRANCIS OLIVER FINCH**, *Ruins of an Ancient City*, watercolour, 55.3 x 75.5 cm (21.8 x 29.7 in)
Opposite, below: **NEIL PITTAWAY**, *Changing Worlds*, 2004, watercolour and bodycolour, 57 x 76 cm (22.5 x 30 in)
Left: **NEIL PITTAWAY**, *City Audience*, 2004, watercolour and bodycolour, 76 x 57 cm (30 x 22.5 in)

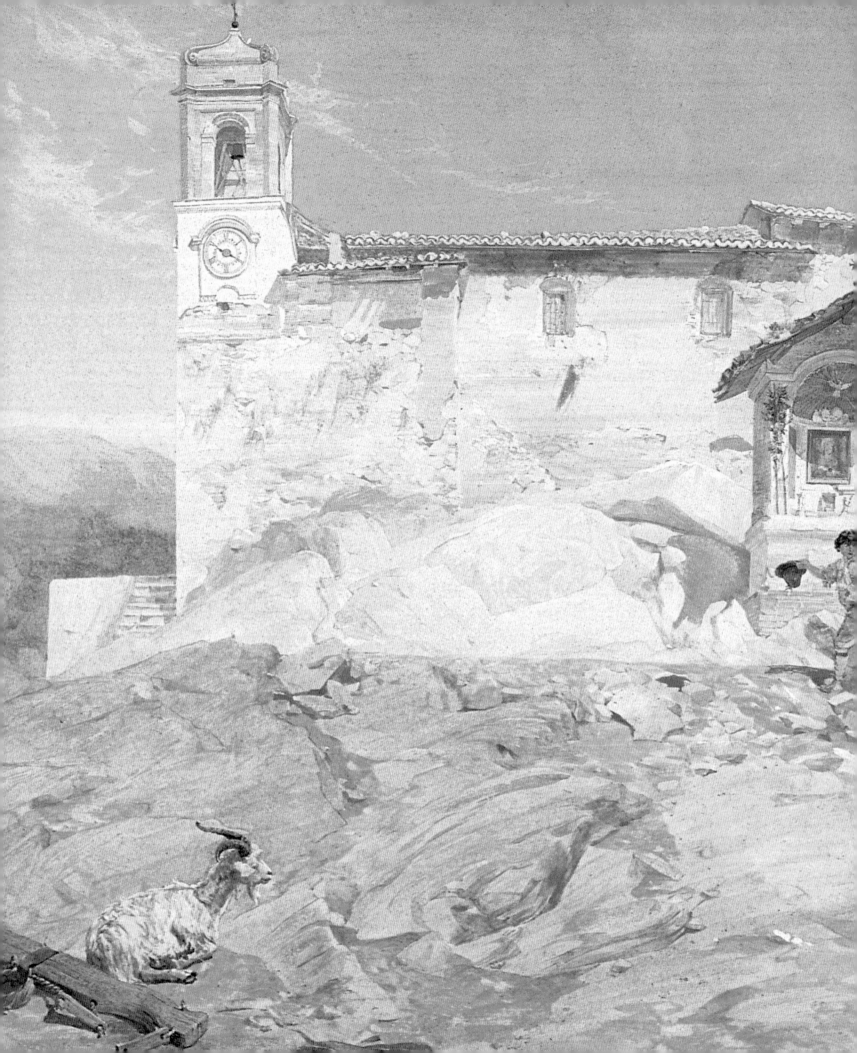

COMPOSITION

When I began my career as a teacher, I wanted to be the greatest art teacher in the world. But I soon realized that there were gifted pupils in all of my classes, but the majority were not, and needed much guidance. Despite the fact that I was teaching drawing (a dirty word in the 1960s) and they were making good progress, many were simply impoverished in the complex activity of painting. One afternoon a more gifted pupil asked me 'for a piece of paper to plan her painting'. I watched her make several small drawings in pencil on her paper, try different colours, and, as I watched her, I realised she was composing her painting before she began it. This was a eureka moment! And so it was that I began to educate pupils in composition: through the introduction of sketchbooks and the myriad of processes that artists use to compose their paintings. The advancement in all pupils' work was enormous.

Composition deals with the whole painting, synthesizing its many components: line, tone, texture, shape, and colour. It is the bringing together in a harmonious – or jarring – whole all the parts of a painting. It's a complex task, unique to each artist. There are many processes involved, such as planning, investigating, and researching. Tools such as sketchbooks, viewfinders, models, photographs are all important in helping painters compose their paintings, and both figurative and abstract painters are concerned with composition.

So, how do I compose my own paintings? I'm afraid I don't know. Like many professional artists I never think about it now, I just sit down and paint, what is before me, and what's in my head. I never make a plan. But, presumably, I can only do this because of the early training I described above. Nevertheless, there are mysteries in composing. Several people have commented on the high point of view in my paintings of large land and seascapes. Strange this, because I'm only five foot four inches tall, and yet whenever I sit and paint these scenes it is from at least a twelve-foot-high point of view. So I think I'm painting what's before me, when all the time I'm painting what I can't see, from above me. How do I do it? I simply don't know. As Matisse said, 'the best things in paintings can never be explained'.

DAVID FIRMSTONE MBE

Left: **ALFRED DOWNING FRIPP**, *San Rocco Olevano* (detail), bodycolour and watercolour over graphite on grey paper, 39 x 53.5 cm (15.4 x 21.1 in)

CHARLES BARTLETT
ROLAND VIVIAN PITCHFORTH (1895–1982): *Kent Marshes*

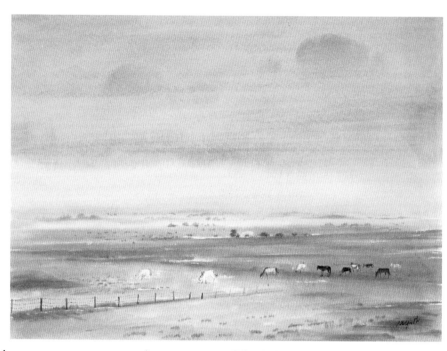

I did not know Pitchforth very well but met him several times and admired his sensitive views on art. We also shared a love of similar types of natural landscape. Pitchforth's painting *Kent Marshes* is typical of many of his watercolour and oils. It is the flat landscape in many ways similar to some of the landscapes of East Anglia. But whereas his paintings – particularly watercolours – were often atmospheric and fluid, I tend to treat similar landscapes in a more geometric manner. Pitchforth's colour was often muted and tended to be literal whereas I tend to express my ideas using expressive colour and texture.

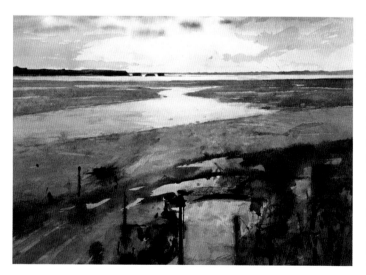

Having sailed small boats for a large part of my life has given me a love of the sea. Pitchforth also loved painting the sea and ships. The angular and straight sea walls of Essex, the lonely marshes and the beautiful reed beds mainly form the basis of my compositions.

I try to find an equivalent in paint and etching to express my feelings about the East Anglian landscape, particularly studying the geographical formation and erosion of the beaches. I do not paint on the spot, but work from drawings and studies that are used to compose my paintings in the studio. I try to express the poetry found in this landscape. The loneliness and unspoilt pure beauty of the landscape, perhaps just the sound of a seagull, the wind and the sea, contrast with the noise and hurly burly of modern life.

Above, right: **ROLAND VIVIAN PITCHFORTH RA**, Kent Marshes, watercolour, graphite and scraping, 43.7 x 58.4 cm (17.2 x 23 in)
Above: **CHARLES BARTLETT**, Low Tide, Stone Point, 2004, watercolour, 42 x 58 cm (16.5 x 22.8 in)
Opposite: **CHARLES BARTLETT**, Low Tide, Walton Backwaters, watercolour, 33 x 58 cm (13 x 22.8 in)

CLIFFORD BAYLY

JAMES PATERSON (1854–1932): *Punta Brava, Tenerife*

The painting I have selected – *Punta Brava, Tenerife* by James Paterson – embodies, I feel, a feeling of controlled excitement at encountering a new landscape experience.

Paterson trained at Glasgow School of Art and in Paris; subsequently living and working in Scotland and making working forays abroad. He became an Associate RWS in 1898 and a full RWS in 1908, a member of the Royal Scottish Academy and President of the Royal Scottish Society of Painters in Watercolour from 1923.

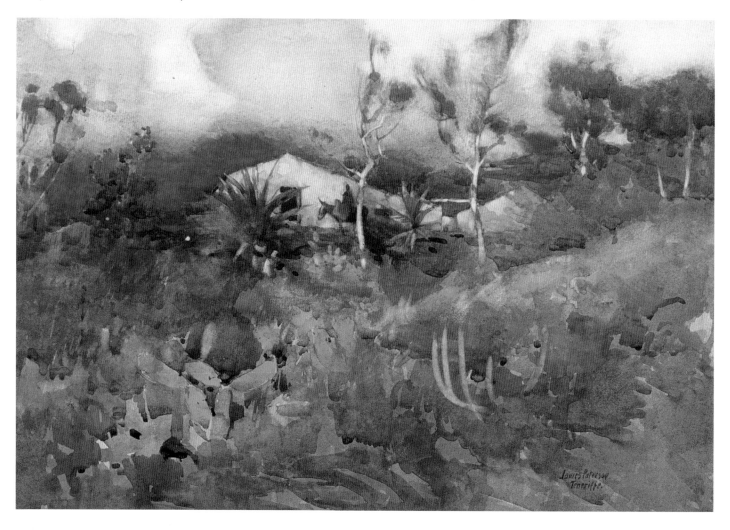

Above: **JAMES PATERSON**, *Punta Brava, Tenerife*, watercolour, 36.6 x 52.8 cm (14.5 x 20.75 in)
Opposite: **CLIFFORD BAYLY**, *Mulla Mulla at Katajuta, Northern Territory*, 1999, watercolour, 51 x 91 cm (20 x 30 in)

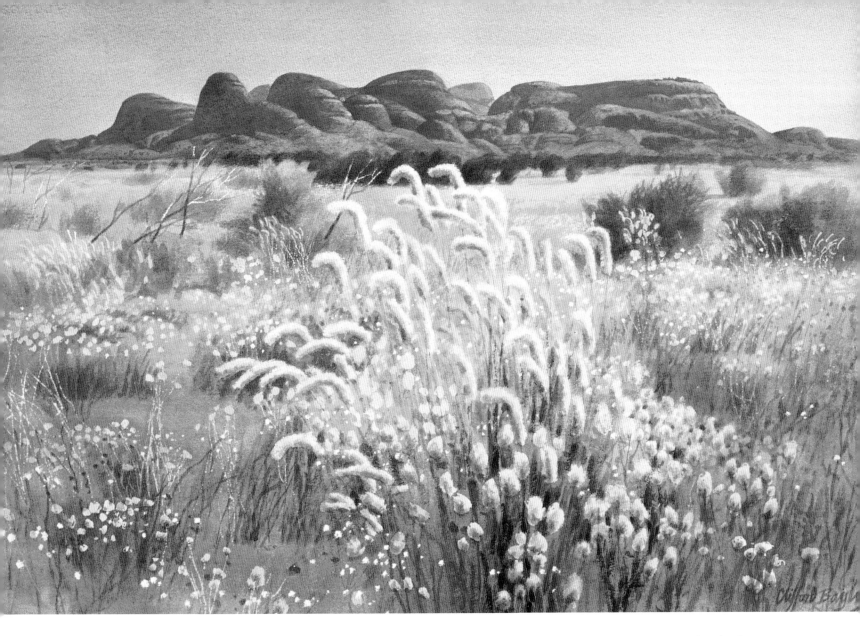

On discovering this painting, I immediately felt an affinity with this artist. There was a strong sense of visual wonderment at experiencing a new and exciting environment, full of urgency in execution and directness in brushwork. This affinity I ascribe to the excitement I experienced when confronted with the unique landscapes of Australia and which I have continued to find challenging now that I live here.

I write principally about composition; my interpretation of this term embraces colour, tone and many forms of contrast, interrelating to provide a comprehensive unity of structure.

Punta Brava, Tenerife's compositional distribution of visual elements – buildings, foliage, a solitary figure, are directly related to the contrasts of tone, warm and cool colour, angular and rounded forms, hard and soft edges. The painting works so well because these elements are visually integrated. For instance, the area of highest tonal and colour contrast is placed at the painting's main focal point.

My painting of the Olgas, now called by their traditional name of Katajuta, is a good example of my reaction to just such a new visual and physical experience as that encountered by James Paterson in Tenerife. The foreground flower heads of this species of Mulla Mulla echo the dome-like forms of the mountains and the palette of pink, mauve and light ochre are typical of this landscape in summer – very different from the UK environment.

Just as Paterson found a stimulus in travel, I sense that the travelling artist is constantly challenged to re-evaluate his or her approach both to their vision and to the visual language in which they work.

JOHN DOYLE
JOHN SELL COTMAN (1782–1842): *Cader Idris from Barmouth Sands*

My hero is John Sell Cotman. In my library here in Warehorne, I have a book of his etchings entitled *The Antiquities of Norfolk*. They are so fine that they need no colour. They are my inspiration. Alas! The Society's Cotman was sold by the then President, Sir William Russell-Flint, before the war in an act of vandalism that cannot be forgiven. It has left a great void in our Diploma Collection. So my painting is inspired by the work of an artist who is no longer represented there.

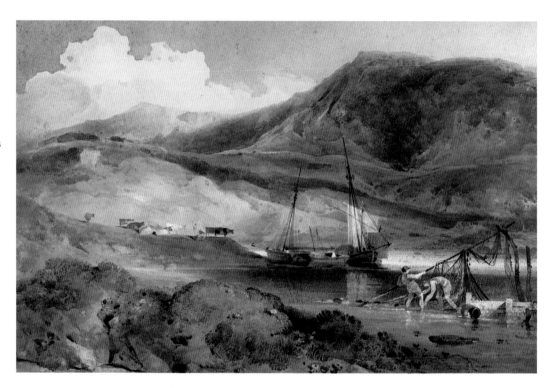

Cotman was able to marshal a mass of detail into great contrasting shapes. Unlike many painters who paint and have painted buildings, the detail never fusses, the surface of the paper is never overloaded but remains fresh and pure. His designs, in beautiful massed shapes, are constructed with amazing solidity.

I have always loved drawing architecture. Up to a certain level, it is one of the less exacting subjects: for a start it stays still. But then the problems begin. To turn a building into a work of art is not so easy; one has to make an inanimate object come alive, full of texture, light and shade. It is one of the paradoxes so often encountered in drawing that one draws inanimate subjects as though they are alive, and living subjects with a structure as firm as a building.

To succeed in drawing architecture depends upon accuracy, the endless fight to establish lines in their right place. The human eye can measure quite accurately up and down and from left to right. Imagine a grid of lines on your paper so that you can crosscheck continuously the details in your drawing. Are they in their right place? Measure the distances with a compass held to the eye – a drawing should expand outwards like a widening blot of ink on a blotter. Do this very carefully with a sharp pencil and do not press too heavily – one may have to alter the drawing later. For in the end it must not be too tight but have freedom and breadth so the architecture sits happily in its surroundings.

Corot listed three main elements in a work of art: composition, tone and colour. He listed them in that order of importance; today colour is more often regarded as the most important factor, but I think Corot was right. Finally, rules are there only to be broken. The most important ingredient in a work of art is love. Without love, enthusiasm and passion, all is a desert. For how can one thrill an audience unless one is thrilled oneself?

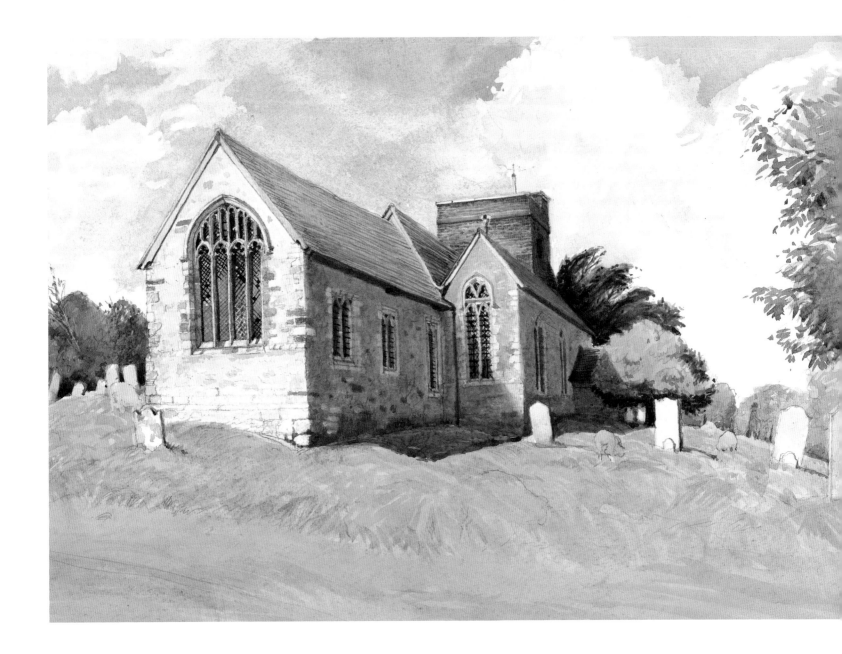

Opposite: **JOHN SELL COTMAN**, *Cader Idris from Barmouth Sands*, watercolour, 36.2 x 53.6 cm (14.3 x 21.1 in) [coll: Provost and Fellows of Eton College]

Above: **JOHN DOYLE**, *St Matthews, Warehorne, Kent, 2005*, watercolour

SHEILA FINDLAY
JOHN HENRY LORIMER (1856–1937): *Table by the Window with Peaches and Pears*

'*What I dream of is an art of balance, purity and serenity, devoid of troubling or depressing subject matter … something like a good armchair which provides relaxation from physical fatigue.*' (Henri Matisse). Matisse's ideas expressed in his 1908 essay, 'Notes on a Painter', wonderfully evoke the harmonious design and domestic pleasures that we find celebrated in his paintings. Matisse's modernist aesthetic is rooted in the late-nineteenth-century cult of domesticity, which also informs the work of John Henry Lorimer, whose watercolour I have chosen to discuss.

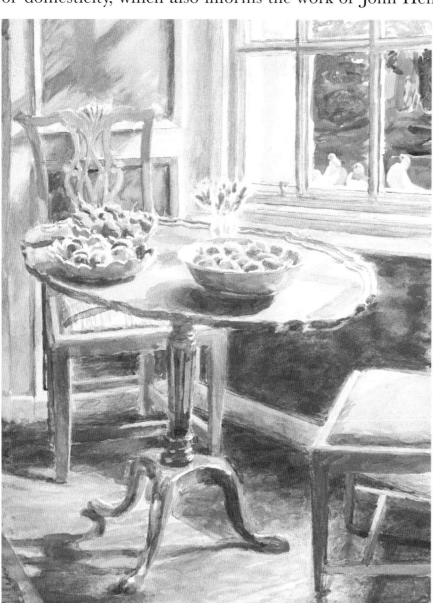

A contemporary of the Glasgow Boys, Lorimer attended Carolus Duran's Atelier in Paris, after training under William McTaggart and G P Chalmers at the Royal Scottish Academy in Edinburgh. The image of the interior flooded the art and design journals of the day. Inspired by his experience in France and by influential Americans like John Singer Sargent and James Abbott McNeill Whistler, Lorimer's genre paintings of the Scottish home, and intimate scenes of domestic incident, reflected an international trend.

In *Table by the Window with Peaches and Pears* the charm of the scene is underpinned by a strong sense of design. The round table, chair, and window frame serve as bold compositional devices, while the simple grouping of the still life, the fruit and flowers, and the doves at the window, add to the decorative effect. A brother of the influential architect Sir Robert Lorimer, architectural elements feature in Lorimer's work and spatial structures and framing devices initiate an interior/exterior dialogue.

Lorimer divided his time between England and Scotland, finally deciding to settle in Edinburgh. Views from my studio in Edinburgh, where I spend part of each year, can be seen in the painting I include here. Like Lorimer, I paint my immediate

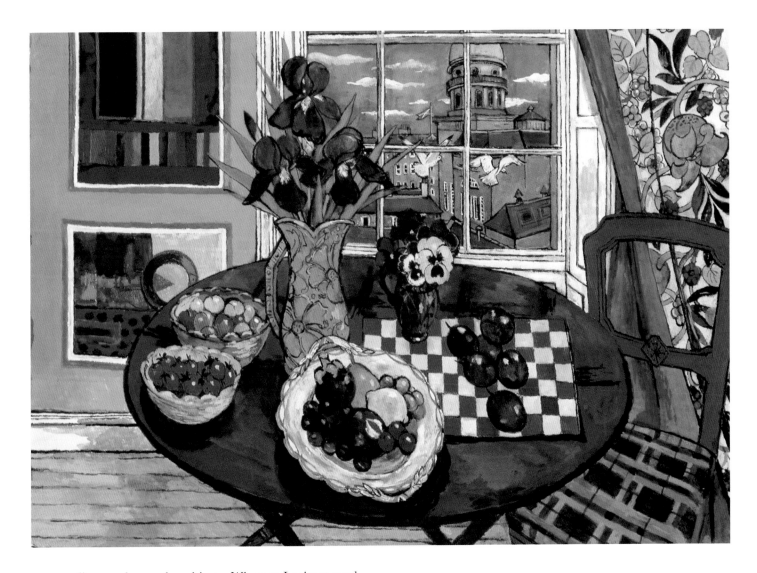

surroundings and everyday objects. Whereas Lorimer used subtly graded colour, favouring gentle schemes of cream, yellow and orange or deep browns and reds, I build up the composition using distinct areas of colour, working to establish a sense of atmosphere and balance. Contrasting busy and calm components I make adjustments, guided by a concern for pictorial effect rather than realistic transcription. In *Round Table by the Window*, rounded and rectilinear elements are repeated throughout the composition. The shapes of the table and window are echoed in the fruit and chequered mat, the details in the artwork on the wall and the domed architecture beyond.

Opposite: **JOHN HENRY LORIMER**, *Table by the Window with Peaches and Pears*, watercolour, bodycolour and graphite, 35.6 x 27 cm (14 x 10.6 in)

Above: **SHEILA FINDLAY**, *Round Table by the Window*, 2005, watercolour and gouache, 75 106 cm (29.5 x 42 in)

SARAH HOLLIDAY
SAMUEL PROUT (1783–1852): *The Doges Palace and the Grand Canal, Venice*

Prout's painting is hypnotic and graceful. The eye is led through the painting to Santa Maria della Salute in the distance, and back again, with layers of tone swinging you gently from side to side. The horizontal lights and darks are so clever, with the punctuations of his beautifully drawn figures preventing you from being led out of the picture. Everywhere, he has used the device of light against dark, and dark against light, never letting a passage become dull and predictable. Then, against all this geometry, there is the graceful curve in the sky counterbalancing the formality of his tonal wizardry. All of this revolves around the still, solitary figure standing in the centre mid-ground. Oh, it is so clever!

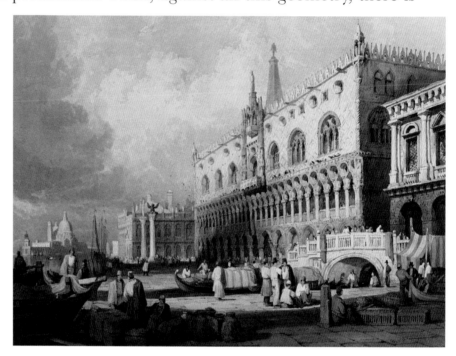

These are the things that I love to explore when painting, and *Strange Meeting* is a contemporary take on this very subject. Like Prout, I have chosen an important architectural setting: the new Paternoster Square development near St Paul's Cathedral. My interests are the same, but the end result is completely different. The space I have created is more mysterious and unconventional. The imagery comes originally from the drapes and scaffolding that shroud new buildings. However, these become a device for carving out space. The lights and darks of the poles define the spaces behind them, with the tower of Christ Church peering through it all, in the way that Prout uses Santa Maria della Salute. My curving line hopefully does the same as his curving clouds, to give a grace and fluidity to the whole thing. Groups of people pepper Prout's Venetian square, giving it scale. My twenty-first-century figure does the same thing, and the carved letters remain from a previous age – Samuel Prout's, maybe?

The whole painting is built up with layers of watercolour and gouache, literally carving out the lights and darks, and playing the game of counterchange, which I admire so much in Prout's great work.

Above: **SAMUEL PROUT**, *The Doge's Palace and the Grand Canal, Venice*, watercolour, 43.5 x 56.4 cm (17.1 x 22.2 in)
Opposite: **SARAH HOLLIDAY**, *Strange Meeting, Paternoster, 2001*, watercolour and bodycolour, 53.5 x 65.5 cm (21 x 25.8 in)

WENDY JACOB
ALFRED DOWNING FRIPP (1822-1895): *San Rocco Olevano*

I have chosen *San Rocco Olevano* by Alfred Downing Fripp. I paint the landscape, usually featuring buildings, quite often on my travels in France or Italy. In brilliant sun, I struggle with the wonderful but unfamiliar tonal values. I find myself using more and more body-colour to achieve the brilliance of the reflected light, or making the paintings very jumpy with exaggerated dark shadows. In this painting Fripp uses close pale tones and yet the painting is powerful and strong, pulsating with heat. Could I achieve this effect by keeping his painting in mind while attempting a similar subject?

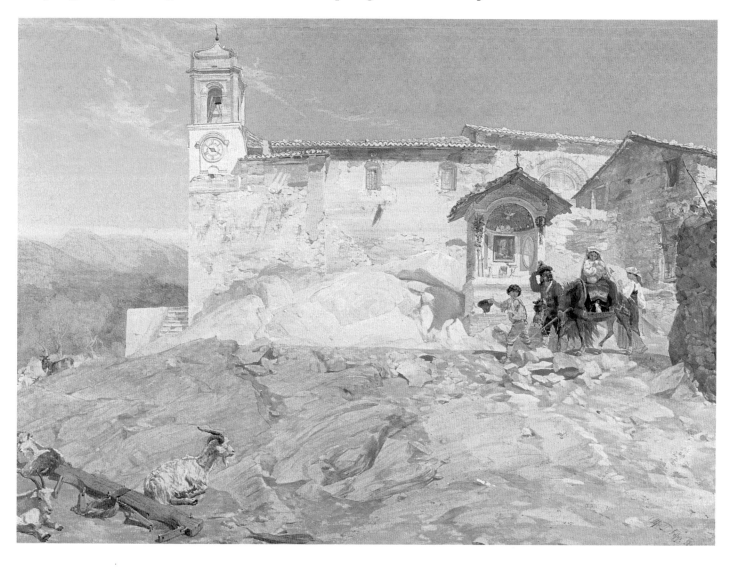

Above: **ALFRED DOWNING FRIPP**, *San Rocco Olevano*, bodycolour and watercolour over graphite on grey paper, 39 x 53.5 cm (15.4 x 21.1 in)
Opposite: **WENDY JACOB**, *Under a Southern Sky, 2004*, gouache, 19 x 21.5 cm (7.5 x 8.5 in)

Well, I tried, when recently I spent ten days in France. I started with several fairly detailed sketchbook drawings, taking particular note of the tonal values and time of day. Back at the house, choosing the strongest of the drawings, the paintings were laid down with thin washes marking the broad structure. Returning to the subject the next day at the same time with paints allowed for corrections and alterations using bodycolour along with the watercolour. Working on several paintings of different subjects, one in the morning, and others at midday and in the evening, blessed with good weather and enough time to allow for thought, I groped towards a resolution. I washed out and repainted areas, editing the subject, trying to maintain simplicity. In the end, although I looked at Fripp's painting regularly, my paintings don't resemble his: but they wouldn't have been the same without the framework of the task.

My admiration for Fripp has grown; the deceptively simple, monumental composition where the church, glowing in the glaring heat, seems to be a part of the rocky landscape, is a sort of magical trick. I don't know how he did it. A humbling experience, this sitting at the feet of a master, but one which gives rise to a new appreciation of all the elements which have to work together to make a painting live.

JANET Q TRELOAR
ALFRED DOWNING FRIPP (1822–1895): *San Rocco Olevano*

The selection of Alfred Downing Fripp's work from the Diploma Collection was not difficult, for several reasons. The first is sentimental. Fripp was the great-grandfather of my husband, and himself the great-grandson of one of the founders of the (Old) Water Colour Society, Nicholas Pocock. Fripp was Secretary of the Society from 1870 until his death in 1895.

The second is that the subject matter is close to a current preoccupation and the basis of a recent exhibition of mine: 'The Romanesque Arch as the Visual Language of Europe'.

But the third, and most important reason is the strong composition underlying this work based on its three horizontal bands of colour: from a blue band just across the top quarter, through two absolutely equal and wider bands of white and yellow ochre occupying the remaining space. This breadth gives an abstract generosity which is broken by a series of verticals and interlocking triangles and squares, leading the viewer back to the main subject matter with the figures and the triangle of the shrine contained in the golden section, and then out again along the roof to the tower and back to the foreground. The tones are very close and the colour key high, so that the success of the work relies on a very simple but subtly organized composition. This use of horizontal bands of colour is something I have been exploring and which has become a recurring theme in my own work over the last few months.

In his notes on the (Old) Water Colour Society exhibition of 1858, Ruskin makes these comments on this work:

'*That church of St. Olivano which looks so strange in its paleness among all the old-fashioned watercolours about it, has had its colours carefully matched with sunshine. Only it will never do to leave hard edges and thin washes if we are going to paint in that key. Treble notes must not be sharp and thin, the paler the tone of a picture the more sweet must be its textures, and the more subtle is gradations, else it will always look like a strange half finished sketch, not as this picture really is – a most truthful study of sunlight ... This goes nearly as far towards Italian noonday as poor paper and colour can reach.*'

My new interpretation of Fripp's work is based on a similar subject matter, a church façade at midday, but in a close-up, version, cutting out the landscape and figures which make the Fripp appear narrative, and concentrating instead on a more abstract sense of design. The area used is to the right of the tower and above the bottom one-third of the yellow foreground. I have used the horizontality of Fripp to make two bands, each occupying 50 percent of the work with the critical triangle being placed centrally instead of to one side. The sides of the triangle come down to enclose the two red squares of the outer

doors and the central red door replaces the figures as both the beginning and returning point of the image. The verticality of the tower is replaced by a warm wash with bodycolour over the left one-quarter of the paper, and the sun and shadow on the right by a slim vertical line indicating the tower of St Gilles. Warm ochre with bodycolour animates the cool underlying wash of the building surface, and cool blue lies over a warm wash on the upper half. The brushstrokes have been left as more evident, and I hope there is nothing sharp or thin that would upset Ruskin in this interpretation.

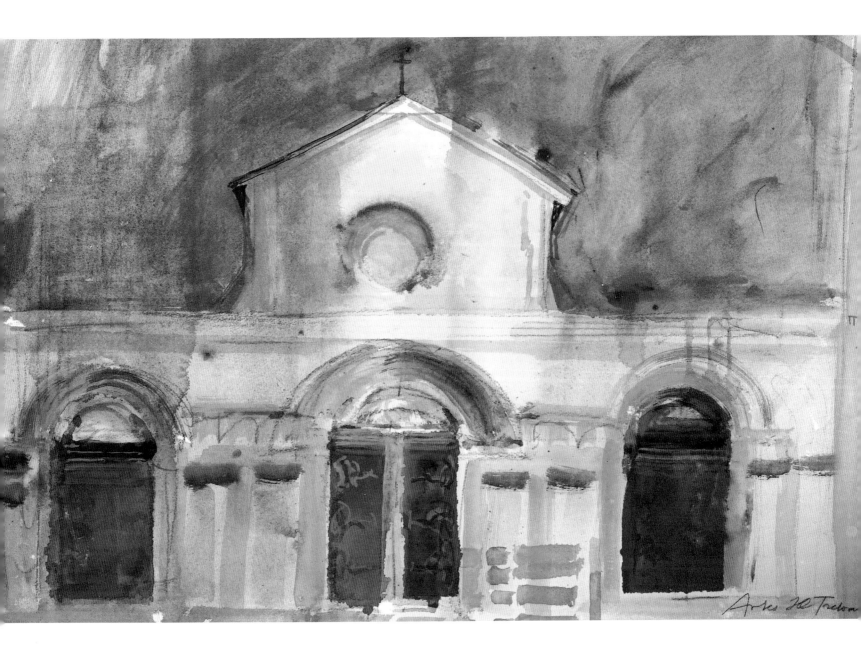

Opposite: **ALFRED DOWNING FRIPP**, *San Rocco Olevano*, bodycolour and watercolour over graphite on grey paper, 39 x 53.5 cm (15.4 x 21.1 in)

Above: **JANET TRELOAR**, *St Gilles-du-Gard, near Arles, Provence*, watercolour and bodycolour, 43 x 68 cm (35 x 27 in)

OLWEN JONES
PERCY HAGUE JOWETT (1822–1955): *Bedroom Window*

My work is concerned with interiors and often conservatories, usually relating an aspect of the inside looking outward, windows being an important element of the design. The structure is enhanced by my emotional use of colour and the frequent inclusion of plant forms, which play an integral but not necessarily the dominant part of the composition.

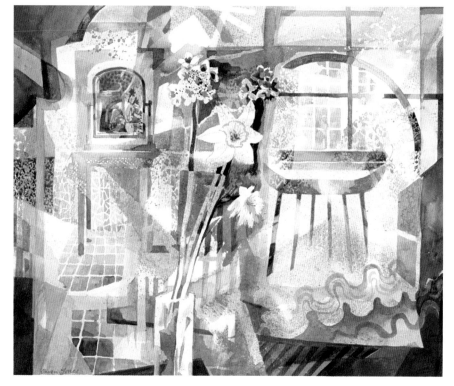

The painting *Bedroom Window* by Percy Jowett depicts part of a small room, but suggests a larger vista beyond the partly opened window in a powerful, evocative work. The vase of flowers fills much of the window space and draws the spectator outward to the bigger world beyond this modest room. The triangular gap left between the curtains, echo the table legs, forming another triangle, leading on to the flowers, which form the focal point and bridge with the exterior. I also try building a mood through related shapes in constructing my pictures. A framework of static shapes complemented by the curvilinear forms of nature can act as markers in a spatial sense, also compositionally when shapes are repeated.

Colour can be used to create mood beyond the naturalistic; it can be used to reinforce a direction, giving a picture vibrancy. I try to orchestrate my palette by limiting my colour range around a pair of complementary colours, like yellow and purple, adding only small amounts of a few other colours.

I rarely paint direct from the subject but start by making studies from situations I feel instinctively drawn to, often working from several viewpoints. Further drawings to select the right composition will follow before I feel confident to begin on the painting in my studio. I feel that this detachment from my subject's starting off point is vital to the creative process. The uncertain conditions of local light and its effects can blur the mind and inhibit the imagination.

Above, right: **PERCY HAGUE JOWETT**, *Bedroom Window*, watercolour and bodycolour, black chalk, gum arabic, 32.7 x 43.1 cm (12.9 x 17 in)
Above, left: **OLWEN JONES**, *April Sunlight*, 2003, watercolour, 36 x 43 cm (13.4 x 14.2 in)

WILLIAM SELBY
SIR HUBERT HUGHES-STANTON (1870–1937): *Hindhead, looking towards Haslemere*

My interest in this particular painting by Sir Hubert Hughes-Stanton, is the way the distant hill – although being the main attraction of the painting and focal point of the composition, is kept low, and almost hidden by the foreground – reminding me of many similar views when travelling and sketching in the Yorkshire Dales.

When returning to Yorkshire, my birthplace, and home for 66 years it feels like slipping on an old pair of slippers. Basing myself in Wensleydale for two weeks, sketching, I found that wherever one stops, in whichever dale, there is invariably a major hill or fell peeping over some high foreground – such as the Howgills, Great Shunner Fell, Pen-Y-Ghent and many others.

From a distance, these highlands could be mistaken for some majestic mountains, when dominated by the foreground – but there are no mountains in Yorkshire – just rounded hills, and a very few above 2,000 feet.

One does not require climbing experience, ropes, picks or breathing equipment. They can be walked over if one is in reasonable health and all that is needed is sensible clothing, a water bottle, a couple of Mars Bars, and perhaps a hip flask! They are friendly hills, enjoyable to be amongst, much like the people who inhabit this part of England.

Of the several paintings which I have done of Wild Boar Fell, the one illustrated shows Hughes-Stanton's approach to his work, in keeping the primary interest – the fell – almost hidden behind the foreground. There has been much artistic license taken, perhaps more than Sir Hubert took.

Here I was looking for less of perspective, light and shade, concentrating more on shapes of colour and tone. The work was painted in the studio in mixed media of watercolour, gouache and acrylic from quick sketches.

Above, right: **SIR HUBERT HUGHES-STANTON RA**, *Hindhead, looking towards Haslemere*, watercolour over graphite, 35.8 x 50.7 cm (14.1 x 20 in)
Above, left: **WILLIAM SELBY**, *Wild Boar Fell, 2005*, mixed media, 71 x 71 cm (28 x 28 in)

AGATHE SOREL
ROBERT ALLAN (1851–1942): *Tarbert, Loch Fyne*

Robert Allan's Loch Fyne depicts a lonely and somewhat derelict tower, similar to the one I discovered and painted in remote farmland in volcanic Lanzarote. No doubt both towers harboured a mysterious or heroic past, but in their gradual decomposition became the subject of fluid associations of ideas.

Allan travelled widely and was greatly influenced by the landscapes in which he painted. An interest in light and weather conditions made his work personal and in this he followed the Impressionist tradition of painting out of doors and taking note of the most transient changes around him.

This approach appealed to me when I painted *Ghost Tower*, where the ruins provided the framework for spatial ideas. The pigeons flying in and out, from the background to the foreground, and maybe also from past to the present, became compelling symbols in an imagined narrative.

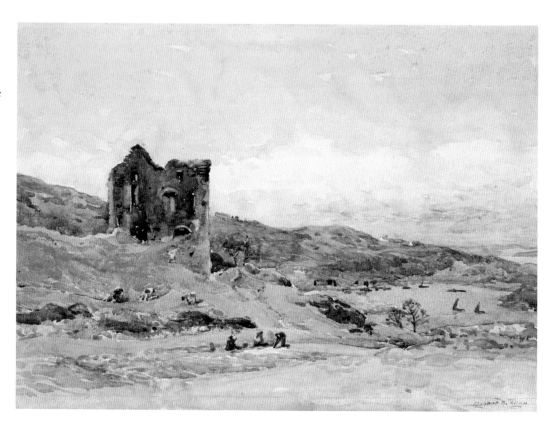

The process of simplification and abstraction transformed the tower into a virtual structure, facilitating experiments with sculptural elements. The collaged areas used with a somewhat reckless spontaneity helped to accentuate movement throughout the picture. The subjective handling of the media was preceded by numerous compositional diagrams and careful consideration of the proportions.

It seems that 1911 was not so long ago and the experience of two artists painting or immersing themselves in the landscape should be very similar. We tend to carry much more baggage these days; it is increasingly difficult to ignore all the recent developments in the arts and the pressures to create novel or conceptual work.

These methods have their own interest and value, but out in the landscape, subjected to the elements, one enters into the different world of spontaneous observation and improvisation. It results in a freshness of vision, which in other circumstances is difficult to achieve.

Above: **ROBERT ALLAN**, *Tarbert, Loch Fyne*, watercolour and graphite, 39.4 x 57.1 cm (15.5 x 22.5 in)
Opposite: **AGATHE SOREL**, *Ghost Tower*, 2003, 45 x 60 cm (18 x 24 in)

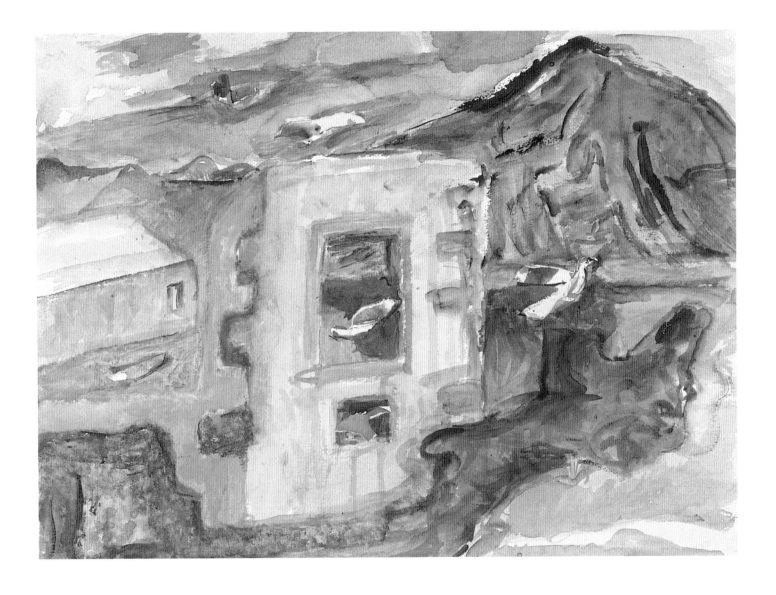

JANE TAYLOR
ROSE MAYNARD BARTON (1856–1929): *Child with a White Cap*

Rose Maynard Barton was elected an Associate Member of the Royal Watercolour Society in 1895, but did not submit this, her Diploma Work, until 1909. Barton was born in Ireland and was largely self-taught, and with no obvious influences which might otherwise blunt or distort a capable and refreshingly unselfconscious approach to her subject. These characteristics drew me initially to this painting. Obviously in my tribute to Rose Barton's painting, no attempt has been made to copy the original: it simply served to 'kick-start' the process – and to translate it into a modern idiom.

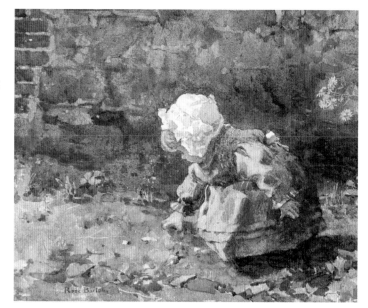

The original is a little gem of observation – and one wonders how it was done. Clearly the child, probably about two years of age, could not be expected to 'pose'. Probably pencil sketches were made, with notes as to gesture, costume, surroundings, etc., and the final, painted in the studio, where those limpid washes could be controlled, and such adjustments as might be necessary could be comfortably made.

My preferred method of painting is using watercolour-gouache, and this work of mine is fairly typical. I usually prefer to tint the paper lightly with a warm wash of colour and then, when dry, work into that, building up the washes towards a final opaque note – as for example in the cap.

Ultimately the honours go to Rose Barton, whose artistry is self-evident. This is a simple and engaging study, seen as it were in a moment and captured forever.

Children were often sentimentalised in Victorian and Edwardian painting, and became tokens of innocence, but this painting tells no story. It is direct and unfussed. The artist had marvellous powers of observation and retention – not only for the child but also for the surroundings, the stony path, the brick and the stuccoed wall. One could live with this entirely convincing portrait – these are my reasons for choosing it.

Above: **ROSE MAYNARD BARTON**, *Child with a White Cap*, watercolour and bodycolour over graphite, 27 x 32 cm (10.5 x 12.5 in)
Opposite: **JANE TAYLOR**, *The White Cap – Crouching Child*, 2004, watercolour and gouache, 26 x 31 cm (10.2 x 12.2 in)

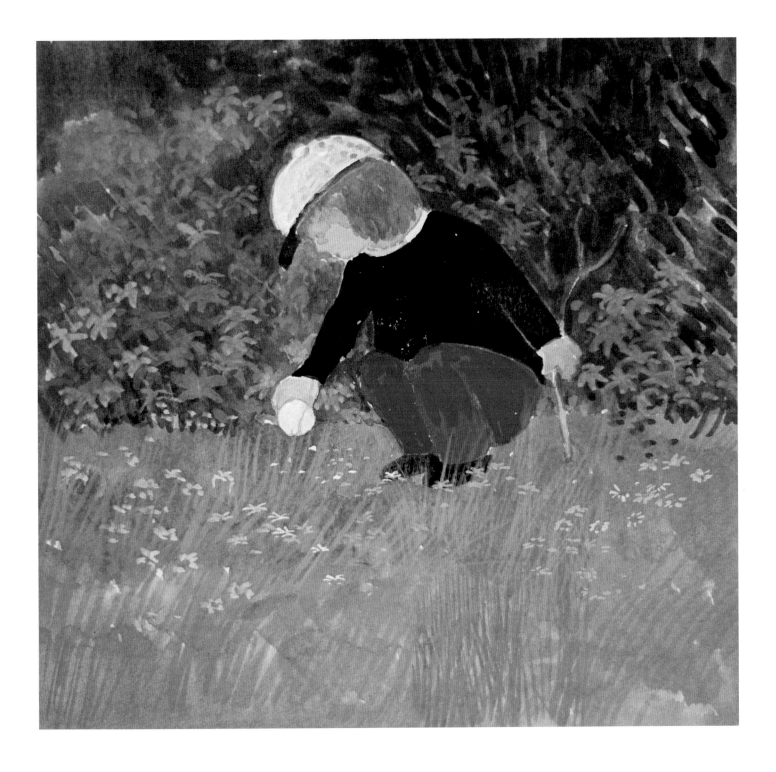

DRAWING

'Draw' is a word with a tricky derivation. Its definition occupies two whole pages in the *Oxford Shorter English Dictionary*, with only a fraction of the entry concerned with our subject here. Think of drawing a bath, drawing a salary or, what some artists have been more famous for, drawing a cork. In the early years of English watercolour, all watercolours were called 'drawings'; 'paintings' were in oil, the grown-up, official medium for the products that adorned the walls of the established well-to-do, aristocrats and grandees. Sometimes, even now, one hears the 'correct' commentator and the auction houses call the watercolourist's wily washes 'drawings'.

But how do watercolourists themselves think of 'drawing'? Is it the use of lines or shading to puzzle things out, such as: 'How does that arm join the shoulder... how do those petals curl? Or is it to plan and design like architects' working plans or engineers' presentations? Mapping of all kinds is drawing, even if done now on a computer, as are graphics and much illustration. The watercolour medium encompasses all of these forms, and we see in our Diploma Collection exact records of the rigging of ships and meteorological observations. Sometimes we are invited by the works to indulge in flights of fancy or wishful thinking; and literary conceits rub shoulders with visual catalogues of farmyard minutiae. And, of course, lovely buildings appear again and again.

The learned and highly sensitive John Ruskin prefaced his 360-page manual *The Elements of Drawing* (1857) with this remark:

'It may perhaps be thought, that in prefacing a manual of drawing, I ought to expatiate on the reasons why drawing should be learned; but these reasons appear to me so many and so weighty, that I cannot quickly state or enforce them.'

Never a man who could be accused of levity, 190 pages later he says to the reader who has followed his instructions thus far:

'You may, in the time which other vocations leave at your disposal, produce finished, beautiful, and masterly drawings in light and shade. But to colour well requires your life. It cannot be done cheaper.'

PAUL NEWLAND

Left: **LIONAL BULMER**, *Greengrocer's Shop* (detail), watercolour, pen and ink and wash, 28 x 39.5 cm (11 x 15.5 in)

STUART ROBERTSON
LIONEL BULMER (1919–1991): *Greengrocer's Shop*

This painting has a relaxed appearance. Lots of different marks have been used to describe various textures. It is quite orderly but also has an incidental look which I find probably the most interesting of all its qualities. The work has obviously been completed on site and has the immediacy that results from economies in decision-making on subject, light and composition that this necessitates. The picture has many other qualities I find attractive.

Strong and confident drawing is very evident. The application of watercolour is factual and has been carried out with speed and competence. The composition itself is very daring, as exemplified by the bold lines cutting through the picture from top to bottom as well as the structural quality of the light. The figure seems only suggested, but is essential and possibly the main focus of the picture.

In my own work I find that this way of working often produces the best results. You can be more concerned with what you are looking at than with what you are painting, the marks on the paper becoming almost subconscious, and this is enjoyable, not least because the results are immediate. Lionel Bulmer's picture looks as if it was completed in one sitting; I like this in my own work when painting in situ. This can be done with watercolour and is the beauty of watercolour painting in its most basic form. When painting in India and elsewhere, I find pen and ink with some watercolour produces fast and easily accessible works.

These are not only interesting in themselves but also invaluable notes for further work in the studio.

My painting of a *chappal* (slipper or sandal) shop in Jaipur was done from across a busy street. The view constantly changes as people crowd around and in front of you. It is hot, and the paint dries quickly. As I paint a customer sails into view and leaves his bicycle leaning against the front of the shop for a few minutes. The cycle becomes the new focus of the picture. It is not merely incorporated, but strengthens the earlier composition making it perfect, as if destined.

Above: **LIONAL BULMER**, *Greengrocer's Shop*, watercolour, pen and ink and wash, 28 x 39.5 cm (11 x 15.5 in)
Opposite: **STUART ROBERTSON**, *Jaipur Dukan*, 1987, pen and ink and watercolour, 22 x 30 cm (8.5 x 12 in)

DAVID PASKETT
LIONAL BULMER (1919–1991): *Greengrocer's Shop*

I share Lionel Bulmer's interest in urban street
paraphernalia as a subject for painting. Also, his choice
of a strongly designed flat pattern set in shallow
perspective like a stage set. In this study I enjoy his use
of varied qualities of marks and contrasting tones set
within the subdivisions of the composition. The artist
has positioned himself so that the row of personable
cauliflowers is at eye level, supported by six boxes of vegetables, each with its own identity.

Then, by way of relief from the hard-edged rectilinear
frames of shop windows and doorways, a watching figure
appears, bringing in human interest and soft curves.

I often use the boxed and flat-packed backdrops of street-
level architecture to frame and pinpoint the shapes of figures
and objects. Shops, work spaces, stores, museums and eating
places provide a framework for my pictorial
organization.

I was sharing a tranquil moment at the next
table to this Chinese gentleman in a Suzhou
teahouse. Engrossed in his newspaper, he
became part of the chance still life created by
the thermos, glasses of tea and ashtray. As in
Bulmer's painting, the grid created by
surrounding fixtures and fittings contains
different scales and qualities of activity, from
the fine strokes of the calligraphy and flowers
to the criss-crossing of the cane chairs. As
well as the obvious red of the thermos in the
centre, I found purples, pinks and blues in the
reflections of the dark wood panels and
pillars. 'Vermeerish' light streams in from
the top corner and a 'Chardinesque' peace
descends on the reading figure at the table.

Above, right: **LIONAL BULMER**, *Greengrocer's Shop*, watercolour, pen and ink and wash, 28 x 39.5 cm (11 x 15.5 in)
Above, left: **DAVID PASKETT**, *Bargain Hunt, Dali, 2003*, watercolour, 49 x 51 cm (19.3 x 20 in)

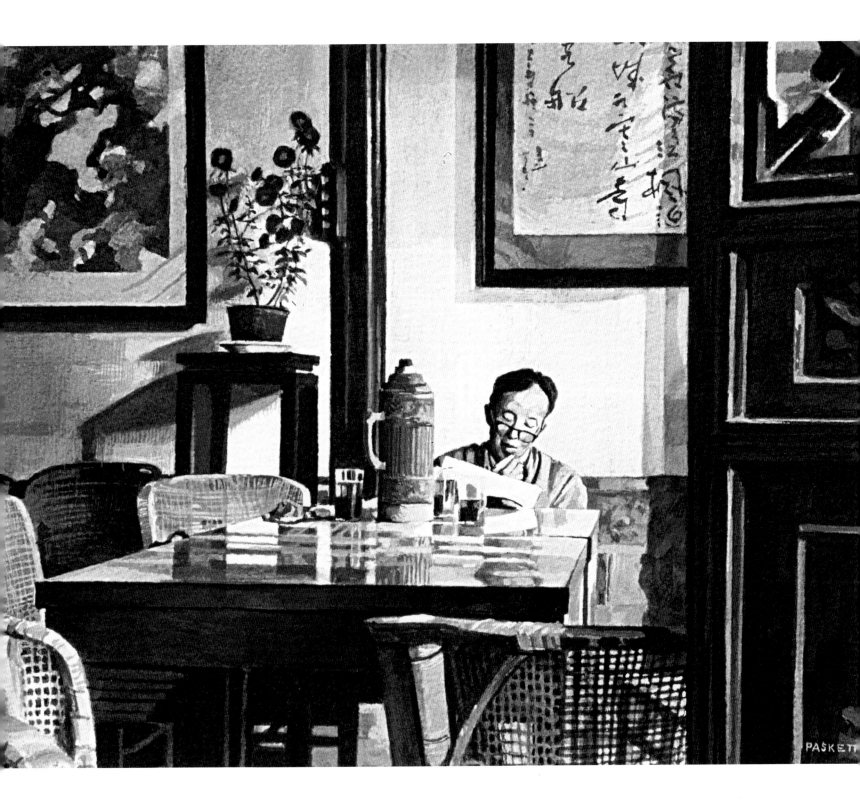

Above: **DAVID PASKETT**, *Calm Moment in a Suzhou Teahouse, 1998*, watercolour 23 x 28 cm (9.1 x 11 in)

AKASH BHATT
ARTHUR AMBROSE McEVOY (1878–1927): *Beatrice*

Beatrice by Arthur Ambrose McEvoy appealed to me through the spontaneous quality of his use of line and paint. McEvoy's painting, at first glance, gives the impression of a loose, quickly executed image. On closer inspection, it reveals expert draughtsmanship and a strong use of line. The painting is masked by loose brushstrokes and areas of paint running down over the image. However, underneath we can see the delicate attention given to both the sitter's face and the way she is seated. This gives the painting its overall strength. This picture is a good example of the strong drawing skills that are fundamental to any successful work.

My aim in my own work was to try and convey as much as possible, using line and detail sparingly, thereby removing the need for any unnecessary information. My interest also lies in the surface quality of the paint and I often employ vigorous techniques to produce a ground that is suitable to work on.

In tackling my own response to *Beatrice* it was important for me to have a clear understanding of the figure in line. Once this was established it made the process of putting the rest of the picture together somewhat clearer. As in McEvoy's picture I used varying degrees of line to place emphasis on particular areas. This can be seen, for example, in the lines used to show the right arm. By doing this it gives the picture depth and contributes to the composition, leading the eye through the painting in an almost zigzag motion. This is

another aspect of McEvoy's painting where the line is used to great effect.

By breaking down the process of the way a picture was made, this gives us a clearer understanding of the technique, and this can help many artists to create new paintings. Ultimately, I wanted to create an image that captures the sense of immediacy and fluidity that I found in McEvoy's *Beatrice*.

Above: **ARTHUR AMBROSE McEVOY ARA**, *Beatrice*, watercolour, ink and chalk, 40.6 x 30.3 cm (18 x 12.2 in)
Opposite: **AKASH BHATT**, *Madhu (A portrait of the Artist's Mother)*, 2005, watercolour, 56.4 x 39.5 cm (22.2 x 15.6 in)

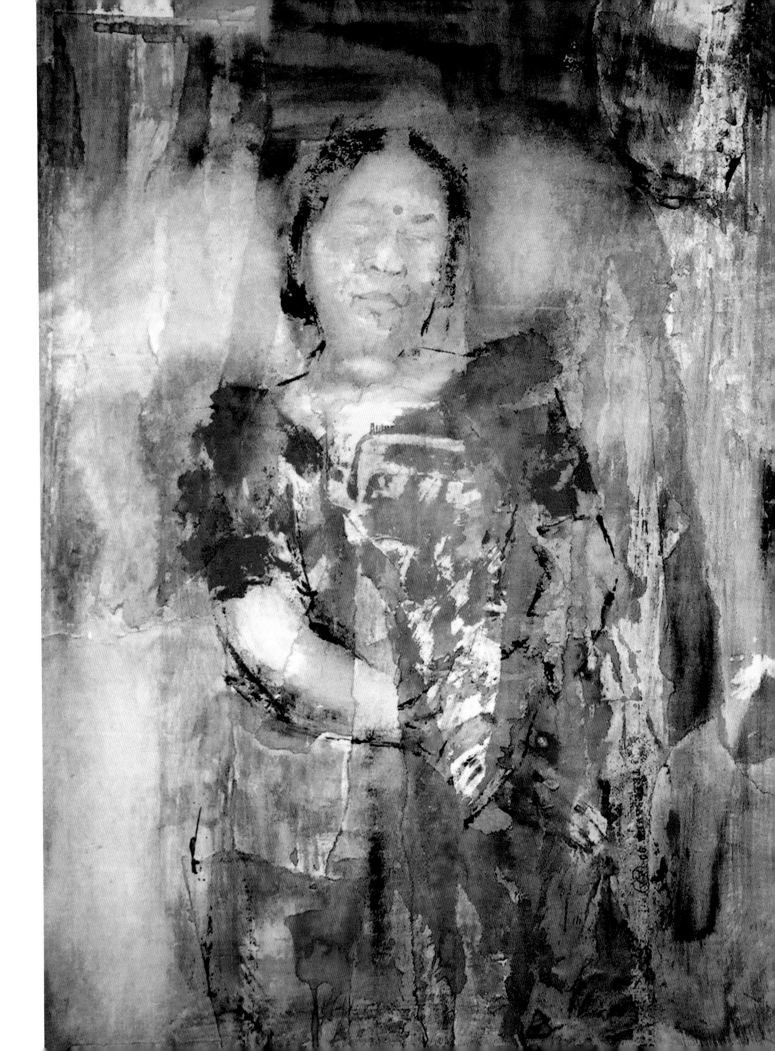

JANE CORSELLIS
ARTHUR AMBROSE McEVOY (1878–1927): *Beatrice*

Ambrose McEvoy studied art at the Slade, and among his fellow students were William Rothenstein, Augustus John and William Orpen. All of them were outstandingly talented and went on to become hugely successful painters. McEvoy began his career painting interiors but by 1915 he was painting portraits, mostly of beautiful women. He was, supposedly, influenced by Gainsborough, and his portraits were painted in a loose, sketchy style in both watercolour and oil that reflects Gainsborough's Romantic style.

This watercolour portrait of *Beatrice* is a particularly fine example of McEvoy's work. He would probably have started using a loaded brush and outlining the form with a series of washes, gradually working up to a greater intensity of colour and tone. In this painting I feel he must have been also influenced by the Japanese prints so popular at that time: the almost abstract qualities of the very dark brushstrokes he uses suggest this.

I have particular sympathy with these working methods and I like to begin a watercolour in the same way. However, the first decision to be made is which paper to use. In the main, my choice of paper is determined by the subject matter and what I see as the essential qualities to express. It depends on whether I want to brush the surface of the paper lightly or actually work on it. For a white paper I prefer the RWS 300 gsm HP or the 425 gsm NOT if I need a surface of heavier or rougher quality. The tinted papers I use are the Two Rivers handmade paper in 180 gsm NOT in a mid-blue/green and, more recently, a heavy, almost dark brown 'Nocturne' paper made by John van Oosterom. The choice of paper also determines the working method: for instance, when painting on white paper I will only use pure watercolour, reserving whites in the traditional way by leaving the lightest areas alone or lifting out with a sponge or a rag. I rarely use masking fluid as I do not like the hard edge it leaves. When using

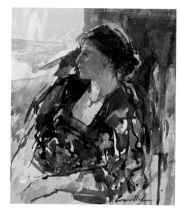

tinted paper I like to use Chinese white or an opaque gouache. Often I will lay this on the surface of the paper quite thickly, let it completely dry, and then quickly brush a thin layer of colour over the top. In this way the white does not 'bleed' into the colour but makes a lovely translucent glaze.

I try not to think too much about technique while I am painting because I find that, if I am constantly questioning the method I am using, my attention is drawn away from the subject and I am unable to paint as freely as I would like to. I begin by laying in the washes. At first I use a pale wash to draw or place the subject on the paper. Occasionally I will use a light pencil, but I prefer to 'work it all out' just using paint and making corrections as I go along, either by washing out or by overpainting. These washes have a considered, random quality rather than being applied too meticulously. From then on, it is a matter of developing the painting wash over wash, working mainly wet into wet and gradually defining areas until I am reasonably content with the result, and feel that I can stop.

Above, left: **ARTHUR AMBROSE McEVOY ARA**, *Beatrice*, watercolour, ink and chalk, 40.6 x 30.3 cm (18 x 12.2 in)
Above, right: **JANE CORSELLIS**, *Rose*, watercolour, 38 X 34 cm (15 x 13.5 in)
Opposite: **JANE CORSELLIS**, *Alex Lister, 2000*, watercolour, 37 x 34 cm (14.6 x 13.4 in)

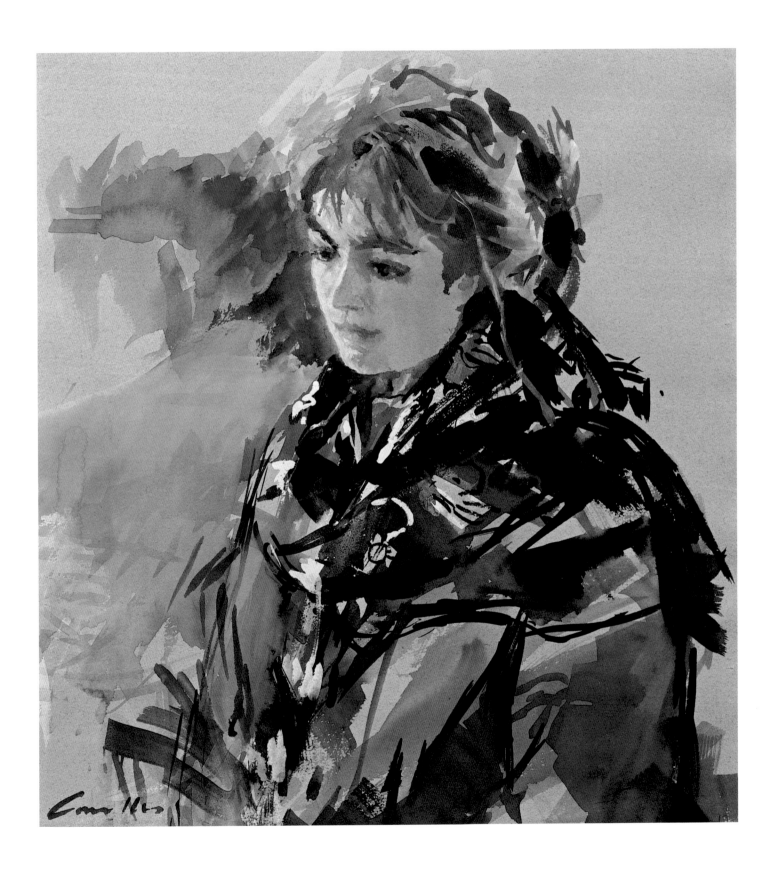

SOPHIE KNIGHT
ARTHUR AMBROSE McEVOY (1878–1927): *Beatrice*

I greatly admire Ambrose McEvoy's painting, *Beatrice*. With his confident handling of watercolour, McEvoy makes the painting almost dance with gestural strokes and such variation of brush marks that the viewer is never bored looking at it. McEvoy uses a limited palette of no more than four colours and this lack of colour enhances the impact of a strong use of tone.

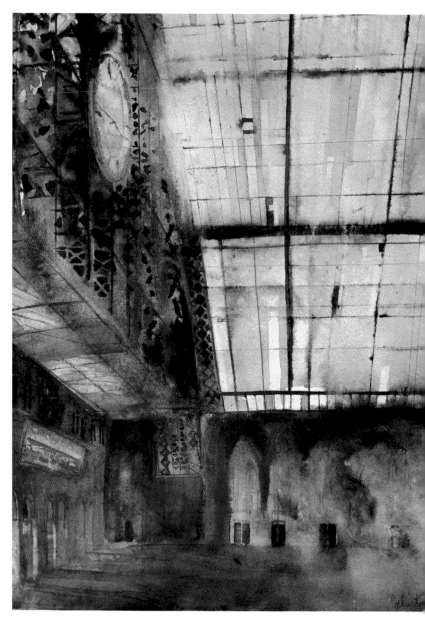

When setting out to paint the subject of St Pancras Station, I borrowed these ideas as a starting point and limited my own palette to six colours in order to concentrate on the obvious tonal qualities such an ethereal space has to offer. By emphasising how richly dark the roof's iron girders appear the visual impact is made stronger when contrasted with the much lighter tones of the window panes.

I also aimed to vary my brush marks from the tiny and quite detailed area of the clock face to the broad washes of colour which suggest the floor and background in the station.

After lightly pencilling in the general proportions of the composition and reminding myself of the perspective in the structure of the roof, I was able loosely to drop in splashes and marks over the area of the ironwork.

At this point the painting seemed to have a life and energy of its own and the subject suggested to me a series of patterns. I began to enjoy the way the window was made up of a grid: rectangles, triangle and diamond shapes emerged from the gaps between the girders and I emphasised this theme throughout the composition.

Ultimately my painting bears little resemblance to McEvoy's *Beatrice*. For me that is one of the exciting things about painting. Whatever the starting point, it's likely that a new idea will emerge and it's a journey of discovery that takes you to ever new destinations.

Above, left: **ARTHUR AMBROSE McEVOY ARA**, *Beatrice*, watercolour, ink and chalk, 40.6 x 30.3 cm (18 x 12.2 in)
Above, right: **SOPHIE KNIGHT**, *St Pancras Station*, watercolour and bodycolour, 76 x 56 cm, (29.9 x 22 in)

SONIA LAWSON

ARTHUR AMBROSE McEVOY (1878–1927): *Beatrice*

I know that colour universally beguiles the eye and the heart, yet I have chosen to engage with an almost monochromatic work from the RWS permanent collection, a watercolour drawing by Ambrose McEvoy called simply *Beatrice*, painted around 1925–26. It is as much a painting as it is a drawing. What attracts me is the sound draughtsmanship, the fluidity, mutability and seeming nonchalance. The ease in handling wash and the careful

economical drawing within the upper body makes it all look very easy, but this is, of course, deceptive. McEvoy achieves his informed draughtsmanship by understanding form, in this case the human form, and by his skill in handling the media: watercolour, ink and chalk.

The work does not feel overstated, it is not 'finished off' to the death, not a finite thought, more an open, ongoing set of notations put down with refreshingly direct urgency. Here is no great show of prowess, but rather an impulse, a reminder of a day and a person – both fleeting. The viewer can participate in something intimate, being offered an invitation to join in the exploration, unstructured, an essence rather than an academic experience.

Ambrose McEvoy was well respected, particularly for his large portraits. His is a 'tasteful' sort of art, a likeable lightweight who has never been an inspirational mentor for me (my formative tastes were more Max Beckman), but I do like the particular McEvoy painting-cum-drawing I've chosen to work with. Having seen it only briefly on a couple of occasions when it has been out of storage I discovered it has real muscle. I found too that because of its 'feel free' approach there is something jocular and easy about it that surmounts its sombre lack of colour. When things work, as with Alexander Cozens (1717–86), monochrome can feel like colour. The name 'Beatrice' is at present associated with past fashion, this made me think of earlier names, for example Charlotte and Emily, two of the three Brontë sisters. The connection, though at first tenuous, was from then onwards a stream of consciousness that made me smile. I found myself engaged in a picture of three feisty females, symbols of Emily's *Wuthering Heights*. This is more or less a monochromatic work, and I have tackled it seriously yet with a freedom in mind aiming to eschew any navel gazing or the dourness of the turgidly serious.

Above: **SONIA LAWSON**, *Feisty Females*, 2005, watercolour, bodycolour and pen and ink, 51 x 52 cm (20 x 20.5 in)

RICHARD BAWDEN
THOMAS BARCLAY HENNELL (1903–1945): *Reykjavik Harbour*

Tom Hennell is an artist after my own heart. He drew beautifully and directly from what he saw: barns, trees, horses and craftsmen at work; it is a poet's eye. *Reykjavik Harbour* is one of several paintings he produced as an official war artist in Iceland. Probably drawn at speed under changeable weather conditions, there are spots where the rain has washed the colour away. One needs to feel, as he might have done, the immediacy of the changing situation; but it is also a record of the war.

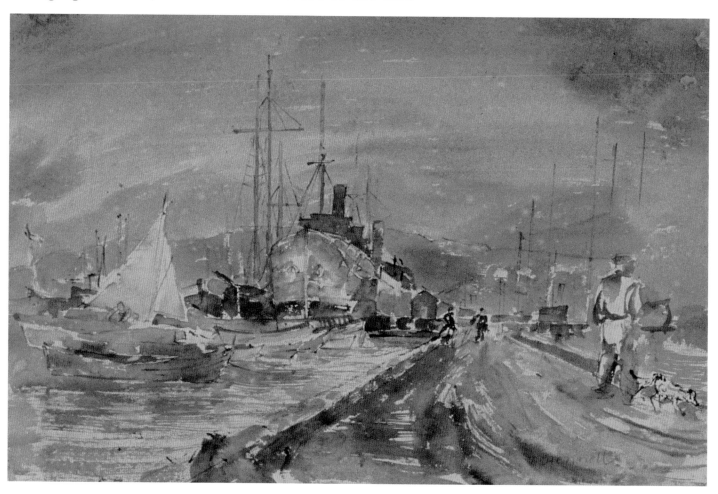

As an artist of the 1930s and 1940s Hennell was part of a period of change. But he was never an abstract artist, nor did he abstract from life. I sense that he was, perhaps unconsciously, influenced by his friend Eric Ravilious, a supreme designer. There is a tension from working on the spot, accepting and discriminating from the scene before you. He had a unique vision, preferring to work, here or there, wherever he could immerse himself in the presence of the place, allowing himself to be taken where it willed and letting it speak for itself. As in this painting, he would sensitively understate something large and clumsy, such as the minesweeper in the middle distance, or introduce a fleeting person and his dog

Above: **THOMAS BARCLAY HENNELL**, *Reykjavik Harbour*, watercolour over graphite on buff paper, 32.4 x 47.6 cm (12.7 x 18 in)

with a simple brushstroke. His philosophy was down to earth and so was his colour: burnt umber, sepia, caput mortum, grey blue and yellow ochre. He would never compose a painting in his studio from drawings and other information: he felt his pursuit of truth was only found through his direct experience, feeling and understanding; not by literal representation.

In making a painting from this I have consciously formulated his spontaneous brush drawing into a sequence of shapes that echo the flow and movement in the picture, aware of the strength in his design.

Above: **RICHARD BAWDEN**, *Reykjavik Harbour, after Thomas Hennell, 2004*, watercolour, 51 x 65.5 cm (20 x 25.8 in)

DAVID GLUCK

DAVID JONES (1895–1974): *Afon Honddu Fach, above Capel-y-ffyn*

David Jones's paintings and drawings have held a fascination for me over the years. He drew with spontaneity, developing the picture through several layers of chiefly linear marks together with localised tones, made with a lightness of touch. The various under-drawings and paintings are visible and tell in the finished work. This procedure is very much in line with my way of working, making Jones an obvious artist for me to choose.

Afon Honddu Fach has an unusual composition with strong elements pushed tight to the paper's edge and executed with a lively graphic style. The painting set me an intriguing and exciting challenge.

Taken from a pencil drawing made on the spot, my painting *Rydal Hall Water, Lake District*, is intended as a work in my own terms, whilst informed by my knowledge of Jones's work, ideas and the diploma work. I considered his use of spatial distortions, language of the graphic line scattered throughout and how the underpainted elements retained significance in the final picture.

Above: **DAVID JONES**, *Afon Honddu Fach, above Capel-y-ffyn*, watercolour and graphite, 56 x 40.2 cm (22 x 16 in)
Opposite, above: **DAVID GLUCK**, *Rydal Hall Water, Lake District*, 2004, watercolour and bodycolour, 47 x 67 cm (18.5 x 26.4 in)
Opposite, below: **DAVID GLUCK**, *Fig Tree, Petrognano, Lucca, Italy*, 2000, watercolour, 96.5 x 124.5 cm (38 x 49.2 in)

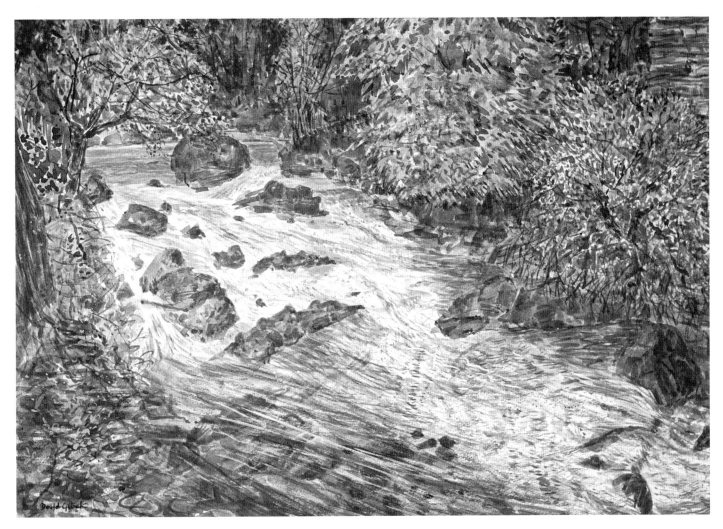

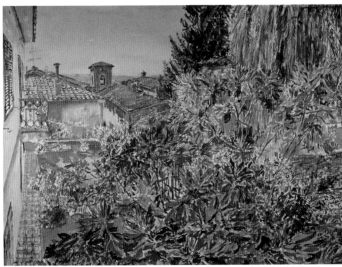

ELIZABETH CRAMP

DAVID JONES (1895–1974): *Afon Honddu Fach, above Capel-y-ffyn*

My watercolours are dependent on drawing, coupled with colour to enhance the rhythmic qualities of the compositional lines, as seen in my *Mog Edwards* from *Under Milk Wood* by Dylan Thomas. It is this quality in David Jones's work, along with his fascination with details such as window latches or sash window decoration and his sense of what is beyond the seen moment, that attracted me to his paintings.

David Jones's paintings are difficult to reproduce, partly due to the mixture and use of media: wash with drawing by the point of a brush, pencil, chalk and body colour, usually white. My working media are much the same, although I use pen and, occasionally, wax as a resist.

I cannot view *Afon Honddu Fach* without being aware of the strong, rhythmic lines and those lines in subtle colour in the hillside with its trees and tumbling stream, or without seeing and feeling the male head suggested by the rocks and grasses. Also, the small rocks look so much like fish leaping up the hillside, and are overlooked from the upper far right of the painting by a suggestion of horses. All this movement is stabilized and anchored by the yellow on the hill.

Above, left: **DAVID JONES**, *Afon Honddu Fach, above Capel-y-ffyn*, watercolour and graphite, 56 x 40.2 cm (22 x 16 in)
Above, right: **ELIZABETH CRAMP**, *Mog Edwards*, 1980, watercolour wax and pen, 35.5 x 25.3 cm (14 x 10 in)

NORMAN WEBSTER
SIR HUBERT VON HERKOMER (1849–1914): *Portrait of Henry Stacy Marks*

I have always been interested in looking at the works of many of the past members of the Royal Watercolour Society, especially those of the nineteenth and twentieth centuries, so to respond to one of their works in a somewhat practical way has been a very enjoyable and challenging exercise.

My chosen watercolour is the portrait of Henry Stacy Marks RWS by his friend Sir Hurbert von Herkomer RA, RWS. It was during the 'Glory of Watercolour' exhibition in 1987 that I first became aware of this particular painting, and for me it was one of the most important watercolours in that show.

I saw it again later, and was able to examine it more closely free of its frame, and the impact on me was just as great. Although this work is quite small, I think it is a masterpiece: it has been beautifully composed, with such skill in execution and draughtmanship that it is impossible to fault it.

I decided that when I had committed myself to responding to Herkomer's painting I would develop one of my portrait drawings that I already had in my studio, and use his techniques and methods where possible to create my watercolour. Accordingly, I painted the background, the garment of the sitter and part of her hair with gum mixed with the watercolour to give richness to the colour. The rest of the head was worked with clear washes although a touch of Chinese white was added to some colours, but the more subtle forms were created by using a kind of pointillism very delicately applied with a fine brush.

The verdict afterwards was that one just has to salute Herkomer's sheer brilliance.

Above, left: **SIR HUBERT VON HERKOMER RA**, *Portrait of Henry Stacy Marks*, watercolour and gum, with scratching out, 17.6 x 12.6 cm (7 x 5 in)
Above, right: **NORMAN WEBSTER**, *The Woman in Blue*, 2003, watercolour, gouache with some scraping out, 37 x 30 cm (14.6 x 11.8 in)

CHARLOTTE HALLIDAY
JAMES DUFFIELD HARDING (1797–1863): *Verona*

When I was twenty-one my parents took me to Italy, where they had first met. It was a sort of 'introductory offer'. I did a lot of small sketches, freely and unselfconsciously. But later I became a nervous traveller and grew particularly claustrophobic about flying. I spent many years 'grounded' in England, until there came an opportunity to go with friends to the Mediterranean again, and I decided I must take it.

However, as the trip drew near, acquaintances invariably said, 'Oh, you'll love it; there will be so much for you to paint!' And I began to feel quite overwhelmed by their expectations, inhibited, almost panicky; then I saw this drawing by James Duffield Harding.

'I could do something at least along those lines', I thought, and my panic subsided. The watercolours of Cotman, Girtin and Turner thrill and move me deeply, but it is far beyond me to attempt to emulate them. Harding on the other hand, was clearly as passionate as I am about architectural detail – it is significant that John Ruskin was his pupil. He records these Veronese buildings accurately, yet the picture is full of grace, sunshine and, above all, fresh air.

Harding's use of bodycolour was apparently deplored by Turner but, in my view, on the toned paper it gives him, as it were, a third dimension. I find it positively liberating in my own work.

My watercolour drawing of the Custom House is obviously a very different subject, though there is just a glimpse of the River Thames. It is one of twelve which I did after the views of London by Thomas Shotter Boys. It was marvellous to find the crane that Boys had drawn in 1841 still there, though the trees are new, but my picture owes more to Harding than to Boys.

I am constantly delighted by his view of Verona and keep finding new details – like the almost invisible outline of a horse and cart on the right. And I am always, unashamedly, excited by sun on stucco.

Above: **JAMES DUFFIELD HARDING**, *Verona*, bodycolour and graphite on buff paper, 37 x 51 cm (14.6 x 20.1 in)
Opposite: **CHARLOTTE HALLIDAY**, *The Custom House E.C.3, 2003*, pencil and watercolour, 40 x 45 cm (15.7 x 17.7 in)

MICHAEL McGUINNESS
ROBERT SARGENT AUSTIN (1895–1973): *Teabreak*

I am frightened of drawing, it worries me; the responsibility of describing what I see seems overwhelming. Even with training and practice, painting and drawing have not come easy, so for me to venture into the act of drawing and painting is a discipline which never gets easier and which I spend much of my time trying to avoid.

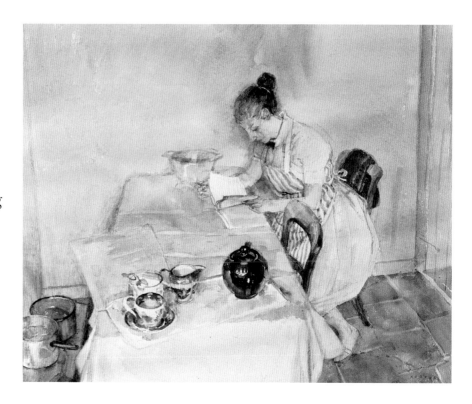

The fact is that certain impressions, whether landscapes, objects or people, seem to command attention. So it was with this discarded enamel teapot, spotted as a flash of blue in the green grass edging the A12 whilst driving into the Essex countryside. I passed this glimpse of blue about five times before stopping and taking the teapot home to paint. I asked myself why I didn't paint it there in the grass rather than on the more orthodox setting of a tray cloth. I cannot justify the decision except that it seemed good to restore the teapot to its proper place.

Robert Austin's depiction of the very English domestic tradition of the teabreak had impressed itself on my mind. My teapot must have played a central, if unappreciated, role in so many different domestic occasions, helping to establish friendships and give comfort whenever required. Eventually, grown old and shabby and made redundant by the arrival of tea-bags and mugs for the casual cup of tea, it had been thrown away, but I felt it should be honoured as a retired, rather than a jettisoned, teapot.

Above: **ROBERT SARGENT AUSTIN RA**, *Teabreak*, watercolour and graphite, 45 x 54.5 cm (17.75 x 21.5 in)
Opposite: **MICHAEL McGUINNESS**, *Retired Teapot*, 2004, watercolour, 18.8 x 18.8 cm (7.4 x 7.4 in)

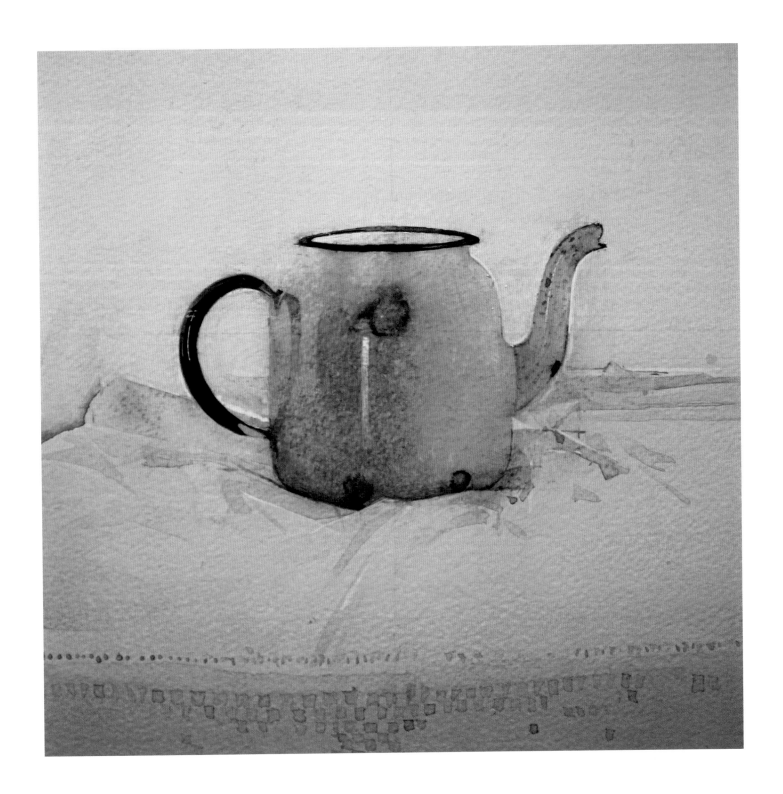

WILLIAM BOWYER
SIR GEORGE CLAUSEN (1852–1944): *Girl and Flowerpot*

Whenever I see drawings by George Clausen I am impressed by the vision and clarity of them. His watercolours have a freshness and immediacy, which shines through. In this simple painting, I admire the way he has drawn the young girl and, with great simplicity, demonstrated his ability to convey her gentle nature to the viewer.

The subtle interpretation in tone of the pot of dark geraniums gently clasped in the girl's hands only serves to contrast and enhance the modelling of her soft features. The head is painted with the utmost sensitivity and magic. Maybe she is related – could she have been his daughter?

It has always been my pleasure and my privilege to paint people, and in enjoying their company to attempt to capture that human spirit, that elusive thread that reveals their true nature.

I occasionally managed to get my mother to sit for me, persuading her to forego her chores for a while I would relish the idea of portraying an individual I knew so well. With her worldly wisdom, this matriarchal figure enjoyed a joke, a gossip and an occasional drink. She enjoyed in particular watching me play cricket and in the 1970s she and my good friend the artist Ruskin Spear downed a bottle of Scotch whilst watching a summer day's match. Needless to say, they enjoyed the game.

Above: **SIR GEORGE CLAUSEN RA**, *Girl and Flowerpot*, watercolour, 34 x 23.2 cm (13.4 x 9.2 in)
Opposite: **WILLIAM BOWYER**, *My Mother, 1974*, watercolour, 32.5 x 25 cm (12.8 x 9.8 in)

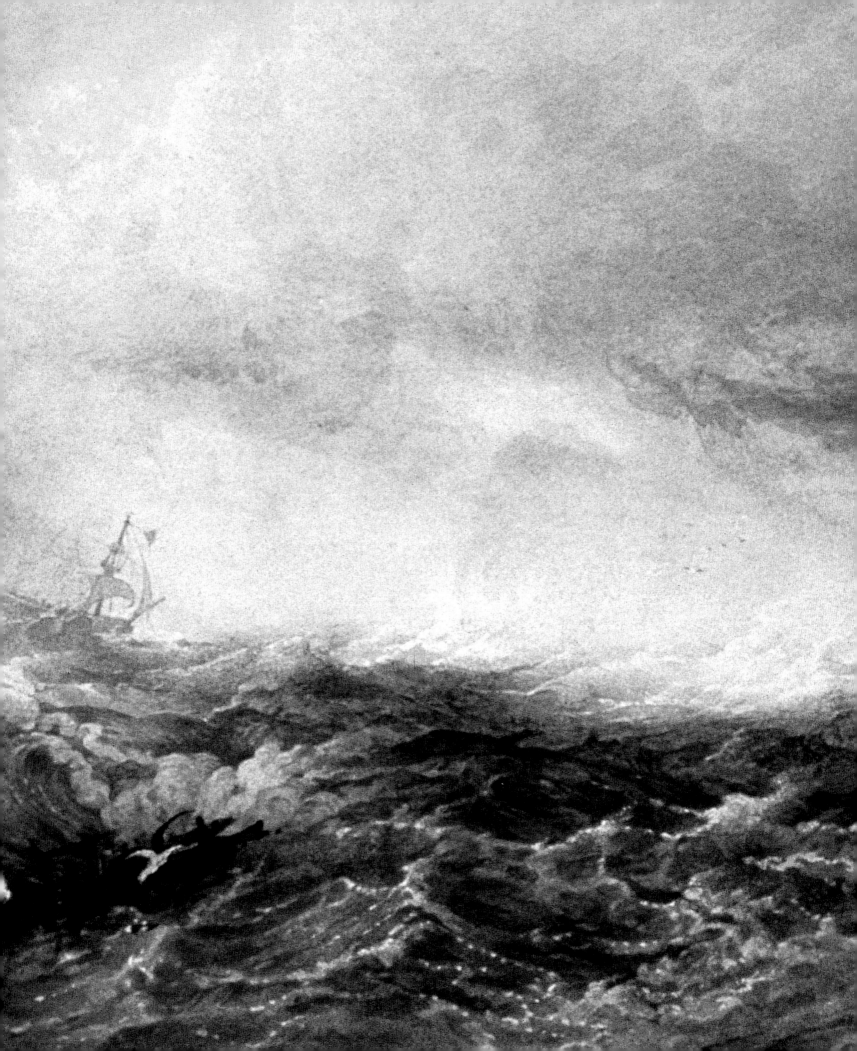

NARRATIVE

The telling of stories is one of the oldest reasons for painting pictures and narrative painting has appeared to a greater or lesser extent throughout the history of art. Early narrative painters told biblical stories in fresco paintings. Giotto was a trailblazer in the fourteenth century, depicting stories with real-life characters. Caravaggio astonished with super realism in scenes, often from horror stories, like modern-day film stills. Victorian painters delighted in moral tales and every picture told a story. Stanley Spencer painted his own eccentric visions of events such as Resurrection Day, full of extraordinary detail. Paula Rego gives us disturbing images with undertones of sex and sadism to read into what we will.

With the arrival of non-figurative art in Britain, narrative painting became a rather derogatory label among the avant-garde, but perhaps because of our strong literary inclinations, narrative themes have retained a constant presence, though sidelined, amongst the sucession of art movements we have seen in the twentieth century. Edward Burra's great watercolours of the 1930s, often on a large scale, show us low life scenes in Harlem and suspicious goings on in bars, clubs and cafés. During World War II Edward Bawden, Thomas Hennell and Eric Ravilious worked as war artists painting superb watercolours documenting the activities of the armed forces here and abroad.

I enjoy paintings that tell a story – paintings that you have to read and which reward a longer look by revealing something else that you didn't at first notice. Sometimes such pictures have an ambiguous or mysterious theme inviting the viewer to interact with the painting, as in the watercolours of Ken Kiff, for example. The artist is happy to leave the way open for the viewer to interpret the picture as he likes and respond following his own imagination.

JUNE BERRY

Left: **EDWARD DUNCAN**, *The Approaching Wreck* (detail),
watercolour and bodycolour, 29 x 58.5 cm (11.5 x 23 in)

JANE CARPANINI
DAME LAURA KNIGHT (1877–1970): *The Girls' Dressing Wagon*

Dame Laura Knight was a passionate recorder of the world around her and never more so than when observing her subjects absorbed in the processes of their work.

My mother worked in a ball-bearing factory during the war and remembers being sent into the noise and hubbub of the workshops to collect time sheets. There she saw Dame Laura Knight hunched at her easel surrounded by screeching machines and working in a persistent fine mist of oil droplets. Whether she was recording men wiping their hands on oily rags or performers dressing or waiting off-stage, she found dignity and grace in her subjects' unselfconsciousness.

It was the opportunity to explore that informality that prompted my series of paintings of the rank-and-file performers at the Opera Festival in Verona. The scale of the productions often means a cast of hundreds, many of whom appear in the various tableaux scenes bearing spears or banners, or simply representing massed bystanders, soldiers, courtiers, conspirators and so on. Between acts they gather in quiet groups in the Piazza Bra outside the walls of the Arena, occasionally retreating into the chambers under the arches to gather helmets or cloaks or to be checked over by the army of wardrobe mistresses.

Although immediately seduced by the colour and drama of the night-time scene, it was not long before I discovered that these young men are innately comfortable with the whole concept of display and are completely unselfconscious in adopting languidly theatrical poses amidst the gilded props and against the backdrop of the Arena's architecture. I was in fact observing the pursuit of that effortless style they call 'bella figura', almost a performance art in its own right, the highest accolade being an appreciative glance.

Dame Laura Knight's performers are caught in those intimate moments of preparation that go towards creating the magic that is theatre. My young Italians draw no distinction here: in their minds, performance and passaggiata merge seamlessly.

Opposite: **DAME LAURA KNIGHT RA**, *The Girls' Dressing Wagon*, watercolour and chalk, 52 x 34 cm (20.5 x 13.4 in)

Above: **JANE CARPANINI**, *Verona – Waiting for 'Nessun Dorma'*, 2004, 46 x 38 cm (18 x 15 in)

DAVID REMFRY
DAME LAURA KNIGHT (1877–1970): *The Girls' Dressing Wagon*

This is a very engaging drawing by Laura Knight. The drawing, satisfying in the apparently simple construction, powerful in its underpinning of solid draftsmanship.

The foreground figures, although not realistic, are real, having weight and character. The figure on the right conveys the wonderful awkwardness, an almost graceless and unconscious sexuality that is often to be seen in off-duty performers or dancers. She stands like a dancer and is drawn almost as a nude, the line on the left side of the torso continuing thought the skirt, the buttocks being simply but well defined in a most sensuous way.

There is a surprising tenderness in the drawing of the nape of the neck and curved parting of the girl's hair. The figure on the left is almost Matisse-like, particularly on the top half, the bottom half seeming more solid, with beautifully observed legs. Knight does not suffer by comparison with the French master.

The subject clearly is one that the artist had great affection for and I can readily understand why. I came to stay in New York in 1995 and at that time there was a resurgence of burlesque and cabaret shows. Nothing to do with Broadway, these were risqué to lewd and funny and often at illegal (unlicensed) venues with someone always watching for cops.

Later, under the Guiliani clean up, it became more difficult to do illicit but fun things. There was a bar round the corner from the hotel Chelsea where I live, called Billy's Topless. Inventively Billy bought himself a couple of extra years by removing the apostrophe and making the name of his bar 'Billy Stopless'.

There was a sometime club on 23rd Street and I began to draw the performers; they would visit the studio and then, over a period of years, I would make drawings of them. I've always been fascinated by performers and dancers; for me they provide ideal subject matter with almost inexhaustible ways in which it may be treated.

Above: **DAME LAURA KNIGHT RA**, *The Girls' Dressing Wagon*, watercolour and chalk, 52 x 34 cm (20.5 x 13.4 in)
Opposite: **DAVID REMFRY**, *Andrea*, 1996, graphite and watercolour wash, 104 x 64 cm (40.8 x 25 in)

BERNARD BATCHELOR
SAMUEL 'LAMORNA' BIRCH (1869–1955): *The Old Brig O'Dee*

For me this is a great watercolour, I can return to it often. It is a cold day and you can feel the chilly breeze on your cheek whilst gazing at the snow-capped mountains in the distance, the wavelets slapping against the rocks in the foreground. The painting is full of atmosphere and all seemingly put down with great authority and skill. There is no hesitating or sponging out – just plain good work.

In some ways there is a similarity in the handling and approach to that of J S Sargent – sort of big and broad. Perhaps it was because they were both in France during the 1890's when the Impressionists were becoming celebrated rather than shunned. I think part of Birch's training was in Paris about then – and of course this new style of painting and assessment, Impressionism, would have been of great interest to him and to Sargent; I am sure it greatly affected their work.

Lamorna Birch was also apparently a keen fisherman and often took his rod and line with him when going painting. It occurs to me that if he had had a 'bad day' at the painting (we all get them!) he could turn it into 'a good day' with the fishing rod!

In *Catch of the Day*, my ideas seem to have started simply as scribbles on the backs of envelopes. I decided to try and improve on just a scene of a fisherman and came upon the idea of a train coming over the bridge with the driver wanting to see the fish.

Morlaix (in Brittany) was a busy sort of place on one of those bright and breezy days when everything was dazzling sunshine and shadow everywhere. People were dashing about, shopping for the weekend – and above it all there was the railway viaduct. So I painted it in a breezy sort of way – the very stuff of watercolour!

Above right: **SAMUEL 'LAMORNA' BIRCH RA**, *The Old Brig O'Dee*, watercolour and bodycolour over graphite, 37 x 55.5 cm (14.7 x 21.9 in)
Above, left: **BERNARD BATCHELOR**, *Catch of the Day*, 2005, watercolour, 32 x 42 cm (12.5 x 16.5 in)
Opposite: **BERNARD BATCHELOR**, *Morlaix*, watercolour, 35.5 x 27.5 cm (14 x 10.8 in)

DAVID BRAYNE

HENRY SCOTT TUKE (1858–1929): *Green Water*

Henry Scott Tuke was a keen sailor who sought to explore man's closeness to the sea. He often painted friends and fishermen working or playing along the Cornish coast from his floating studio, an old brigantine, Julie de Nantes. *Green Water*, his diploma work of 1911, captures a brief moment between an oarsman and a dimly seen swimmer.

I, too, often paint boats, though the figures they contain are usually female and, unlike Tuke, I work from memory, on land and indoors. I am drawn to this quiet painting which holds the emotional tautness and vitality I hope to achieve in my own work. The treatment of the paint (watercolour and bodycolour) in *Green Water* is loose and energetic, underpinned by a strong central composition. The gaze of the two figures across the water is parallel to one oar of the rowing boat, while the boatman's arms and legs are parallel to the other, creating a gentle rhythm. In my painting, *Leaping Fish*, I have turned this around, placing two figures in the boat who look out in opposite directions. I hope their physical closeness and the curving lines of their bodies echo something of the intensity of Tuke's *Green Water*.

I paint the sea viewed from the shoreline, while Tuke's floating studio enabled him to look in any direction. The cove, seen from the water, forms the backdrop to his painting and becomes a band of violets and pinks at the top of the image. This pictorial structure offered a significant departure from my usual blue sky. I placed a wedge of earth colours at the top edge of the sea in *Leaping Fish*, using bone black, verdigris and French ochre pigments. This changed the light in my work radically and created a more intimate atmosphere.

Above: **HENRY SCOTT TUKE RA**, *Green Water*, watercolour and bodycolour, 29.5 x 45.3 cm (11.7 x 18 in)
Opposite: **DAVID BRAYNE**, *Leaping Fish*, watercolour, raw pigment and acrylic gel on paper, 25 x 30 cm (10 x 12 in)

ALFRED DANIELS
SIDNEY CURNOW VOSPER (1866–1942): *The Weaver*

One of the watercolours in the RWS Diploma Collection that impressed me most is *The Weaver* because it tells a story about a person doing something valuable. I admire it also because since leaving the Royal College of Art all my paintings have mainly been concerned with people, how they look, and what they do at work and play. I am basically a subject painter that ranges from sport and industry to social commentary.

It was the result of a long visit to Italy during my last year at college that I discovered the delights of murals in public buildings and churches, the painted *cassoni* (marriage chests) and paintings in tempera and fresco. All of them told stories about people and events. My admiration was such that after graduation I spent two years as a postgraduate studying mural design. I was fortunate to have as my tutors Kenneth Rowntree and Ruskin Spear, the latter getting me my first commission to paint five murals in the Hammersmith Town Hall, which still exist today. This was followed by murals and large paintings all concerned with printing, heavy industry, transport, fishing and farming.

I have found that watercolour and acrylic are the ideal media in which to research and compose in readiness for paintings in oil, alkyd and acrylic. I tend not to paint in situ but research my subjects using pastel pencils and crayons, as painting in watercolour on the spot is time-consuming and awkward. I prefer to complete my watercolours in the studio, and I imagine that Vosper did much the same.

Above: **SIDNEY CURNOW VOSPER**, *The Weaver*, watercolour and bodycolour, with stopping and scratching out, 30.4 x 26.8 cm (12 x 10.5 in)
Opposite: **ALFRED DANIELS**, *The Peat Cutters of Scotland, Brar, 2001*, acrylic and watercolour, 91 x 71 cm (36 x 28 in)

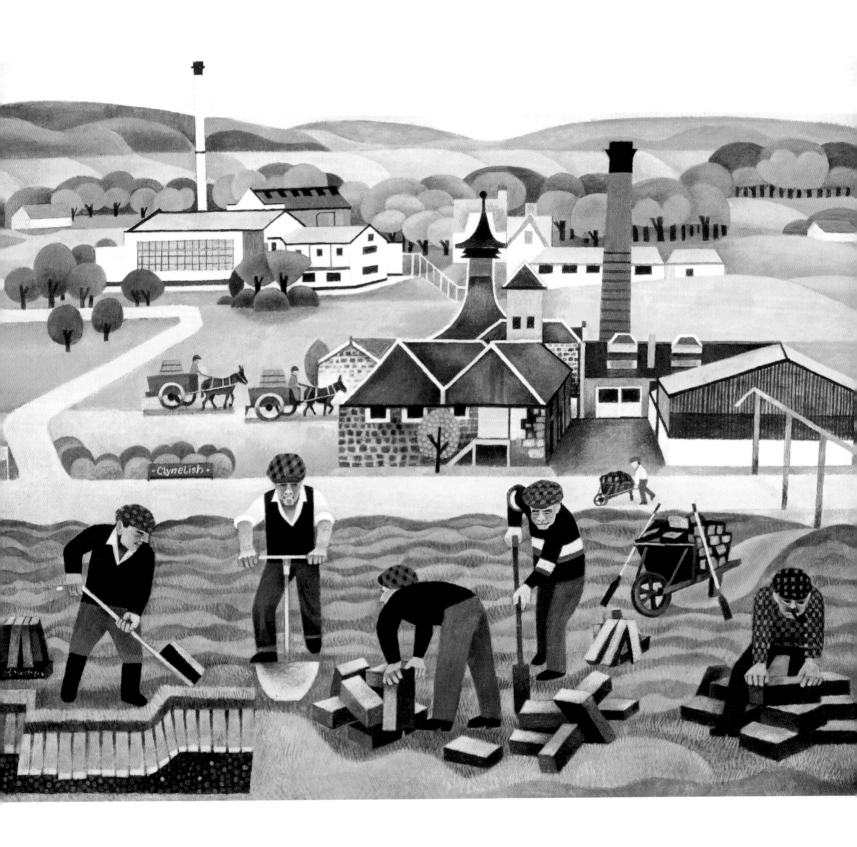

SALLIANN PUTMAN
SIDNEY CURNOW VOSPER (1866–1942): *The Weaver*

When I paint it is the abstract qualities that excite me – the colour, the composition and the paint itself. My work in watercolour is generally on a small scale. I want to draw the viewer into a private world.

Sidney Curnow Vosper's little painting *The Weaver* is an intense study of one man preoccupied with the task in hand. It is an intimate space that he works in. The floor is tilted towards the viewer, providing a 'stage' for the real subject of the work, namely the beautiful still life with its rhythms and fascinating relationships. The dark background also works to direct our attention to those vessels. Vosper has taken the ordinary and made out of it something extraordinary, a kind of visual music. This quiet corner, this private space has been translated into a symphony of quiet, close tones; there is no drama here. But there is a richness of colour and touch.

I make drawings of the landscape and then use them in the studio, where I can be free to interpret them. To me colour must be an emotional response. I have never forgotten my first encounter with a painting by Mark Rothko. I was so moved by the colour; indeed my attitude to its use changed radically after that experience. Like Vosper, I do not seek to make a drama – I enjoy using close tones striving to create poetic relationships. Very often my landscapes are tilted up, like a Bonnard tabletop. My skies become narrow bands. Vast open landscape does not draw me. I grew up in London where buildings blotted out most of the sky. So here in *Red Landscape* there is a quietness, with colour being orchestrated to emphasise this. The dark sky serves to direct the eye over the entire picture. I am painting my feelings here, and those feelings have more to do with paint than with landscape.

My work always refers to nature – even my seemingly non-figurative pieces. *Close Encounter – Blue Forms* was painted from

a small study made on the beach at Aldeburgh. The objects have lost their identity because I zoomed in so closely on them. Here the forms occupy a shallow space, as does the interior in the Vosper painting. They hover according to their intensity and colour. Generally the tones are close. I am not 'tied' to a recognizable subject and so I can be free to concentrate on the colour and mark. As soon as I make a mark, or place a colour, then the painting has its own life and makes its own demands. It is my concern as a painter to respond to those demands. I have placed the small red area because the painting needed it. Perhaps Vosper placed the blue on the man's trousers for the same reason.

Above, left: **SIDNEY CURNOW VOSPER**, *The Weaver*, watercolour and bodycolour, with stopping and scratching out, 30.4 x 26.8 cm (12 x 10.5 in)
Above, right: **SALLIANN PUTMAN**, *Close Encounter – Blue Forms*, 2005, watercolour, 28 x 28 cm (11 x 11 in)
Opposite: **SALLIANN PUTMAN**, *Red Landscape*, 2006, watercolour and gouache, 20 x 20 cm (8 x 8 in)

LESLIE WORTH
EDWARD DUNCAN (1873–1965): *The Approaching Wreck*

This painting, Duncan's diploma work, was painted in 1857, when the artist was of mature middle age. A tour de force, it bears all the evidence of an experienced painter – familiar with the subject and at home with the vagaries of the watercolour technique.

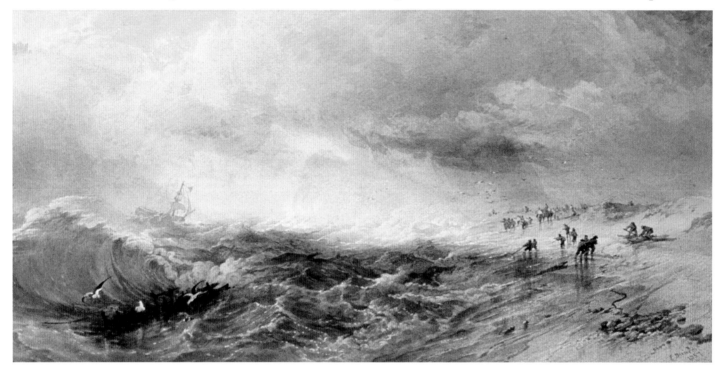

Obviously it is not a factual representation, but a work of great imaginative power, nourished by the several coastal trips that Duncan made during his early and middle years. My father was a sailor, and I spent most of my childhood within three miles of the sea in Devonshire. I confess I am no sailor myself, content to watch the awesome might of the water from the safety of the shore, but fascinated and not a little horrified by the forces and the restless energy unleashed before me.

It is therefore not too surprising that I was drawn to Duncan's work by its sheer, raw energy. In an age when the natural world is remotely and antiseptically transmogrified for us, and is then fed in digestible slices through the media, such an emotional display seems almost indecent, and out of kilter with current practice.

Nothing about this painting is 'arty' or contrived. The elements are violent, but there is no gratuitous display or indulgence. In some curious way the painting as such is very cool and restrained. Such is the realism, however, that one can hear the surge of the breakers, and the rattle of the pebbles as the water is sucked back.

The viewpoint is extraordinary, for it is as though we are in the middle of the sea, looking back towards the helpless watchers on the shore, impotent and powerless to avert the impending tragedy. Painted, perhaps on a lightly tinted paper, with a pale grey tone, the palette is limited.

With respect I offer my own imperfect tribute, with no attempt to copy the original. My picture is simply a respectful acknowledgement of Duncan's genius.

Opposite: **EDWARD DUNCAN**, *The Approaching Wreck*, watercolour and bodycolour, 29 x 58.5 cm (11.5 x 23 in)
Above: **LESLIE WORTH**, *Ship in a Storm Tossed Sea, 2004*, watercolour, 37 x 53 cm (14.5 x 21 in)

DAVID FIRMSTONE
EDWARD DUNCAN (1873–1965): *The Approaching Wreck*

In Duncan's small, powerful painting a magnificent storm is taking place. You can hear the huge force of the waves crashing in on the shore, see the people struggle with its force. The breakwater is finally set loose, agitating the screaming seagulls as the ship struggles vulnerably against the ever turbulant sea. It's a fantastic painting and as I look closely at it and scrutinise Duncan's marks I'm left wondering 'how did he do this?'

In my painting the sky and beach are cleansed of the storm's debris, and the breakwaters have long ago been washed away. We can smell the fresh morning air, hear the birds sing, but the movement is of a different kind. The power is no longer with the sea but with the birds' delicate dancing flight on a light, warm breeze over the vapour trails of aircraft, reflected in the still, calm waters below.

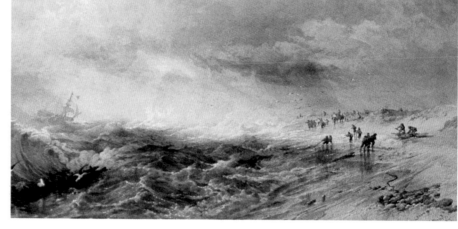

Technique is critical to my aesthetic. I constantly search for new ways to make watercolours and some are the result of pouring paint and allowing it to run across the surface, as I turn and tilt the paper, so I'm 'drawing with the pour'. I love the illusion of movement that the mark of water gives.

I'm not just interested in representation, in fact I'm always disappointed when only that takes place and I plunge the painting into the bath, or throw paint over it, spoil it, so I have to struggle with it all over again. And I can never quite remember my previous approach, so each painting is an act of learning to paint again.

Above: **EDWARD DUNCAN**, *The Approaching Wreck*, watercolour and bodycolour, 29 x 58.5 cm (11.5 x 23 in)
Opposite: **DAVID FIRMSTONE**, *Flight and Reflections V*, watercolour on paper, 91.5 x 94 cm (36 x 37 in)

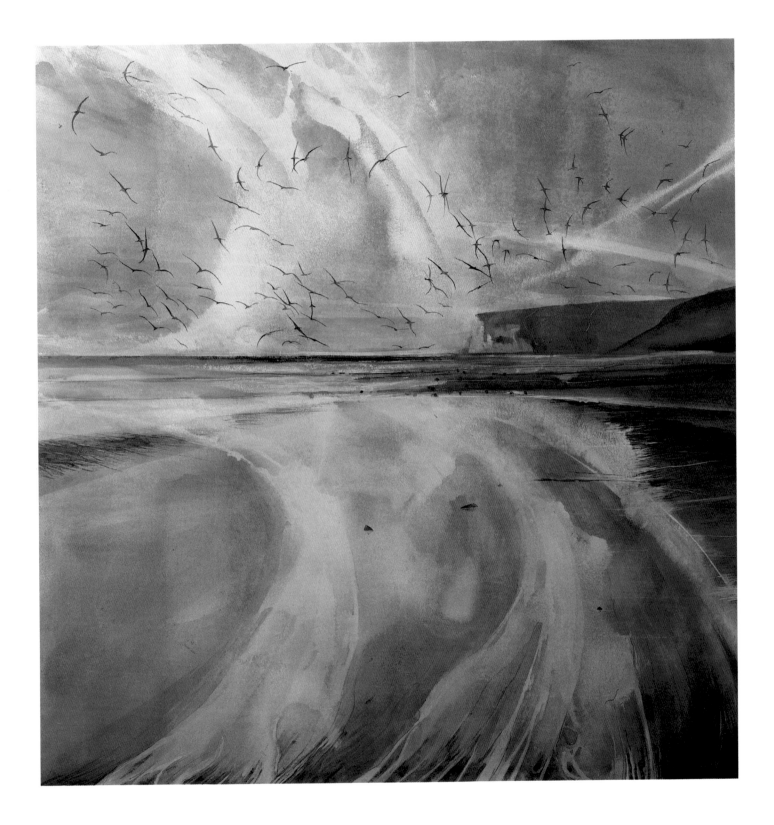

JOHN NEWBERRY
CHARLES BENTLEY (1806–1854): *Sailing Barge Near Dover*

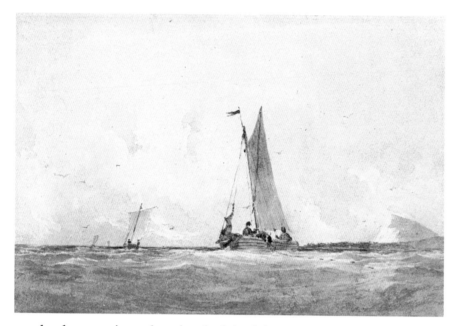

Charles Bentley has a special quality. He combines observed natural subject matter with lucid watercolour technique. An ordinary sailing barge off Dover Beach becomes exciting because of the way it is painted. This picture was an obvious choice. I have been working on the Kent coast around Deal and have used this view with Shakespeare Cliff several times. The beach has not changed but parked container lorries behind it now replace the thousands of commercial and naval vessels which once thronged these waters. Today there are a few longshore fisherman, groups of yachts and the endless stream of huge car ferries coming in and out of Dover Harbour.

Bentley was one of a group of topographical painters, stemming from Bonington's activities in Paris, who included Thomas Shotter. Boys and the Callows. Their pictures were full of light. They used clear washes, bright colour and many surface devices such as scraping and thumbprints to achieve spontaneity. Though it is unlikely that this work was painted on the beach, surely sketches were drawn there. The reflection of the cliff on the top of the waves must have been observed.

My own picture was completed on the spot, in one sitting. I try to present the whole scene as a unity: sea, sky and light as they were on that afternoon. I, too, scrape, with the brush handle, through wet paint; I use pressure from palm or fingertip to give texture and I use a variety of smudgings and liftings, all in the cause of speed to finish before things change. My ideal is summed up in the words Delacroix wrote about his friend Bonington: '*That lightness of touch which particularly in watercolours makes his pictures as it were like diamonds that delight the eye, quite independently of their subject, or of any representational qualities.*'

Opposite, above: **CHARLES BENTLEY**, *Sailing Barge near Dover*, watercolour, 17.2 x 24.8 cm (6.75 x 9.75 in)

Opposite, below: **JOHN NEWBERRY**, *Two Beached Fishing Boats, Deal*, 2002, watercolour, 22 x 32.5 cm (8.7 x 12.8 in)

Above: **JOHN NEWBERRY**, *Deal Beach Looking South*, 2002, watercolour, 22.6 x 32.5 cm (8.9 x 12.8 in)

DENNIS ROXBY BOTT
SIDNEY LEE (1866–1949): *Boatbuilding*

Boats are naturally associated with water and what appeals to me about Lee's picture is the mild incongruity of the buildings, with absolutely no water in sight. Artists in Lee's time were lucky enough to find traditionally built boats to draw, or in this case, being built traditionally. I find they are far more satisfying and worth drawing than modern plastic ones, so I was delighted to find some old boats at Worthing where I could also incorporate the Regency and Victorian houses behind.

Of course topographical artists in Lee's day had a very different outlook. Clearly Sidney Lee's picture is largely illustrative of the men working hard on the boats. In fact I think his main interest is in the figures and what they are doing. He is not much concerned about the fairly unremarkable buildings. My main interest is the buildings themselves, their architecture and the physical surroundings of the particular coastal resort; the very nature of the seaside.

I remember when I was very young the importance put on having figures in a picture. It was an often repeated emphasis in 'How to Do It' books and even television programmes. I was never quite convinced of the idea, feeling that they do to some extent turn the picture into a snapshot of a moment and that, I felt, was unsatisfactory.

I hope my work has other priorities. If the subject is a building I would like my picture to reflect something of the atmosphere of the architecture. Fortunately we are under no such pressures to include figures nowadays, or indeed to put in anything recognisable at all!

Above: **SIDNEY LEE RA**, *Boatbuilding*, bodycolour over graphite, Indian ink, with touches of oil paint, 31.5 x 43.5 cm (12.5 x 17.1 in)

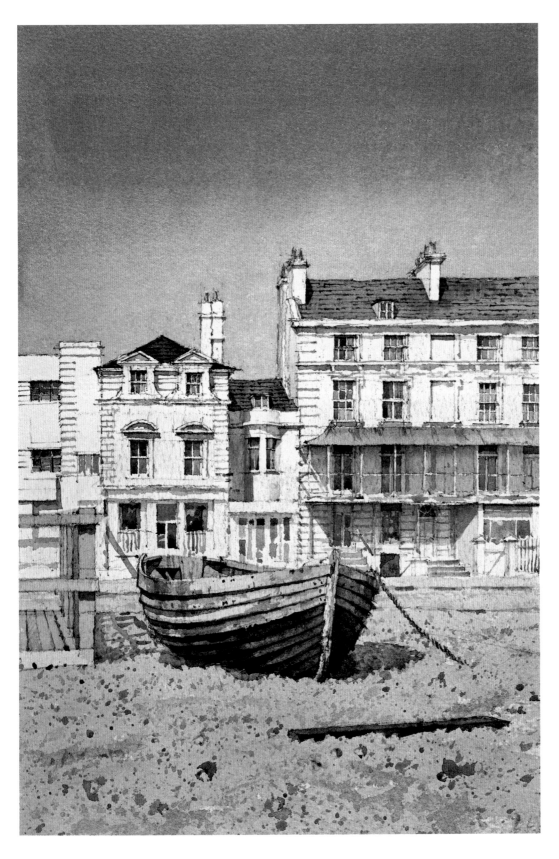

Above: **DENNIS ROXBY BOTT**, *Boat on Worthing Beach, 2003*, pencil and watercolour, 30 x 18 cm (12 x 7 in)

JAMES RUSHTON
SAMUEL PALMER (1805-1881): *Shady Quiet*

I first came across Samuel Palmer in a little illustrated book called *British Romantic Artists* by John Piper, published in 1942. In it was a coloured illustration of a painting by Palmer called *Harvest Moon*. This painting haunted me so much that I was soon making drawings using crayon and watercolour in the manner of Palmer.

A year or two before the War, my parents rented a bungalow in a fold in the hills of North Staffordshire, at a place called Ashley. Even before seeing the Palmer, this place held a magic for me which I couldn't describe: his work seemed to articulate what I already felt. Up to that point I had no knowledge of painters and painting, so the impact was especially strong.

In ensuing years I learned more about him, His son wrote: 'his imagination led him far away from beaten tracks, mysterious shadows shortening before a rising moon, the cut edge of standing corn – these were realities that gave substance to his visions', and Palmer wrote himself: 'Nor must be forgotten the motley clouding, the fine meshes, the Arial tissues that dapple the skies of Spring nor the rolling volumes and piled mountains of light.'

This is part of the exquisite description of his own work. It could have been written by Thomas Traherne, the seventeenth-century mystic who, I think, had much in common with Palmer. He wrote: 'The corn was orient and immortal wheat, which never should be reaped, nor was ever sown. I thought it had stood from everlasting to everlasting.'

I have always loved the monochrome paintings of the Shoreham period, which gave stark emphasis to those 'piled mountains of light' of which he was so fond and, achieved an intensity that was never repeated and could not be sustained.

The painting in the Diploma Collection is a later work, very different from the solemnity of the monochromes. All is drenched in golden light, and is a lovely example of how technique and feeling meld together. It is the work of a unique and distinct personality.

Finally, a word about my own painting, *Whisper Lane*: I almost always use watercolour and gouache, a method I would guess to have been favoured by Palmer. I also tend to paint places and situations which have a very particular meaning for me, more often than not from memory; part fact, part invention. *Whisper Lane* is more fact than invention, and it is a revered part of my childhood. It pleases me to think that it has something of Palmer about it.

Opposite: **SAMUEL PALMER**, *Shady Quiet*, watercolour, bodycolour and gold leaf, 18.7 x 41 cm (7.4 x 16.2 in)

Above: **JAMES RUSHTON**, *Whisper Lane, 2003,* watercolour and bodycolour, 30 x 40 cm (11.8 x 15.8 in)

RICHARD SORRELL

ALAN SORRELL (1904–1974): *The Resurrection*

My father painted this picture, the only neo-romantic work in the RWS Diploma Collection, more than ten years before my birth. It is an image of great power and restless energy. Its strength comes from the incisiveness of the drawing and from a real understanding of clear black-and-white contrast and silhouette. These qualities of dramatic lighting and turbulent rhythms were carried through to my father's later work, his reconstruction drawings of ancient sites. In these drawings of Roman Britain and medieval castles, which were based on rigorous archaeological evidence, he would create scenes of life from the distant past that were so convincing that he became a legend in the archaeological world. These later drawings are of course great feats of the imagination, and, in the same way as this religious subject, *The Resurrection*, is too.

Above: **ALAN SORRELL**, *The Resurrection*, pen and ink, pastel and bodycolour on brown paper, 50.6 x 34.4cm (19.9 x 13.5 in)
Opposite: **RICHARD SORRELL**, *Three Trees, 2003*, watercolour, 53 x 71 cm (21 x 28 in)

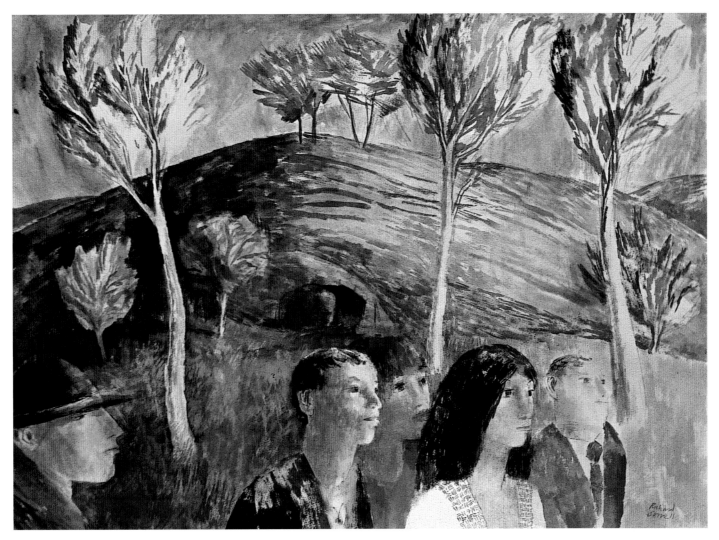

My father's work was a very great formative presence in my early career. In my picture *Three Trees* I have responded to his painting through colour rather than powerful tonal contrast – and in my painting the narrative focus is outside the picture rather than within it. I have used a cooler colour range than usual in this painting, basing it on a yellow/purple axis. *The Resurrection* is a centrifugal composition centred on the Tomb; *Three Trees* (symbolically the Crucifixion) is a flowing composition with a gentler left-right movement suggestive of wonder and questioning. Although both pictures have a reference to biblical stories, we are not a religious family.

I have come to realise that the main difference between my father and myself is one of temperament. He was essentially a pessimist – I think he believed that he was living in a time of relentless decline, like the last years of the Roman Empire. I am an optimist, and I think of humanity as being still in its period of infancy.

PETER BLAKE
ARTHUR RACKHAM (1867–1939): *A Bargain with the Devil*

In 1969, my daughter Liberty was born, and I moved from London to Somerset soon afterwards. During my time in Somerset in the mid-1970s, with six other like-minded artist friends, I formed the 'Brotherhood of Ruralists'. A Ruralist is someone who has moved from the city to the country. Our first manifesto allied us to the Pre-Raphaelite Brotherhood, and our declared aim was to paint about the English landscape, love, sentimentality, and, in my case, Fairyland.

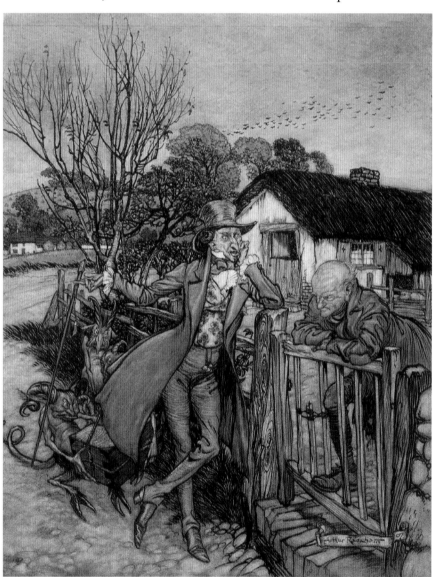

Reading to Liberty, then aged five, renewed my interest in the illustrators Edmund Dulac and Arthur Rackham, and the painters of Fairies, Sir Joseph Noel Paton and Richard Dadd. In particular I returned to Dadd's tiny masterpiece, *The Fairy-Fellers, Master Stroke*: at first, just the large fairies are visible, but then smaller fairies, and even smaller, down to minute figures about as big as a grain of sand, begin to appear as you study in wonderment.

These artists were an important influence on my work, and I produced some large paintings of Titania, the queen of the Fairies. Then I worked on a group of small paintings of Fairies that were my own invention. There were also a number of watercolours, including this detail from *The Death of a Butterfly*, which depicts a group of young girl fairies in mourning for a beautiful insect.

Above: **ARTHUR RACKHAM**, *A Bargain with the Devil*, watercolour, bodycolour and Indian ink, 35.5 x 28 cm (14 x 11 in)
Opposite: **PETER BLAKE**, *The Death of a Butterfly*, watercolour, 35 x 36 cm (13.8 x 14 in)

ALEXANDER VOROBYEV
ARTHUR RACKHAM (1867–1939): *A Bargain with the Devil*

I think in terms of the construction of a dream, or of worshipping paper. A painter's thinking needs to be cosmic. Because of the intense inwardness of my vision, and the purity and power of my reactions to the world around me, I aspire to break through in the way that Dali, Kandinskiy and Klee managed to break through in the twentieth century.

I think that my works of art combine, in an organic whole, two lines of development, surrealism and abstractionism. Perhaps there are too many symbols in my works – crosses, spirals, springs, spheres or quite real snails and flies, human bodies and severed limbs are all part of a medieval mysticism worshipped by me. But this expresses the force of my imagination and the concentration of my dreams.

A lot of my works have titles such as 'Construction of a Dream'. I was stunned by the words of a famous French poet Arthur Rimbaud: 'irregularity of thought is sacred'. When I work, I feel like I am having an adventure and I want to plunge the viewer in the cosmic sfumato, adding new horizons to my imagination and to the viewer's. Our imagination is the authentic realism. Sometimes an old posted envelope could mean more to me than a picture, and if it is a burning postal stamp, it is even more exciting. That is what I call worshipping paper. For many years, I, like a pagan, have been worshipping paper. I feel excited because of the paper's different types and textures, while the transparency of watercolours allows me to effortlessly levitate in my dreams and waking hours.

When I first saw Arthur Rackham's fantastic illustrations they took my breath away because of their fine lines, fantasy, grotesque and mysticism. Arthur Rackham and William Blake have definitely influenced my art. Like Blake, I see the sky in a flower-cup.

Above, left: **ARTHUR RACKHAM**, *A Bargain with the Devil*, watercolour, bodycolour and Indian ink, 35.5 x 28 cm (14 x 11 in)

Above, right: **ALEXANDER VOROBYEV**, *Summer Melancholy, Fed by the Energy of a Beehive, 1991*, silver pencil, gouache and watercolour, 66 x 51 cm (26 x 20.1 in)

Opposite: **ALEXANDER VOROBYEV**, *One Summer in Hell, 1991*, gouache and watercolour, 55 x 51 cm (21.7 x 20.1 in)

Glastonbury

TONE

What is tone? *Chambers Dictionary* tells us: 'a depth of brilliance of colour … colour relationships …'. The Dictionary expands a lot on this to talk about tonality in music, with which visual tonality has a number of revealing parallels. Just as it is impossible to conceive of a musical note without its inherent pitch or volume – loud or soft – or timbre, so it is impossible to conceive of colours, without specific relationships, singly or within a scheme or 'key'.

James McNeill Whistler and Augustus John were once conversing as they left an exhibition of Gwen John's paintings, and John remarked that his sister's work showed great character. 'What's character to do with it?' replied Whistler, 'it's tone that matters'.

I consider Whistler's observation to be significant. Whistler trained in Paris and was imbued with the French tradition. John, on the other hand was heir to the British tradition – romantic, rhetorical – responding to an impulse. Whistler was far more poised and systematic: for instance he once spent an entire day laying and grouping the tones on his palette in preparation for a seascape, which he painted the following day, in an hour.

Both of these artists were primarily oil painters. If they used watercolour at all, it was as an accessory to the oil painting – a preliminary sketch , as it were. Yet in thinking of our chosen medium, the best watercolourists, such as Cotman, Callow, Bonnington, or Girtin, all possess an innate sense of 'tonality'.

The watercolour medium, with its charming translucency, fluidity, spontaneity and dynamics of handling, does not at once encourage a more careful system or structure. But if artists are to avoid the weakness of vapid or insipid statements, I believe we must understand this principle of tonality as the ground base of our paintings.

LESLIE WORTH

Left: **ALBERT GOODWIN**, *Glastonbury* (detail), watercolour, bodycolour and black ink, 30 x 48 cm (11.8 x 19.5 in)

DIANA ARMFIELD
ALBERT GOODWIN (1845–1932): *Glastonbury*

There are masters of watercolour whose methods defy easy analysis: one cannot quite make out how the result has been achieved. Albert Goodwin is such a one. How did he attain those strange shadowy areas, those difficult to define colours? His textures suggest a secret life going on underneath, layers of soil under the surface of the sloping field he depicts in Glastonbury.

He must have brought this about in unhurried stages; the surface is never dull with overloading. That must have meant that he allowed time for drying before retouching. It looks as if he washed a thin opaque layer over areas more than once, and then reinvigorated the surface with ink drawing. He has clearly learnt from Turner, another magician.

We can take courage from these wonderful works. If our first touches have gone wrong, there is still much we can do: fresh, direct watercolour is not the only way to resolve a work, rewarding though that can be. We can experiment with sponging, scraping, bodycolour, ink and anything else that we think might help us to achieve our vision.

Above: **ALBERT GOODWIN**, *Glastonbury*, watercolour, bodycolour and black ink, 30 x 48 cm (11.8 x 19.5 in)
Opposite: **DIANA ARMFIELD**, *Crowds in the Piazzetta, Venice, 2005*, watercolour and bodycolour, 14 x 16.5 cm (5.5 x 6.5 in)

In *Crowds in the Piazzetta* I have tried to bring about in the shadows something which asks for a second look before it will reveal all I want it to convey. The sunlit buildings are seen very simply and painted directly, but I have used several different washes over the shadowed areas and lost and found the figures in them more than once.

It is a tiny work, but I spent a long time over it, alternating opaque and pure watercolour, adding and subtracting bits of drawing, and playing with contrasting blues to keep the shadow area alive. Concentrating on this small work allowed me to imagine myself back in Venice, that most beguiling of cities.

FRANCIS BOWYER

ALBERT GOODWIN (1845–1932): *Glastonbury*

'Poetic' was my first thought when I saw the picture *Glastonbury* by Albert Goodwin. My second was admiration for his adventurous approach to what is, in my opinion, a fairly ordinary topographical view.

Goodwin was a master watercolourist, and is probably best-known for his work in that medium. He used all sorts of techniques and approaches: watercolour, bodycolour, pen and ink, pastel, and gum on both white and tinted papers. He wiped and scraped out.

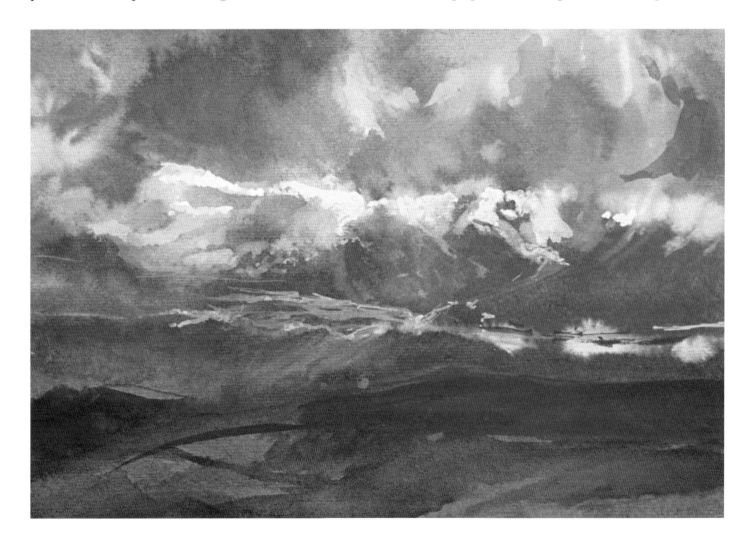

As he put it in his diary (17 March 1912): '… *[I] hammered at them with the blade of a safety razor, a knife, sandpaper, sponge, rag and a fitch brush!!! So many are the expedients that the despairing watercolour painter in the last has to resort to.*'

Aah, I sense a man after my own heart! How often I hear words of frustration expressed about this form of art, but then at its best it is exhilarating and exciting – an uncertain roller-coaster ride is inherent in this very British medium.

Watercolour at its very best can capture an immediacy, a feeling or mood, a sense of a place and a moment in time as no other medium can; something Goodwin so clearly

manages to achieve. I wanted the same responses he attained from my picture of *Dusk, The Highlands*.

Unlike Goodwin, I painted my picture with just watercolour and a little bodycolour (opaque white). The cleanest air in the British Isles, as I was informed, gave a clarity of colour that inspired me. Layers of colour could be built up, while at the same time I attempted to make it a simple, direct, uncomplicated and of the moment picture.

In this most magical place, with its ever-changing and fast-moving skies over a wonderfully raw Scottish landscape, I felt that, if there is a God, He is here.

Opposite, above:
ALBERT GOODWIN,
Glastonbury, watercolour,
bodycolour and black ink,
30 x 48 cm (11.8 x 19.5 in)
Opposite below:
FRANCIS BOWYER,
Lowering Clouds, 2003,
watercolour and bodycolour,
19 x 25 cm (7.5 x 10 in)
Left: **FRANCIS BOWYER**,
Dusk, The Highlands, 2003,
watercolour and bodycolour,
30 x 35 cm (12 x 14 in)

LIZ BUTLER
ALBERT GOODWIN (1845–1932): *Glastonbury*

I have always admired Albert Goodwin's evocative landscapes. He paints with spirituality drawn from nature that he shares with Samuel Palmer and the Pre-Raphaelite artists, with whom he is associated. Like Palmer he attempted to preserve, with integrity, his youthful passion in the presence of nature for all his working life. His artistic ability and aims never faltered, and he was painting exceptional and unique paintings until his death at eighty-seven, remaining uninfluenced by any of the art movements of the twentieth century.

He trained under Arthur Hughes, whom he met as a young boy on a sketching trip to his local woods, and later under Ford Madox Brown. He developed a friendship with Ruskin, whom he accompanied on several trips to Europe. He was a hard task-master to himself and achieved amazing technical virtuosity in the use of watercolour, developing exceptional skill at combining washing, hatching and scraping out, something he may have learned from studying Turner's watercolours which he greatly admired.

It is his very individual composition, however, that makes his work so instantly recognisable. He is very fond of steeply rising or plunging vistas, and uses uninterrupted expanses of emptiness within a composition to add dynamism.

The Spectator of 3rd May 1879 said of Albert Goodwin: '[He has a] peculiar faculty of painting a natural scene with an undercurrent of supernatural feeling.'

In his painting of Glastonbury, which I have chosen as my inspiration, he uses Glastonbury Tor as a viewing place. He makes us giddy by perching on the steep hillside, from where we are encouraged to look down the slope, and into the valley. We move like birds, sweeping over the low hill, and across the Somerset Levels towards the horizon, where we catch the last light of the day in the glowing sky and setting sun. The mood of the painting is of an almost arrested stillness and it glows with a curious inward intensity. On close inspection, the large areas of hillside, which appear to be a single colour, are made up of thousands of minuscule brush marks of many colours. The figures in this painting are very much a part of the composition. They are there to add scale, and perhaps to witness his passion for the natural phenomenon of nature in this extraordinary landscape. The entry in his diary for 12 October 1909 reads: 'I have been thinking, how much joy I have had ever since I was little in the colour of the evening and morning sky and what delights thousands have in the same thing.'

In my painting, I chose to stand on a hill as a viewing place, with my back to the summit, my eye could sweep over the contoured landscape down to the Vale of Clwyd and on into infinity. It was a wintry afternoon with a lukewarm sun setting; I was captivated by the chilly blue shadows, describing the gentle undulations of the landscape and with the small glowing patches of snow reflecting warmth from the hazy sun, here and there. There was an amazing tranquillity that afternoon and no noise of wind. I purposefully restricted the number of colours I used and included uninterrupted expanses of nothingness to help me recreate the harmonious atmosphere I had experienced that day.

Opposite: **ALBERT GOODWIN**, *Glastonbury*, watercolour, bodycolour and black ink, 30 x 48 cm (11.8 x 19.5 in)

Above: **LIZ BUTLER**, *Vale of Clwyd, 2004*, watercolour with chinese white on handmade, tinted paper, 16 x 22 cm (6.3 x 8.7 in)

JANET KERR
ALBERT GOODWIN (1845–1932): *Glastonbury*

When I first came across Albert Goodwin's painting of Glastonbury I was reminded immediately of a composition I had been mulling over for some time. There were definite similarities in the content of his subject and my own of Heptonstall, even down to the church tower! However, in Goodwin's beautiful and atmospheric work we are invited to look down on the subtle and understated hillside village, but in my painting we are looking across the valley of Crimsworth Dean and slightly up at the hilltop village of Heptonstall.

Goodwin's composition allows us to meander through the work, being led by a series of gentle diagonals, pausing here and there and generally taking our time across the undulating countryside spread out before us. My composition is more abrupt.

The South Pennine landscape, featured in my work, consists of characteristically steep hillsides and deep valleys. On a clear day, even from a modest vantage point, it's not unusual to see six or seven substantial hills receding into the distance. The steepness of the sides of these hills makes them appear like flat, upright planes and has the effect of giving a plan view of field shapes. The houses are built into the hillsides, and often, what seems to be a normal, two-storey house turns out to be four-storied when viewed from the other side! To me, this landscape creates high horizons and flattened perspective.

In order to avoid a stack of unconnected horizontal bands in the composition, I have sought out, and emphasized, related vertical movements through the work, giving rise to a faster initial journey upwards. Finally, I have used a narrow strip of very dark sky, hoping that it will act as a barrier and cause the viewer to work his way back down the painting, perhaps taking in some previously undiscovered areas of interest.

Above: **ALBERT GOODWIN**, *Glastonbury*, watercolour, bodycolour and black ink, 30 x 48 cm (11.8 x 19.5 in)
Opposite: **JANET KERR**, *Heptonstall, 2005*, watercolour and gouache over charcoal and pasted paper, 36.5 x 36.5 cm (14.5 x 14.5 in)

RICHARD PIKESLEY
ALBERT GOODWIN (1845–1932): *Glastonbury*

Goodwin's picture tells of a painter with an extraordinary gift for pitching tonal values very precisely. In much of his work, including some of the most ravishing sunsets ever painted, he is looking back to his hero, Turner, but here he displays a daring modernism in his ability to compose such a haunting image from almost nothing. By thinking in terms of big compositional masses rather than fussy description of trees and hedges he gives us a sense of vastness helped by the high horizon and the foreground group of figures low down in the picture.

The flat land of the Somerset Levels is intersected by thousands of drainage ditches, ruler-straight, criss-crossing the view; but there at the back of it all there are always hills, islands in an ocean, like Glastonbury, or the great arc of the Mendips to the north. For Albert Goodwin as for me these hills provide a bit of height from which to look out and get an idea of the scale of the place, and whereas he painted from the Tor, my first day's painting took me a little to the south in search of shelter from the rain at Walton Hill, where I could sit and paint in the lee of my Land Rover, protected from the wind and the lashing rain.

Weather zips across this landscape at an alarming rate and as the light fluctuated I made several starts, abandoning each one in turn; but as I watched I saw a cloud shadow spread over the foreground, leaving the middle distance strongly lit by the sun. Knowing that this was the effect I wanted, I painted fast, switching back to another painting each time the foreground was flooded with light.

Over the next hour or so the painting gradually took shape in a series of brief episodes, but eventually the sky filled up with cloud and I drove off to paint elsewhere.

Above: **ALBERT GOODWIN**, *Glastonbury*, watercolour, bodycolour and black ink, 30 x 48 cm (11.8 x 19.5 in)
Opposite: **RICHARD PIKESLEY**, *Rain, Somerset Levels from Walton Hill*, 2003, 26 x 35 cm (10.2 x 13.8 in)

JULIE HELD
JOHN RHEINHARD WEGUELIN (1849–1927): *Venetian Gold*

I chose *Venetian Gold* from the Diploma Collection because of its dazzling light. I love the way the light animates everything within the picture whilst retaining a sense of its external source.

Once decided upon a still life as the subject for my own watercolour, I decided upon a vanitas painting as its theme. In attempting to infuse light from the outside source, *Venetian Gold* seemed the perfect inspiration in my own attempt to do the same. In both Rheinhard Weguelin's painting and my own the light becomes as much the subject as the women in *Venetian Gold* or the skulls in my still life.

In making my painting, I firstly worked with thin, broad washes, establishing the lightest colours and tones and the light source, the shaft of light on the right side. Then I applied a wash to establish the major areas of oranges and yellows, to create the light in its diffusion.

Secondly, I painted the three skulls and the jug of flowers upon the table. When dry, I painted the tones within each object and began to paint the large swirls in the wallpaper on the table, further creating the pictorial space.

Thirdly, taking a thin brush I painted all the fine details of the wallpaper, tablecloth and jug. Lastly, I put in all the strong shadows cast by the various objects.

Although my painting has little obvious resemblance to *Venetian Gold*, I hope that the dramatic impact of the diffused summer light is homage to John Rheinhard Weguelin's work.

Above: **JOHN RHEINHARD WEGUELIN**, *Venetian Gold*, watercolour, gum and bodycolour, 53.8 x 72.5 cm (21.2 x 28.5 in)

Opposite: **JULIE HELD**, *Still life with Skulls and Flowers*, 2003, watercolour, 38 x 34.5 (15 x 13.6 in)

EILEEN HOGAN
CHARLES GINNER (1878–1952): *Street Scene*

Light and shade have always been important to my work. Patterns on chairs and tables made by the strong light in Greece falling through slatted awnings of tavernas inspired me when I was a student in the British School at Athens and, before that, the dappled light and striped shadows in South London parks were constant themes.

I am still interested in shadows, but those that fall in Marylebone now, rather than in Greece or Tooting and, in particular, the theatre of light in four contained spaces: Bryanston, Manchester, Montagu and Portman Squares. I have been studying these for the last four years, watching the transient movement made by light filtering through trees onto the façades of the surrounding buildings, including Home House, Hertford House (the Wallace Collection) and the terraces of Georgian domestic architecture. These shifts of mood chart the passing seasons in the city – the fewer the leaves, the sharper the shadows cast – and the more minute the alterations within each single sitting. Inadvertently, too, I have captured landscaping alterations in the squares and the environs.

Although Charles Ginner's street scene represents a different district of London, and the architecture there is Victorian, I feel that there are similarities in intention. I like his flat representation of the stucco façade where the formality of the structure is relieved by indications of dilapidation and neglect. I admire his commitment to the city. Ginner trained as an architect before he studied painting in Paris. When he returned to London he became a key member of Walter Sickert's Camden Town Group, mainly recording North London working-class areas.

Above, right: **CHARLES GINNER**, *Pimlico*, watercolour and Indian ink, 37 x 26.8 cm (14.6 x 10.6 in)
Above, left: **EILEEN HOGAN**, *Portman Square: Home House, 2005*, acrylic on paper, 16 x 12 cm (6.3 x 4.7 in)
Opposite **EILEEN HOGAN**, *Manchester Square, Hertford House, 2005*, acrylic on paper, 16 x 12 cm (6.3 x 4.7 in)

KENNETH JACK

THOMAS MILES RICHARDSON (1813–1890): *Norham Castle, Evening*

The skill of medieval builders in erecting cathedrals and castles has intrigued me from my early years when I saw photographs of them in various publications. Living as I do in Australia, I don't have many opportunities to see this favourite subject matter.

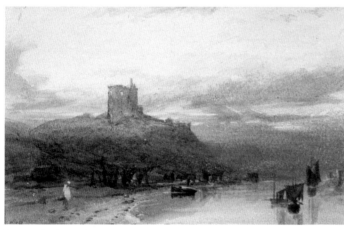

My painting of Bamburgh was made in the studio from a pencil and pastel drawing done on site on a grey morning in April, 2003. Several photos taken at that time also helped, particularly with details. It is my belief that an artist who draws on site will gain a greater feeling for forms in space than one who relies on photographs.

emphasized forms in space more prominently. Also, I've enjoyed painting meaningful details in contrast to Richardson, and these help give scale and bulk to the building.

As an artist who enjoys drawing and painting architecture, I have sought out buildings such as Bamburgh Castle on my many visits to the British Isles. This castle is one of a group in Northumberland that I have drawn, and on several visits, I have drawn it from different positions.

On seeing Thomas Richardson's *Norham Castle, Evening,* I was impressed by his capturing the last light just before twilight, his feeling for both space and atmosphere, his simple and very effective colour scheme, his range and depth of tone, and his abstract placements of boats people and clouds in compositional relationships to the dominant castle. It is a beautiful masterpiece, small in size, but big in artistic statement.

Richardson's painting was the starting point for my watercolour. Both the castles are in Northumberland. My view of Bamburgh does not have a river in the foreground, as at Norham, but a road instead. Bamburgh absolutely dominates the village and this I've slightly exaggerated by making the hill, on which it is built, higher – this better gives the feeling one has when actually in the village. My painting is larger than Richardson's and I have

Above, left: **THOMAS MILES RICHARDSON JUNIOR**, *Norham Castle, Evening*, watercolour and bodycolour over graphite, 13.8 x 22.7 cm (6 x 9 in)

Above, right & opposite: **KENNETH JACK**, *Bamburgh Castle, Evening*, 2003, watercolour and bodycolour on Arches 300 gsm rough, 34 x 54 cm (13 x 24 in)

ALISON C MUSKER

ARTHUR RACKHAM (1867–1939): *Abbaye d'Ardennes, Caen*

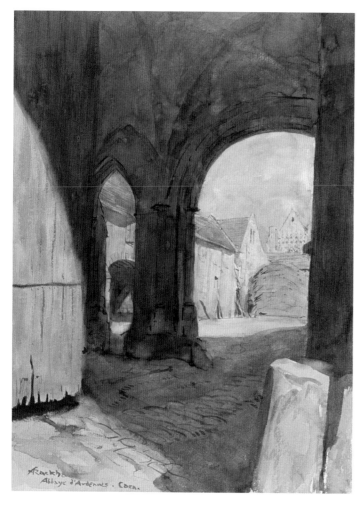

The great painters drench each tone with as much of the wine of colour as it will hold, without contradicting the light and shade. Contrasting tones are in juxtaposition, repeating each other three times.

Through the rat-gnawed door one treads over raised cobblestones, with dirt tracks on either side for the carts, under the darkened Norman archway with mellowed deep-yellow groining, and then one steps out into the courtyard in full sunshine. 'Where the light is brightest the shadows are deepest' (Johann Goethe, 1771).

The Venetian Doorway is also a tonal painting. Against the light Istrian stonework and the windows looms a darkened doorway. The colours used in my watercolour were Venetian red (the earth colour extracted from Badia di Calcarena, near Verona), raw siena, burnt siena, burnt umber and prussian blue, light red and French ultramarine, which created the shadows.

Tone refers to variations in the dimensions of hue and brightness, being the relationship of relative depth of different colours. Tonal values can alter in relation to each other when placed side by side and may flatten the images, as on the shadow cast in Rackham's watercolour by both doors.

Sickert used gradation in tones and even numbered them on his preparatory drawings. Compare the light and shadows of one area to another, half close your eyes and you can decipher the tones more easily. You need a dark tone to make the crisply lit side stand out; chiaroscuro is the contrast between these highlights and shadows. Rackham used a limited palette and you can see what he has achieved.

Above: **ARTHUR RACKHAM**, *Abbaye d'Ardennes, Caen*, watercolour and bodycolour, 31.6 x 22.8 cm (12.5 x 9 in)
Opposite: **ALISON C MUSKER**, *The Venetian Doorway*, watercolour, 77 x 58 cm (30.5 x 23 in)

JENNY WHEATLEY
LORNA BINNS (1914–2003): *Salina Bay, Malta*

Lorna Binns has been a strong influence in my work from the time that I was first elected to the RWS. She was such an unlikely and unassuming personality to have produced her poetic, high-key paintings that dance so lightly on the paper – and for the exotic subjects that she chose on the many travels she made to various countries around the world.

Her Diploma work hints at the stronger patches of colour that she tenuously placed across the picture surface in her later paintings, and which I saw every time I delivered my works to the RWS shows. She was always so eager to ask my opinion when I was still such a young member of the Society, and I became increasingly interested and involved in her images and the processes she used to arrive at her finished work.

It was Lorna who first introduced me to the vibrant and finely ground make of watercolours that I have used so often, and it was she who first drew my interest to using high-key, close-tone colours to make images glow so richly.

Over the years I have continued to pursue my interest, pushing the use of close-tone colours while using mostly transparent paint to try and make the paintings look as though they glow from within the paper surface, rather than sit upon them.

The materials used in creating a piece of work, from hand-made papers to luminous, transparent colours, have continued to preoccupy me throughout my painting career.

In Lorna's Diploma work of a Maltese landscape, her colours were still soft and her marks were almost Cézanne-like, but the way she placed the patches of colour, finding objects in amongst the empty landscape, hinted of the bolder work that she produced increasingly, right up to her death. It suggested to me an interest that I share in making subjects emerge from the painting rather than be imposed upon the viewer in some way.

My own paintings represents similar interests to hers, developed over many conversations about the process of painting and the reaction to the subject. While denser in colour than her early work, they demonstrate mydevelopment of the high-key painting that I saw emerge from such a quiet and tentative character.

Above: **LORNA BINNS**, *Salina Bay, Malta*, watercolour, bodycolour and graphite on tinted paper, 24.8 x 37 cm (9.8 x 14.6 in)
Opposite: **JENNY WHEATLEY**, *Telephone Office, Uzes, 2003*, mixed media on paper, 94 x 71.2 (37 x 28 in)

JONATHAN CRAMP
SAMUEL PROUT (1783–1852): *Lucerne*

What a difference a shadow makes! Imagine Samuel Prout's *Lucerne* without the cast shadow on the left. I am sure he would have made a very pleasing picture without it, but the shadow adds considerable drama and makes a much better composition. Within the luminous dark area he is able to simplify details and the contrast of detailed and more simplified areas gives an added vitality. And as in Rembrandt's work, the shadow has an element of mystery. The viewer wants to peer into the darkness.

In *Shadows and Reflections*, the buildings are close up, as in Prout's painting, but they are a little more parallel to the picture plane, which emphasizes the geometry of the vertical and horizontal. The shadows do not override this structure, but they are nonetheless the real subject of the picture, coupled with the reflections in the windows. I was not particularly interested in making a picture only of the façade – delightful though this was. The excitement came when the sun came out and the tree behind me cast its mottled shadow over the wall, the metal balustrade, and the railings and windows. The tree was also reflected in some of the windows. Technically the execution of the picture demanded careful drawing and observation of the subtle changes in tone. Just as in Prout's work the contrast of light and dark raises the picture above mere description.

Similarly, in *The Bishop's Palace, Mathern, near Chepstow* the sun came out in early evening after a dull grey day and transformed everything. I became more excited in the tonal contrasts than in the gardens and buildings themselves.

While I would not pretend that my pictures are anywhere near Samuel Prout's in quality, we have both used shadows and tonal contrasts to vitalise the composition.

Above, left: **SAMUEL PROUT**, *Lucerne*, watercolour and bodycolour, 26.8 x 20.2 cm (10.5 x 8 in)
Above, right: **JONATHAN CRAMP**, *The Bishop's Palace, Mathern, near Chepstow*, 1997, watercolour, 39 x 55 cm, (15.2 x 21.8 in)
Opposite: **JONATHAN CRAMP**, *Shadows and Reflections*, 1984, watercolour, 48 x 38 cm (19 x 15 in)

TOM GAMBLE
SIR WILLIAM RUSSELL FLINT (1880–1969): *Incoming Tide, No. 1 Slip, Devonport Dockyard*

As a mainly urban painter anchored principally in the 1930s and as a 'street walker', I collect my building materials from the visual events that I encounter and place them at random, as the mood dictates, across the pages of a large sketchbook. Although outside drawing and note-taking are essential to my work, in the end I make landscape rather than draw and paint it. Literal paintings of a city are much less important to me than what lies beneath the surface. To penetrate a world not normally visible to the waking, walking multitudes, I experience the sounds, smells, music and colours and compose visual 'symphonic variations' in an attempt to create a personal oeuvre.

Technically I work in pure watercolour, so I was instantly drawn to the superb painting in the same medium by Sir William Russell Flint. The subject, in a limited colour palette of ochres, sepias and siennas, is of a slip in Devonport Dockyard. This is a wonderful work that features all the debris of an industrial wasteland, the shapes and structures of which would provoke no interest in the average passer-by.

Whereas *Incoming Tide* shows a scene just before it was destroyed by bombing, my painting, *The Aftermath*, is soon after destruction. It is in another place and time but, by coincidence, there are similarities in composition, in tone and in the limited earthy colour range with tiny touches of pale blue against the browns. Both paintings, associated with shipping, have water creeping up in the foreground and a pale view in the distance, and are framed with uprights of stark concrete. My buildings are a menagerie of warped and twisted metallic shapes and secret enclaves slowly filling with garbage. The paintings are linked by the silence that comes before and after a devastating event.

Opposite: **SIR WILLIAM RUSSELL FLINT RA**, *Incoming Tide, No.1 Slip, Devonport Dockyard*, watercolour over graphite, 48.7 x 66 cm (19.2 x 26 in)
Above: **TOM GAMBLE**, *The Aftermath, 2004*, watercolour over graphite, 42 x 55 cm (26 x 21.8 in)

MICHAEL CHAPLIN

SIR WILLIAM RUSSELL FLINT (1880–1969): *Incoming Tide, No. 1 Slip, Devonport Dockyard*

A visit to a distillery always sounds like a good idea and mine was no exception. It offered insight into a process that I knew little about and I think that any artist should put themselves in the way of new and interesting visual experiences. My tour of the Barcelona Cave factory offered a wealth of information, some of it about the technique of wine production but, more excitingly, more about the extremes of visual material: from a glimpse of vines curving away in perspective across soft Spanish hills to the sudden darkness of five layers of cellars full of maturing wine – cool in both temperature and colour. Arriving back at the production rooms at ground level, I was greeted by an explosion of warm light and colour bathing the ancient vats, casks and wicker baskets. The echoes between the vaulted architecture and the graceful curves of the objects intrigued me.

Clues as to how to deal with this subject lay in an interior painting, which is almost the same age as myself: Sir William Russell Flint's *Devonport Dockyard* (now in the RWS Diploma Collection), for many years one of my favourite pictures. It was painted in 1941, and a few days later the dockyard was damaged by enemy bombing – an irony considering the air of calm which seems to pervade the painting. This is perhaps due to Flint's decision to make this an almost monochromatic piece.

The scene is shown as subtle recessive tone and the structuring of the paint varies from soft broken edges in the superstructure to the one or two points of hard narrative interest at the far end of the building. The foreground is decisive in its handling, with the lapping waves introducing a cursive counterpoint to the strictly regulated geometry of the architecture. I hope some of these compositional devices – the use of monochrome, the balancing of hard and soft areas and the warm palette – also work in my painting to communicate an intimate experience.

Above: **SIR WILLIAM RUSSELL FLINT RA**, *Incoming Tide, No.1 Slip, Devonport Dockyard*, watercolour over graphite, 48.7 x 66 cm (19.2 x 26 in)
Below & opposite: **MICHAEL CHAPLIN**, *Codornieu Distillery*, 2004, watercolour, 51 x 61 cm (20 x 24 in)

KEN HOWARD

SIR WILLIAM RUSSELL FLINT (1880–1969): *Incoming Tide, No. 1 Slip, Devonport Dockyard*

Sir William Russell Flint's *Incoming Tide, No. 1 Slip, Devonport Dockyard* has many points of resonance for me. Firstly the subject, which is industrial, clearly illustrates the beauty which can be found in such situations; I myself started by painting industrial landscapes in North London. The railway sidings of Neasden and Cricklewood gave me the opportunity to reveal the beauty to be found in everyday subjects. I am quite sure the non-painter, on entering Flint's Dockyard, would not naturally recognize its beauty without having seen this brilliant watercolour. When I first went to India it was not the exotic architecture and people that inspired me, but the dirty railway sidings, the working locomotive's, the steam and the smoke.

On that trip I learnt that in painting and drawing it is the particular observation that matters. On seeing one of my watercolours, the head of the Indian Railways informed me that the train in my painting had just had its boiler cleaned. When asked how he knew he said it was only when fired up after such a clean that the smoke appeared as it did in my watercolour. This gave me a great thrill for I had painted a particular truth, not a generalization.

Being a tonal painter, this Russell Flint touches me because of the expression of light through tonal contrast. There is no bright colour – only rich earth colour, which has always appealed to me. His use of umbers, siennas and ochres are in the tradition of early watercolourists such as my favourite, John Sell Cotman, on whom I wrote my dissertation at the Royal College of Art.

Speed is of the essence with watercolour and I love to feel that a work has been done at a hundred miles an hour. This gives it vitality and excitement, and of course with industrial subjects there is always the threat that the train will leave or a boat will suddenly arrive in the shed.

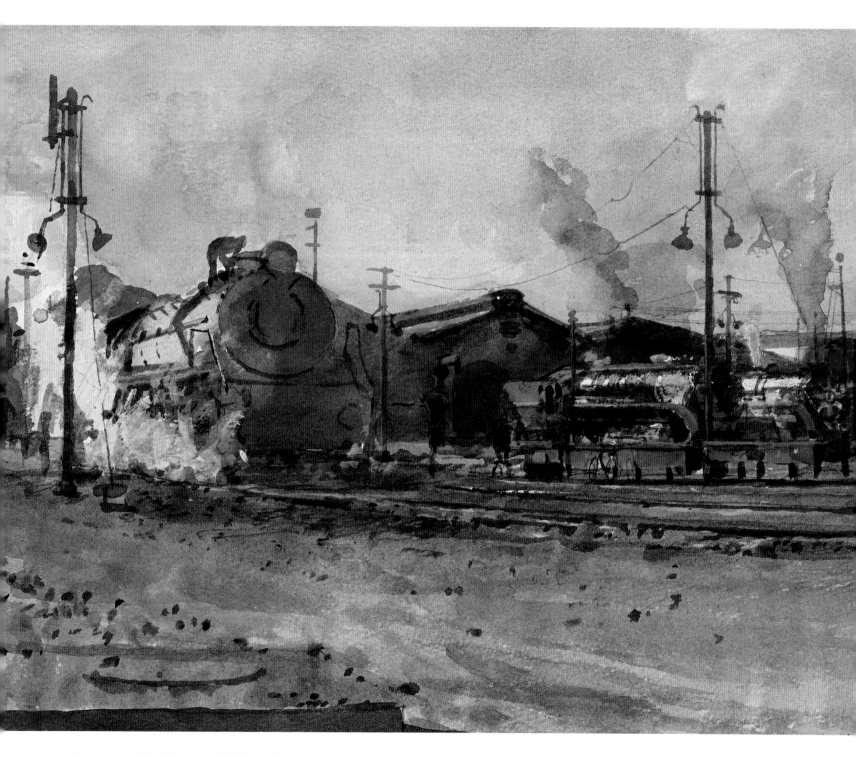

Opposite, left: **SIR WILLIAM RUSSELL FLINT RA**, *Incoming Tide, No.1 Slip, Devonport Dockyard*, watercolour over graphite, 48.7 x 66 cm (19.2 x 26 in)
Opposite, right: **KEN HOWARD**, *Jhansi Loco, 1984*, watercolour, 13 x 18 cm (5 x 7 in)
Above: **KEN HOWARD**, *Steam and Smoke, Jhansi, 1984*, watercolour, 38 x 56 cm (15 x 22 in)

MICHAEL WHITTLESEA
SIR WILLIAM RUSSELL FLINT (1880–1969): *Incoming Tide, No. 1 Slip, Devonport Dockyard*

Sir William Russell Flint has many admirers and collectors, and is well known to this day for his paintings of naked ladies beside Spanish wells. They are painted with supreme confidence and are very remarkable in many ways. They did, and still do, sell for large

amounts of money. There is an intriguing story about this period, which I hope is true. It was one of these Spanish nudes that had been deposited by Sir William as his Diploma work at the RWS. He later asked if he could exchange this picture, which he could easily sell, and substitute a painting that nobody would buy. This painting, now safely in the Diploma Collection, is the magnificent Devonport Dockyard painting.

The Spanish Civil War must have curtailed Sir William's travel plans, and then with the onset of World War II, he became an official War Artist. It is one of the works produced during this period that I so admire: I think it's wonderful. It is a very well constructed picture, planned and drawn in pencil first. The huge timbers supporting the roof are drawn with care, the perspective is correct. There is no doubt about the solid construction. This dockyard certainly housed tall sailing ships in the past.

Sir William left nothing to chance. Once he applied the watercolour, which he did with economy, the important detail is there. It required broad brushstrokes, layered so carefully. Not much 'wet in wet' here; nothing is left to chance. The watercolour never becomes 'muddy'. In the middle distance, the slipway and the machinery are painted, again with economy and acute observation. Sir Russell used a little 'scratching out'. The pigment on the right shows signs of light scratching out, and it is done with great sensitivity.

For many years I lived in a Thames-side village, and Peter Freebody's boatyard was the subject of many of my drawings and paintings. I must have had Sir William's dockyard in mind whenever I visited that boatyard in Hurley.

Above: **SIR WILLIAM RUSSELL FLINT RA**, *Incoming Tide, No.1 Slip, Devonport Dockyard*, watercolour over graphite, 48.7 x 66 cm (19.2 x 26 in)
Opposite: **MICHAEL WHITTLESEA**, *The Boatyard, Hurley, 2003*, watercolour and pencil, 44.5 x 58.5 cm (17.5 x 23.2 in)

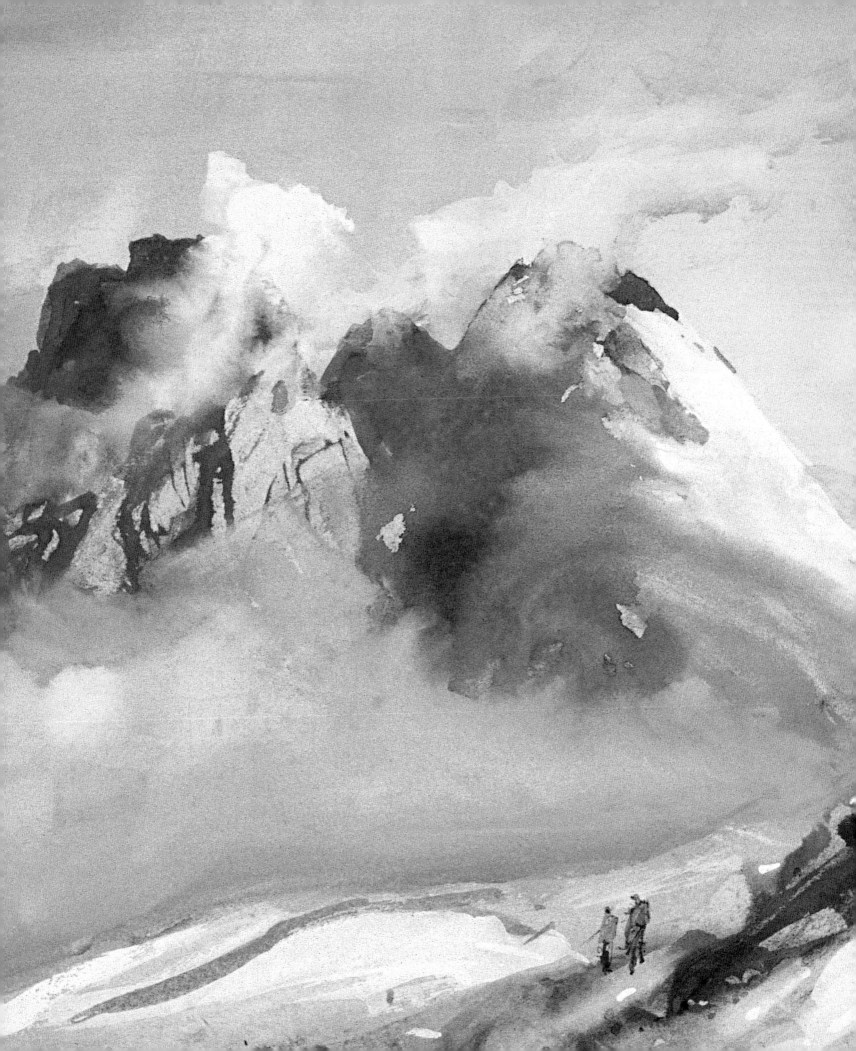

ROBERT WEIR ALLAN (1851–1942)
ARWS 1887, RWS 1896

Allan was born in Glasgow, the son of a publisher. Like many of the Glasgow School he studied in Paris where he shared rooms with his friend Arthur Melville – whom he claimed to have influenced – in the Boulevard d'Enfer ('the Street of Hell'). They made porridge with imported oats, sang Scottish songs and danced Highland reels in the studio. The French Realist Jules Bastien-Lepage had a profound influence on his work. Allan's impressionist, 'blottesque' manner of painting (tilting the paper and allowing spots of watercolour to run like raindrops) seems to have developed in response to Monet. His extensive travel included visits to India and Japan, although much of Allan's work was painted en plein air in the fishing villages of north-east Scotland. According to Sir William Russell Flint: 'To the very end Allan adored the R.W.S.' In 1900 he presented the Society, which owns six of his works, with its vice-president's gold badge of office.

HELEN MARY ELIZABETH ALLINGHAM (1848–1926)
ARWS 1875, RWS 1890

The daughter of a surgeon, Allingham was born at Swadlincote in Derbyshire into a Unitarian family. After the death of her father her family moved to Birmingham where she trained at the Government School of Design; subsequently she attended the Female School of Art in Queen's Square and the Royal Academy Schools in London. In 1870 she became the only female member of staff of *The Graphic*, where she worked until her marriage to the Irish poet William Allingham. Her husband introduced her to literary and artistic circles which included Carlyle, Ruskin and Tennyson, who said of her work: 'I should like to do that. It does not look very difficult'. In 1890, having been proposed by Alfred William Hunt, Allingham became the first woman to be elected a full member of the Society. The President, Sir John Gilbert, said that he was 'disgusted and ashamed' by this development. More than thirty years later she also became the first woman to serve on the RWS Council. The country cottages for which Allingham became known have charm, although they have often been 'improved' by the removal of ugly outbuildings, and the posed figures standing outside almost certainly more physically attractive than the true inhabitants.

ROBERT SARGENT AUSTIN RA (1895–1973)
ARWS 1930, RWS 1934

Austin was born in Leicester, the son of a cabinet-maker. Apprenticed at thirteen to a firm of printers, he attended Leicester Municipal School of Art; subsequently he studied in the School of Engraving in the Royal College of Art under Sir Frank Short, from where he won a Rome Scholarship. Thereafter Austin taught at the College from 1926 until his retirement. Inspiring as a teacher, if sometimes caustic, his students learnt to draw models within the confines of the real world, the figure often distorted by closeness. His own influences included early German engravers, Degas and the cropped woodcuts of William Nicholson. More widely acknowledged as an engraver than as a painter, Austin's work included designs for the £1 and 10-shilling notes and bookplates for the library in 10 Downing Street. His near-perfect technique and remarkable draughtsmanship eventually became unfashionable, however. Serving as President of both the Royal Watercolour Society (1957 to 1973) and the Royal Society of Painter-Etchers and Engravers (1962 to 1970), he and Malcolm Fry, the Secretary, ran the Societies and the RWS Gallery in Conduit Street between them. Austin lived in Chiswick Mall in London and in a converted Methodist chapel at Burnham Overy Staithe in Norfolk.

ROSE(MARY) MAYNARD BARTON (1856–1929)
ARWS 1893, RWS 1911

Barton was born in Rochestown, County Tipperary. The daughter of a solicitor, her background was the Anglo-Irish gentry. She was presented at the Vice-Regal Court in Dublin Castle in 1874. It is conjectured that after an unhappy love affair she went to Brussels to study painting; she also studied in Geneva, in London under Paul Naftel RWS, and in Paris with Henri Gervex. In Paris she became aware of Impressionism and learnt to share Monet's love of the foggy streets of London. Many of her works are impressionistic street scenes of London and Dublin. In 1904 she wrote and illustrated *Familiar London*: 'it is wonderul to see the shrouded forms looking gigantic as they come towards you. The scene is weird, ghostly, almost silent. The fog deadens sound, and you hear little more than the shouts of charioteers.' She also painted gardens, topographical views of Irish houses and somewhat sentimental scenes of children – 'charming little idylls'. As her health deteriorated on account of asthma (probably exacerbated by the fog) she lived in Knightsbridge with a nurse known as 'Kitchener' because of her military bearing. A lover of racing, Barton backed two winners on the day of her death.

CHARLES BENTLEY (1805/6–1854)
AOWS 1834, OWS 1843

Bentley was born in the Tottenham Court Road in London, the son of a master carpenter and builder. Apprenticed to Theodore Fielding to colour prints and then as an engraver, he went to Paris to work on plates made from watercolours by Bonington, whose watercolours were an undoubted influence. Bentley is best known for his breezy coastal scenes of the British Isles and Normandy. According to his obituary in *The Athenaeum*: 'He had few compeers in the delineation of water in movement' (13 June 1846). He was also employed by amateur painters to work up their sketches into full paintings – including views of Turkey and Guiana – and various imaginative scenes. Despite his considerable merit, Bentley had little business acumen and was swindled by picture-dealers; he is described as 'always poor' and left less than £300 on his death. Bentley died suddenly of cholera. Copley Fielding wrote from Worthing: 'I cannot come to Town … Then I know that many would be very timid in attending the funeral of one who had died of Cholera tho' I believe there is not the slightest danger'. The Society endeavoured to help his widow and elderly mother, who relied solely on him for support.

LORNA EMILY BINNS (1914–2003)
ARWS 1973, RWS 1977

Binns was born in Wadsley Bridge near Sheffield where her father was a manufacturer of stained glass. From Sheffield College of Art she won a scholarship to the Royal College of Art to study fashion. The artist Paul Nash saw a work which she had entered in a competition and gave her a tutorial. Using pieces of coloured paper to demonstrate, he instructed her that 'colour on either side changes the colour in the middle'. She held that this was the most important thing ever said to her in her life. The outbreak

Left: **CECIL ARTHUR HUNT**, *Dents des Bouquetins, Arolla* (detail), bodycolour over graphite, 26.7 x 36.2 cm (10.5 x 14.3 in)

of war made a career in fashion impossible, so she returned to Yorkshire where she was conscripted into a firm of leatherworkers. Her husband was the Head of Design at Kingston College of Art, and they undertook designs jointly for a variety of clients. Binns's work is full of colour and light. Usually she painted landscapes – especially if they included water – and intense flower studies: 'When I am looking for a subject, I see something very beautiful which excites me and in that moment the reason for working and the final feeling of the painting is born.'

SAMUEL JOHN 'LAMORNA' BIRCH RA (1869–1955)
ARWS 1912, RWS 1914

Birch was born at Egremont in Cheshire, the son of a painter and decorator. At twelve he left school to work in an oil-cloth factory in Manchester but soon began to sell the watercolour sketches he made in his spare time. Birch moved to near Lancaster, where a river bailiff taught him a love of countryside and fishing which lasted all his life. By 1892 he was so successful as an artist that he moved to Cornwall where he settled in the Lamorna Valley west of Newlyn. (He adopted the name 'Lamorna' to avoid confusion with a local painter, Lionel Birch.) Among his circle of artist friends in Cornwall was Laura Knight who recalled 'the brownish tweeds he wore – and a rather battered hat … His knickerbockers strapped and buckled just below the knee, allowed the display … of his splendidly developed legs, the calves of which would have been the envy of any man.' Birch worked in the Barbizon tradition of plein-air realism, beginning work just after daybreak and storing his current work overnight in the barns of farmer friends. During the course of his career he produced more than 20,000 pictures. His colourful landscapes and river scenes brought him great popularity, especially in the Dominions; reproductions of his work as greeting cards and fine art prints sold in huge numbers.

LIONEL BULMER (1919–1992)
ARWS 1959, RWS 1974

Born in London, Bulmer was the son of an architect who imbued in him a love of buildings. He studied at Clapham School of Art and, after war service, at the Royal College of Art under Percy Jowett. At the Royal College he met the artist Margaret Green, and the various prizes she was awarded allowed them to travel around France. They were together for forty-eight years, although they did not marry until weeks before Bulmer's death. Their work is sometimes indistinguishable: she was to write, 'I knew we were too dangerously together for future happenings. We never had a separate life.' In 1948 he took a post at Kingston School of Art, where he continued to teach until the 1980s. In the late 1950s he and Margaret bought Lodge Cottage, a derelict medieval hall house near Stowmarket in Suffolk, which they restored; they added a studio where they painted, inspired by the neighbouring cornfields and coastal stretches around Southwold and Walberswick. Bulmer's early work was understated and influenced by the Camden School of Painters; his later compositions are more stylised and use distinctive, strong colours.

SIR GEORGE CLAUSEN RA (1852–1944)
ARWS 1889, RWS 1898

Clausen was born in London. His father was a Danish decorative artist, his mother Scottish. From 1867 to 1873 he worked in the drawing office of a firm of decorators in Chelsea until he won a scholarship to the National Art Training School in South Kensington. He also worked as an assistant, copying works in the National Gallery. Clausen studied in Antwerp and Paris where he was influenced by the new realism of both the Hague School and his French contemporaries. He worked mostly in the Essex countryside en plein air: 'It was Clausen's determination to see life as it was, to find his pictures, not to make them, that was to influence the whole of his painting career.' Although in 1886 he was a founding member of the New English Art Club, which was set up in opposition to the Royal Academy, Clausen was subsequently elected to the RA and served both as Professor of Painting and as Director of the Schools. In 1925 he was chosen as a muralist for St Stephen's Hall in the Palace of Westminster, and his painting *The English people, in spite of persecution for heresy, persist in gathering secretly to read aloud Wyclif's English Bible*, earned him a knighthood in 1927. Although personally modest, by the time of his death at the age of 92 Clausen was feted as the 'grand old man' of British art.

JOHN SELL COTMAN (1782–1842)
AOWS 1825

Cotman was born in Norwich, the son of a hairdresser (subsequently a silk merchant). He moved to London in 1798 where he worked as an assistant to the publisher and dealer in engravings Rudolph Ackermann. In 1800 and 1802, with Paul Sandby Munn, Cotman travelled in Wales, and then in 1803 and 1805 he toured Yorkshire. While staying at Greta Bridge during the latter tour he produced what are now regarded as some of the finest watercolours in British art. However, the following year he failed to be elected to the Society of Painters in Watercolours while his friend Munn succeeded, and he returned to Norwich where he held a retrospective of several hundred works. Dante Gabriel Rossetti, a pupil, described Cotman as 'an alert, forceful-looking man, of modest stature, with a fine well-moulded face, which testified to an impulsive nature, somewhat worn and worried'. Although suffering from depression – and a crushing sense of failure – Cotman was undoubtedly a major artist. Victor Rienaecker wrote of him: 'While Turner's reaction to the spirit of the romantic revival was in the main emotional, [Cotman compelled] his own feelings to come to terms with the scientifically verifiable coceptions of nature and reality … [his] discovery of pictorial structure has given rise to a long echo in the consciousness of many succeeding painters.'

EDWARD DUNCAN (1803–1882)
ARWS 1848, RWS 1849

Duncan was born in London, the son of a painter and engraver. Precociously talented, he was apprenticed at sixteen to the acquatint engraver, Rudolph Ackermann, and his son. Duncan also worked as an engraver and from 1843 to 1851 he was on the staff of the *Illustrated London News*, for whom his wood-engravings included pictures of the Great Exhibition. Although not a sailor, he is best known for his sea pictures: he also painted shorelines, storms and sheep, or if possible all three in one picture. Duncan was highly prolific and left over 5,000 sketches and studies on his death. His obituarist in *The Builder* described him as 'a very industrious man. Hardly in England a drawing room owned by any one of taste but has drawings of his … He was a very liberal man too; kept an open house, a dinner party weekly; and his billiard room was open to all comers.'

Duncan was an arch-reactionary: for instance, he refused to shake Edward Burne-Jones's hand when he was elected to the RWS in 1864.

FRANCIS OLIVER FINCH (1802–1862)
AOWS 1822, OWS 1827

Finch was born in London; after the death of his father, a merchant, he was brought up with his grandmother at Stone near Aylesbury in Buckinghamshire. He received little formal education but read deeply and, for instance, learned *Paradise Lost* by heart; he himself later wrote poetry. At twelve Finch was articled to John Varley for five years. A tour of Scotland revealed to him the possibilities of landscape painting. Influenced by the spiritual searchings of William Blake, Finch formed together with Samuel Palmer, George Richmond and Edward Calvert a romantic brotherhood of young artists, 'The Ancients'. They made expeditions into the countryside: 'At the end of long summer days, when the moon was new or at the full, these young adventurers would sally forth on foot – sketchbook in hand, sandwiches in pocket … in quest of effects, and for the purpose of asking nature questions, and jotting down here replies when the day-light dawned and the memory was yet fresh.' Finch was elected to the Society of Painters in Water-Colours at nineteen, its youngest ever member. He was musical, deeply religious (a Swedenborgian), 'serious and refined'. His work is imbued with an autumnal melancholy reminiscent of Keats, whom he loved; Palmer called him the last representative of the old, Claudean, school of painting. *Ruins of an Ancient City* (page 38) was given to the Society in 1865 and was one of the first ever pictures in its collection.

SIR WILLIAM RUSSELL FLINT RA (1880–1969)
ARWS 1914, RWS 1917

Flint was born in Edinburgh; his father was a graphic designer and watercolour artist, his mother one of Scotland's first female civil servants. At fourteen he began a six-year apprenticeship as a lithographic draughtsman with a printing firm. In 1900 Flint moved to London in order to study art; to finance his studies he worked part time as a medical illustrator, making pictures of bullet wounds from the Boer War, and of leprosy and eye diseases. Subsequently he worked for the *Illustrated London News* and as a freelance illustrator. During World War I, and despite 'a completely non-mathematical brain', he became an inspector of airships. When Flint first stood for election to the RWS he overheard someone calling him a 'dangerous revolutionary' and he was elected only on his seventh attempt. Influenced by, among others, Arthur Melville, Flint was technically a major watercolour artist. However, he is best known for his erotic – but highly lucrative – nudes, which have been described as 'somewhere between the art of striptease and the art of painting and drawing'. Knighted in 1947, Flint served as President of the RWS between 1936 and 1956

ALFRED DOWNING FRIPP (1822–1895)
ARWS 1844 RWS 1846

Fripp was born in Bristol, the sixth child of a clergyman and a grandson of Nicholas Pocock, one of the founders of the Society. His brother George Arthur Fripp (1813–1896) was also a member. After studying at the British Museum and the Royal Academy Schools he travelled in Ireland and then lived in Italy from 1850 to 1859. As can be seen in *San Rocco, Olevano* (page 54) (Olevano Romano is a small hill town twenty miles east of Rome), Fripp's

work combines rather sentimental groups of figures and – in the harsh luminosity of sunlight – great subtlety of tone. From 1870 until his death Fripp served as Secretary of the Society. He was very supportive of the President, Sir John Gilbert, and shared his conservative instincts. In the annual elections of 1883 five other candidates, including his brother, stood against him but, during a period of bitter in-fighting within the Society, he invariably outmanoeuvred everyone. He returned to Rome in 1893 but complained that it was full of Americans. Fripp died at his home in Hampstead during an influenza epidemic in March 1895; both his wife and youngest son also died within days.

CHRISTA GAA (1937–1992)
ARWS 1986, RWS 1989

Gaa was born in Hamburg in Germany. Her father served as a general in the German Army on the Russian front. In her youth she was a junior tennis champion. She read German philosophy and art history at the Universities of Cologne, Florence and Bonn and later studied painting at the Fachhochschule für Kunst und Design in Cologne. In 1980 she moved to England where her work found greater appreciation. She painted both landscape and still life: 'I become particularly fond of certain groups of objects, and paint them over and over. You see Morandi doing this too, and you find that the relationship between the objects becomes the interesting thing.' A typical work by Gaa was an arrangement of domestic objects. Bernard Dunstan wrote of her that 'the table top contained the essence of the world that her painter's eye needed.' Gaa first met Ken Howard when she was studying in Florence during the Easter of 1959. He proposed to her a fortnight later but her parents refused to let them wed. They met again in London in 1980 and married ten years later.

CHARLES ISAAC GINNER ARA (1878–1952)
ARWS 1938, RWS 1945

Ginner was born in Cannes, the son of a pharmacist from Sussex. On leaving school at sixteen after illness he sailed the Mediterranean and South Atlantic on a tramp-steamer. Between 1899 and 1904 he worked in an architect's office in Paris and enrolled at the Académie Vitti. After exhibiting in Buenos Aires he moved to London in 1909 and took a studio in Chelsea. Ginner was a founder member of the Camden Town Group in 1911 – for which he wrote a manifesto, asserting the neo-realism of the modern age and 'all it contains of great or weak, of beautiful or of sordid'. He subsequently joined both the London Group and the Cumberland Market Group. His innate sense of rhythm and design found expression in the urban landscapes to which he was particularly drawn. They were planned with the use of a hand-held viewfinder and turned into his typically tight, intricate and deeply coloured pictures in his studio. Ginner was an official war artist in both world wars, but became increasingly reclusive after the death of his close colleagues, the artists Spencer Gore and Harold Gilman (who caught influenza after tending Ginner) and after seeing the woman he loved marry another man. He was awarded a CBE in 1950.

ALBERT GOODWIN (1845–1932)
ARWS 1871, RWS 1881

Goodwin was born in Maidstone in Kent, the son of builder. He was briefly apprenticed to a draper but while still 'a small weedy-looking boy' he was

introduced to the artists Arthur Hughes and Ford Madox Brown, from whom he received lessons. He subsequently became friends and travelled with Ruskin (who called Goodwin 'Bogie'). Ruskin was a major influence, and over the years the increasing sway of Turner liberated Goodwin from the thrall of the Pre-Raphaelites. Goodwin was a deeply religious man whose work is imbued with a poetic feeling for atmosphere and landscape. He believed that landscape painting was a kind of divinely inspired activity: 'Our business is to study the natural world as the continual revelation of God, guiding us forever into fresh revelation of himself'. He was also immensely prolific, exhibiting over 700 works during the 61 years of his membership of the RWS. His granddaughter recalled: 'Our house was full of furniture painted by Grandpa. Also he used to haunt the town rubbish tip, and collect bits of broken china which he made into the most lovely mosaics set in cement in iron blacksmith-made trays … he seemed never to stop painting except to eat or bicycle or walk.'

JAMES DUFFIELD HARDING (1797–1863)
AOWS 1820, RWS 1821

Harding was born in Deptford, the son of a drawing master who had been taught in turn by Paul Sandby. Harding himself received lessons from Samuel Prout and first exhibited at the Royal Academy at the age of thirteen. Sketching in Greenwich Park on one occasion, an older artist shut a sketchbook in his face when he asked a question of the man: deeply hurt, he vowed that he would teach anyone who wanted to learn. His commitment to training art teachers interested both Sir Robert Peel and Dr Arnold of Rugby, but Harding's reputation was made by his many drawing manuals. King Louis Philippe of France awarded him a Sèvres breakfast service and a diamond ring for his publications. Harding believed that drawing was the only true foundation of art. He made great use pencil and chalk and preferred tinted paper. Verona was drawn after an Italian tour with Ruskin who recalled 'a most happy time' and praised Harding's 'vivid, healthy and unerring artistic facility', but said he lacked sentiment. Whereas the truculent William Evans of Eton called Harding 'a vain, disappointed, jealous man', Matthew Hale recalled that he was known as 'The Doctor' because of his willingness to give advice, and his obituary in the *Art Journal* said that he was 'in the true sense of the word a gentleman'. Harding died after catching a cold while sketching in Kent.

THOMAS BARCLAY HENNELL (1903–1945)
ARWS 1938, RWS 1942

Hennell – 'a tall, awkward rustic chap' – was born at his father's rectory at Ridley near Gravesham in Kent. He studied at the Polytechnic School of Art in Regent Street, London, and then taught in Bath and elsewhere in Somerset. Following the rejection of a marriage proposal, Hennell had a nervous breakdown and spent two years in hospital. In 1935 he returned to Kent where he illustrated and wrote on agricultural topics. His art, poetry and prose evoke his love of the land: 'all the country's history … is written out in the carpentry of broken carts and waggons, on the knots and joints of old orchard-trees, among the tattered ribs of old barns'. In 1943 he was appointed an Official War Artist following the death of his friend Eric Ravilious. Some of the splodges in the sky of *Reykjavik Harbour* (page 76) appear to have been caused by raindrops: in Iceland painting conditions were so hard that Hennell sometimes used his own urine to mix the watercolour. In 1944 he took part in the allied landings in Normandy and also worked in Holland, Burma and the former Dutch East Indies. In November 1945 Hennell disappeared in Java, where he was probably killed by Indonesian nationalists.

SIR HUBERT VON HERKOMER RA (1849–1914)
ARWS 1894, RWS 1894

Herkomer was born in Waal in Bavaria. His father's family had been woodcarvers and weavers for generations. His mother was a piano teacher. In 1851 his family emigrated to the USA but returned to Europe in 1857 and settled in Southampton. Herkomer trained at the Southampton School of Art, the Munich Academy and South Kensington; however, life was hard and he lived from hand to mouth, working as a mason and playing the zither in the evenings for small sums of money. Scenes of hardship are the subject matter of much of Herkomer's work. He became a successful magazine illustrator, however, and his work was to make a deep impression on van Gogh. But it was Herkomer's 1875 painting, *The Last Muster: Sunday* in the Royal Hospital Chelsea which made his reputation, and it was exhibited internationally for forty years. Portrait painting alone earned him over £250,000 during his career. This wealth enabled him to build Lululand (named after his second wife), a huge castle-like house in Bushey in Hertfordshire where he also founded an art school. His many interests included acting, film-making and car-racing. In 1894 Herkomer was elected to become a member of the RWS and he presented the Society with its Presidential jewel and chain. In 1897 he failed – by one vote – to be elected President; this humiliated him and he effectively withdrew from the Society. In 1899 Herkomer was enobled by the Kaiser and added 'von' to his name; he was knighted in 1904.

ALFRED WILLIAM HUNT (1830 – 1896)
ARWS 1862, RWS 1864

Hunt was born in Liverpool, the son of a landscape artist. When a small boy he came home one day proudly announcing that the Duke of Wellington had spoken to him; asked about their conversation, he replied that the Duke said, 'Get out of my way, you little devil.' He read classics at Corpus Christi College, Oxford, and was elected a fellow in 1853 but while marriage (his wife, 'the wittiest woman in London', was a novelist) obliged him to give up his fellowship, it also freed him to follow his vocation as an artist. A close friend of Ruskin, Hunt followed his precepts of 'truth to nature' and his Pre-Raphaelite landscapes are full of meticulous observation and intense colour. For the sake of his art, his daughter wrote, he was pursued by bulls, stung by midges and suffered wasps down the neck of his coat collar. 'I have seen my father confronted by a wall of water coming straight down on him. I have watched him, quick as thought, rise and leaping from slippery rock to slippery rock carry his wet drawing upheld breast-high to a place of safety.' Burne-Jones called him 'a regular worry-mutton'. Hunt was active as a progressive force within the RWS and from 1888 to 1890 served as its first-ever Deputy President.

CECIL ARTHUR HUNT (1873–1965)
ARWS 1919, RWS 1925

Hunt was was born in Torquay in Devon, the son of a writer on scientific and geological matters. Educated at Winchester and Trinity College,

Cambridge, he was called to the Bar in 1899. A stammer made it difficult for him to present cases so he practised as a conveyancer at Lincoln's Inn. Subsequently he worked at the Home Office in connection with Sinn Fein prisoners interned in England and with the employment of conscientious objectors. Hunt had no formal artistic training, although he went on sketching tours with Frank Brangwyn and Alfred East. After 1919 he devoted himself entirely to art. A member of the Alpine Club and an occasional climber, his finest work is inspired by his love of mountains – the Alps and Dolomites as well as mountains in Spain and America: 'Even the simplest mountain face or ridge a mile or two away is full of exquisite details, all apparently well defined. But when you try to draw one of these details, you cannot discover where it begins or end or runs into another …' He also painted flowers and industrial scenes and wrote on art and law. Hunt served as a Vice President of the RWS from 1930 to 1933.

WILLIAM HENRY HUNT (1790–1864)
AOWS 1824, OWS 1826

Hunt was born in London, the son of a tin-plate work and japanner. One of his uncles recorded that his 'nevvy, little Billy Hunt … was always a poor cripple, and as he was fit for nothing, they made an artist of him'. After working as a scene painter he found success as a professional artist by following contemporary fashion closely: he moved from topographical scenes to ones of human interest and finally the still lifes for which he was best known (Ruskin regarded him as the greatest ever painter of still life). Hunt's habit of including birds' nests within his compositions as tours-de-force earned him the sobriquet 'Bird's Nest Hunt'. His studio was described by Walter Sickert (in 1910) as 'a little box lit from above that cannot have been more than seven foot square'. Hunt was regarded as one of the most important painters of his day and his work – which anticipates the Pre-Raphaelites – was hugely influential. At the Paris Universal Exhibition of 1855 his pictures sold for more than those of Ingres and Delacroix but Hunt's reputation was at its height at the time of his death and it has never regained its pre-eminence.

DAVID MICHAEL JONES ('DAI GREATCOAT') (1895–1974)
Hon RWS 1960

Jones was born in Brockwell in Kent, the son of a printer from Holywell in Flintshire from whom he learnt some Welsh. He trained at the Camberwell School of Arts and Crafts and subsequently at the Westminster School of Art. During World War I he enlisted in the Royal Welch Fusiliers and was wounded in the leg in Mametz on the Somme. His war experiences inspired his poem 'In Parenthesis', which won the 1938 Hawthornden Prize. Although Jones's work draws on many influences from William Blake to Wassily Kandinsky, his artistic vision is unmistakably his own. Intellectually and emotionally Jones was inspired by his feeling for nature, as in *Afon Honddu Fach, above Capel-y-ffin* (page 78), which invokes 'the intimate creatureliness of living'. He also cared deeply about his Celtic heritage (on his walls he hung ordnance survey maps of Roman and Dark Ages Britain), As a Catholic convert, he was also deeply concerned with religion: 'Man, sacrament at every turn and all levels of the 'profane' and 'sacred', in the trivial and in the profound, no escape from sacrament.' He was greatly loved by his intimates but he was eccentric and suffered from mental illness.

PERCY HAGUE JOWETT (1882–1955)
ARWS 1936, RWS 1938

Jowett was born at Bishop Monkton near Ripon in Yorkshire, the son of the headmaster of the village school. He trained at the Harrogate Technical Institute, the Leeds School of Art and the Royal College of Art from where he gained the Prix de Rome travelling scholarship. In Italy he met the author Arnold Bennett who introduced him into influential circles. During World War I Jowett (who was known as 'PJ') served in the Royal Artillery. In 1920 he was invited to join the Seven and Five Society of painters and sculptors, the most important group of artists of the post-war period, but was voted out of the Society in 1934. In 1923 he helped found the Modern English Watercolour Society which was dedicated to 'the probity of drawing as the essential understructure of any watercolour', but this soon failed and many of its members subsequently joined the RWS. Influenced by Cézanne, still life was a favourite subject for Jowett and his best work has a strong sense of rhythm and colour. Jowett spent much of his life as a teacher and administrator, becoming Principal of the Royal College of Art from 1935 to 1948, but he could seem a remote figure and during the war years he gave the impression that he thought his male students would be better employed fighting. He was awarded the CBE in 1948.

DAME LAURA KNIGHT RA (1877–1970)
ARWS 1909, RWS 1928

Knight was born at Long Eaton in Nottinghamshire. Her father had no settled occupation and she became an artist under the influence of her mother, who had fallen on hard times and always longed for a better life. She studied at Nottingham School of Art, where she met her husband, the artist Harold Knight; together they became part of artistic communities in Staithes in Yorkshire and in Cornwall. Diaghelev allowed Knight to draw his ballet company, both on stage and behind the scenes, and she took lessons in order to understand the dancers better. She also worked with Bertram Mills' Circus. Preferring to paint in the open, she was attracted by the nomadic lives of gypsies and fitted up an old Rolls-Royce as a miniature studio in order to work with them. In 1946 she went to Nuremberg to paint a pictorial record of the trial of the Nazi war criminals. Flamboyant and immensely energetic, she lived in St Johns Wood where her parties were legendary. 'Dame Laura, in her own estimation, is no housewife. "Why pretend … I have lived in too many caravans, tents, corners of dressing-rooms to care."' (*The Times*).

SYDNEY LEE RA (1866–1949)
ARWS 1942, RWS 1945

Born in Manchester, the son of a cotton spinner, Lee studied at Manchester School of Art and the atelier Colorossi in Paris. He achieved success early in life and received many awards. He travelled widely in Europe and his subject matter was largely town scenes and landscapes. Lee was versatile in a variety of media and especially in printing techniques (he was a founder member of the Society of Wood Engravers). *Boatbuilding*, (page 108), which may be a study rather than a finished work, demonstrates his interest in the structure of a picture. In 1922 he was elected to the Royal Academy and later served as Treasurer, but he failed in 1938 to be elected President by only two votes. He became a member of the RWS only at the very end of his life. His obituary in *The Times* seems unnecessarily harsh: 'Comparison between the

man and his work suggested one of those efforts at compensation which are not uncommon in the history of art, as if he sought to overcome some timidity of temperament by building his pictures largely and forcibly, and he often worked on too large a scale for the content of his pictures.'

JOHN HENRY LORIMER (1856–1936)
ARWS 1908, RWS 1932

Lorimer was born in Edinburgh, the son of the Professor of Public Law at Edinburgh University. (The family's summer residence was Kellie Castle in Fife, now owned by the Scottish National Trust.) Educated at Edinburgh Academy and University, Lorimer trained as an artist in the Royal Scottish Academy Schools under William McTaggart and in Paris under Carolus Duran. In his early work he concentrated on portraiture and flowers but later became a painter of interiors. His work was always concerned with the effects of light and colour value. Lorimer's oil painting *The Ordination of the Elders in a Scottish Kirk* (National Gallery of Scotland) has been described as 'one of the most national pictures ever painted' (Sir J L Caw), but his work is generally concerned with the cultivated lives of the middle classes, 'the graceful side of life'. Lorimer was a Corresponding Member of the Institut de France, where his work was popular. After his death his heirs unsuccessfully disputed a bequest he had made to the RWS on the grounds that if he had left money to the Society he could not have been of sound mind.

ARTHUR AMBROSE McEVOY ARA (1878–1927)
ARWS 1926

McEvoy was born at Crudwell in Wiltshire. His father, who had served with the Confederate Army in the American Civil War, was an authority on submarine warfare and a friend of Whistler. At the age of fifteen McEvoy entered the Slade School of Art in London where he became a close friend of Augustus John and had a stormy affair with Gwen John. Sickert was an important later influence. McEvoy was one of the most sought-after portrait painters of his age, particularly of fashionable women, but he also produced a masterly series of portraits of naval officers and ratings who had won the Victoria Cross (now in the Imperial War Museum). His preference was for half-lengths. McEvoy was 'a portrait painter of exquisite taste and subtle interpretation'; stylistically loose and free, 'occasionally his dewy irridescence fades into the pale obliteration of fog' (Gleadowe). William Rothenstein described McEvoy as looking 'like a Pre-Raphaelite, with his strikingly large eyes in a long, angular face; and he spoke in an odd, cracked voice'. Heavy drinking led to his early death from pneumonia.

ARTHUR MELVILLE (1855–1904)
ARWS 1888, RWS 1900

Melville was born at Loanhead-of-Guthrie in Forfarshire, the son of a coachman. In 1870 He was apprenticed as a book-keeper to a grocer but, despite parental disapproval, attended evening art classes in Edinburgh. After his father's employer purchased a work by Melville from the Royal Scottish Academy he had the confidence to enroll at the Edinburgh School of Art. Later he studied in Paris, where he encountered work which inspired him to travel and paint in the Middle East and Egypt. His journeys were often full of danger. On one occasion he was captured by robbers, stripped naked and left for dead in the desert; rescued by villagers, he recovered his tartan plaid and his Bible, which had a bullet hole in it. On his return to

Scotland he encountered the 'Glasgow Boys' and lived among the artistic community in Cocksburnpath in Berwickshire; Sir James Caw described Melville as 'stalwart of figure, forcible in the expression of his ideas, full of enthusiasm and driving power'. These characteristics find expression in the immense vitality of his work which greatly impressed contemporaries such as Whistler. Melville died of cholera contracted after a visit to Spain. The critic Frank Rutter said of his memorial exhibition in 1906 that it showed Melville to be 'unquestionably the most brilliantly audacious watercolour painter of his time'.

SAMUEL PALMER (1805–1881)
ARWS 1843, RWS 1854

Palmer was born in Newington, the son of a bookseller. He first exhibited at the Royal Academy at the age of fourteen and had soon encountered a group of young artists, the 'Ancients', such as Francis Oliver Finch, who were greatly influenced by William Blake. He also met John Linnell, whose daughter he married; however, differences of religion and temperament caused difficulties with his father-in-law for the rest of his life. In 1824 Palmer moved to Shoreham in Kent, 'that genuine village where I mused away some of my best years'. Some of his finest – albeit artistically unorthodox – drawings were produced here; the 'tangled wild-flower beauty' (Martin Hardie) of these pictures of a pastoral England became immensely inflluential in the mid-twentieth century. Palmer's life was beset with anxiety and depression over money, health ('the doctors, monsters as they are, have forbidden me rump steak dumpling'), and, later, the death of his son. Even his appearance invited jeers: when out sketching, his 'coat was an accumulation of pockets in which were stowed away the all-important snuff-box, knives, chalks, charcoal, coloured crayons, and sketch-books, besides a pair of large, round, neutral-tint spectacles made for near sight.' Ironically, one of the most original and important of British landscape artists whitewashed his studio window in order not to see the world outside.

JAMES PATERSON (1854–1932)
ARWS 1898, RWS 1908

Paterson was born in Glasgow, the son of a cotton and muslin manufacturer. To please his parents he worked in business for four years but attended Glasgow School of Art in the early morning and took private lessons until, in 1878, his father allowed him to study in Paris. In 1882 Paterson returned to Glasgow and became associated with the 'Glasgow Boys', a group of painters influenced by Whistler and Bastien-Lepage who intended to bring an end to the monopoly of conventional Scottish painters (the 'Gluepots'). Paterson married in 1884 and moved to 'a low cottage-like house with irregular gables and slated dormers' in Moniaive, a remote village in Dumfries where he lived for the rest of his life. Much of Paterson's work, invariably loosely painted and rather decorative, is inspired by his poetic response to landscape – as can be seen in *Punta Brava, Tenerife* (page 46), which was painted on a journey made to the Canary Islands on account of his wife's health. As young men, the Glasgow Boys exhibited with the Munich Secession and new exhibiting bodies throughout Europe, but they gradually became absorbed by the establishment. Paterson was President of the Royal Scottish Society of Painters in Watercolour in 1923 and served as both Librarian and Secretary of the Royal Scottish Academy. A church elder he listed his interests as 'walking, golf, croquet and chess', and took a 'naïve

delight … in meeting people of importance or distinction, an aimiable weakness which rather amused his fellow artists'.

ROLAND VIVIAN PITCHFORTH RA (1895–1982)
ARWS 1957, RWS 1958

Pitchforth was born in Wakefield in Yorkshire and trained at Wakefield and Leeds Schools of Art and the Royal College of Art. Not interested in innovation, he held that 'a profound belief in draughtsmanship is essential'. He was particularly sensitive to atmospheric effects and often worked out of doors in the evening when watercolours done on the spot were freer than those done during the day: the dew falling on the paper helped the brush to move with greater facility. 'A pure translucent water-colour is a oncer, or one wash, which means putting down 90% of your subject at one go.' In 1915 Pitchforth joined the Royal Garrison Artillery (60 pounders) and, as a result of his war service, eventually became stone deaf, carrying with him a note pad to communicate. During World War II he was appointed by the War Artists' Advisory Committee to make records of Civil Defence, war industries, and events in Africa, India, Burma and Ceylon. 'Pitch' was an ebullient figure and a stimulating teacher; his hobbies throughout his life were sailing, billiards and chess.

SAMUEL PROUT (1783–1852)
OWS 1819

Prout was born in Plymouth, the son of a clothier and naval outfitter. After sunstroke in childhood he suffered disabling ill health all his life and for many years he was forced to spend one or two days in bed every week. Prout had little formal training but learnt his trade working for the antiquarian publisher John Britton. Rather than being a landscape painter, his work comes out of the eighteenth-century topographical tradition of artists who selected their views on account of their historical or human associations, and most of his drawings include groups of figures going about their daily business. After the end of the Napoleonic wars, Prout made a number of continental sketching tours; these resulted in the many studies of Gothic architecture for which he is best known (and which earned him the sobriquet 'Brussels Prout'). His vision of Europe made a deep impression on contemporary English imagination. According to Ruskin, Prout made Venice 'peculiarly his own': 'I had not the least idea of the beauty and accuracy of those sketches of Venice, – so touchingly accurate are they, that my wife who looks back to Venice with great regret, actually and fairly burst into tears over them, and I was obliged to take them away from her.' In 1828 Prout was appointed Painter in Water Colours in Ordinary to George IV. He died from an apoplectic fit after a birthday party given by Ruskin's parents for their son, which oddly, Ruskin himself did not attend.

ARTHUR RACKHAM (1867–1939)
ARWS 1902, RWS 1908

Rackham was born in Lambeth in London. His father was a clerk at the Admiralty. At school he won drawing prizes but a journey to Australia on account of his health gave him time to practise both drawing and painting. On his return he enrolled at the Lambeth School of Art while, still working as a junior clerk in the Westminster Fire Office from 1885 to 1892. However, he longed to be a professional artist; later he wrote: 'In the nursery, at school and then during the long years when the office stool was my lot, my paint box was as impatient as I for the freedom of the holidays'. Subsequently Rackham worked as an illustrator for magazines and the colour illustrated books – made possible by recent developments in colour printing – for which he is most widely known. Rackham's artistic bent was for the fantastical and strange, which could be either exquisitely whimsical or oddly cruel, like his Diploma work, *A Bargain with the Devil* (page 114) drawn to illustrate a short story by James Morrison called 'The Seller of Hate'. His nephew, the writer Walter Starkie, believed that Rackham was himself a goblin 'in his shabby blue suit and carpet slippers, hopping about the studio with a palette on one arm, waving a paintbrush in one hand'.

His final illustration was of Rat and Mole collecting a boat for a picnic in Kenneth Grahame's *Wind in the Willows*.

THOMAS MILES RICHARDSON, JUNIOR (1813–1890)
ARWS 1843, RWS 1851

Richardson was born in Newcastle-upon-Tyne where his father, who was also an artist, initiated the first Fine Art Exhibition in the North of England in 1822, and later founded the Newcastle Water-Colour Society. Thomas Miles Richardson Junior moved to London in 1843. In all he exhibited 702 works during his years with the Society, where his rather brightly coloured panoramic views of Scottish and continental scenery proved popular. Ruskin wrote that he seemed 'always to conceive a Highland landscape only as a rich medley of the same materials … the whole contemplated under the cheering effects of champagne, and considered every way delightful.' His smaller sketches, such as *Norham Castle, Evening* (page 134), are considered better. Richardson combined his work as an artist with that of a photographer. In November 1853 he was taking several calotypes (an early form of photography) a day at his home in Radnor Place, Hyde Park, and the earliest photographs in the Society's archives are his portraits of a number of its members.

JOHN SINGER SARGENT RA (1856–1925)
ARWS 1904, RWS 1908

Sargent was born in Florence, the son of wealthy American parents, and studied art in Italy and Paris. He had immense success as a portrait painter in oils until, bored by the work, he turned to watercolour which offered new possibilities of subject and style. Sargent was elected to the RWS at the height of his reputation although his work was described as likely to embarrass the other members by its obvious superiority: 'The laboured sketches hanging round [his drawings] look empty senile efforts compared with the titanic force of Mr. Sargent's sketches.' Cosmopolitan, reserved and hating flattery, he was described by Henry James as 'civilised to his fingertips', although he was happiest among intimate friends and family. Immensely energetic, Sargent travelled and worked ceaselessly, undeterred by difficulty of place or circumstances – as in *Bed of a Glacier Torrent* (page 20), which was painted in the Val d'Aosta in Italy. 'I saw him working on a steep mountain side [wrote Adrian Stokes] the branch of a torrent rushing between his feet, one of which was on stones piled up in the water. Several umbrellas were anchored round about him to keep off reflections.'

ALAN SORRELL (1904–1974)
ARWS 1937, RWS 1942

Sorrell was born at Tooting Graveney in south London, the son of a jeweller and watchmaker who was also an amateur artist. A sickly child, Alan spent much of his early youth in a bath chair. After studying at the Municipal School of Art at Southend-on-Sea, he worked briefly as a commercial artist before attending the Royal College of Art between 1924 and 1928. In 1928 Sorrell won the Prix de Rome in mural painting, enabling him to spend three years in Rome before returning to England to teach (his students called him 'Old Angles' because of his insistence on form and structure). His Roman years were seminal to his work, in which a feeling for history and the ultimate frailty of the buildings made by man are constant themes. Sorrell was a neo-Romantic, and these themes were ideally suited to the years before and after World War II in which he was painting. His pictures are full of a brooding atmosphere of an alarm of almost dream-like intensity. In 1936 he began a series of reconstruction drawings in partnership with archaeologists, usually commissioned by the Ministry of Works. These drawings, which helped popularize British history, included prehistoric sites such as Stonehenge and Avebury, as well as Roman forts on Hadrian's Wall and medieval castles and monasteries. Perhaps his most significant project was *Nubia – a Drowning Land*, the drawings he made in February and March 1962 for the *London Illustrated News*, which recorded the monuments that disappeared when the Aswan High Dam raised the level of the Nile.

JOSEPH EDWARD SOUTHALL (1861–1944)
ARWS 1925, RWS 1931

Southall was born in Nottingham into a Quaker family. After his father's death his mother moved to Edgbaston, where Southall spent most of his life. Originally articled to a Birmingham architectural practice, he attended evening classes at the Birmingham School of Art and won prizes in national art competitions. He also fell under the influence of John Ruskin, who praised Southall's work highly. In 1883 he spent eight weeks in Italy where he gained an appreciation of the Italian primitives as well as an interest in egg tempera painting. This led him in 1900 to help found the Society of Painters in Tempera. Southall's art is a fusion of medieval mannerisms, technique and, occasionally, subject matter with the clean individualistic shapes of 'Art Deco'. Works such as *A Cornish Haven* (page 30) recall the travel posters of the interwar years – he loved to paint boats, and these non-contemporary sailing ships contribute towards the somewhat hallucinatory atmosphere of the picture. Holding to his inherited pacifist and radical sympathies all his life, Southall also served as chairman of the Birmingham Independent Labour Party and later the Edgbaston Labour Party.

HENRY SCOTT TUKE RA (1858–1929)
ARWS 1904, RWS 1911

Tuke was a Quaker from York where his great grandfather and father were doctors caring for the mentally ill. At the age of six he moved to Cornwall before studying at the Slade School of Art in London and in Paris and Florence. The subject matter of his paintings was, most typically, nude boys and boats: artistically what interested him was the effect of sunlight on flesh and water. In 1885 he returned to Cornwall where he spent the rest of his life, renting a cottage in a converted smelting works where in privacy he could paint male nudes on the secluded beaches. These pictures were considered somewhat scandalous at the time. He also painted ships at sea with 'effects of fairylike delicacy' (*The Times*) and portraits. Aside from art, Tuke loved cricket, yacht racing (he was commodore of the Falmouth Sailing Club) and the novels of Robert Louis Stevenson. Beside his studio he constructed a netted cricket pitch and kept silver racing cups on the mantelpiece in the work room. A biographer, writing in a magazine, wrote: 'With black hair and a strong, manly face absolutely bronzed with the sun he looked every inch an athlete – certainly anything but a typical artist'.

SIDNEY CURNOW VOSPER (1866–1942)
ARWS 1906, RWS 1914

Vosper was born in Plymouth, the son of a brewer. The name Curnow is derived from Kernow or Cornish. 'I am not English but Cornish!!' he wrote. After three years in an architect's office in Plymouth he abandoned his apprenticeship to go and study at the Académie Colarossi in Montparnasse in Paris until admiration for the work of Dagnan-Bouverez drew him to Britanny. For twenty years Vosper continually returned to the village of Le Faouët, where he cut an eccentric figure, wearing knickerbockers and a coloured tie and riding a large green bicycle with his painting equipment strapped to the crossbar. However, his love of character and colour found scope in Britanny and in its traditional crafts, such as spinning and rope-making, which were under threat of industrialization. He also learnt to speak the Breton language fluently. During World War I Vosper served with the French Red Cross and was an orderly in the Military Hospital at Nevers. 'An artist's life is generally supposed to be uneventful, with no adventure in it,' wrote Vosper in 1935. 'Nothing can be further from the truth; that is if he be a water-colour painter – just think a moment of that white, unspoiled sheet of paper staring him in the face, waiting for the first touch of the brush … Woe betide the man whose foot slips; during this major operation he should be wearing rubber shoes.'

JOHN REINHARD WEGUELIN (1849–1927)
ARWS 1894, RWS 1897

Weguelin was born at South Stoke near Arundel in Sussex, the son of the rector, who was later to convert to Roman Catholicism and was obliged to give up his living. Several years of his boyhood were spent in Rome where he had art lessons; however, his teacher joined Garibaldi and was never heard from again. In 1860 Weguelin was sent to be educated at the Oratory School at Edgbaston under the future Cardinal Newman, and then started a career as a Lloyds underwriter. At the age of twenty-three he began to study art and for five years attended the Slade School of Art under Sir Edward Poynter and Alphonse Legros. His early works were classical fantasies greatly influenced by Sir Lawrence Alma-Tadema: his own genre, biblical and historical subjects, are never didactic in purpose. From 1893 onwards he worked exclusively in watercolour. Weguelin was a sensualist who took pleasure in painting the female figure, frequently nude. The critic of the *Sussex Daily News* of 28 April 1903, visiting the RWS Summer Exhibition, wrote of 'Mr Weguelin whose fancy is always at home in thoughts of the white, swift bodies of mermaids, dryads, nymphs at play in the solitude of the ancient earth'. He also illustrated several volumes of poems and translations and wrote and illustrated short stories for the Graphic magazine.

INDEX OF ARTISTS

The creation of this book has come about through the generosity
of the Society's Members, both past and present, in sharing
their knowledge and promoting the art of watercolour.

A SEARS POCKNELL BOOK

Editorial Direction:	Roger Sears
Art Direction:	David Pocknell
Design:	Pocknell Studio
Editorial Coordination for the RWS:	Francis Bowyer

First published in Great Britain in 2006 by Cassell Illustrated,
a division of Octopus Publishing Group Limited
2–4 Heron Quays, London E14 4JP

Distributed in the United States of America by
Sterling Publishing Co., Inc., 387 Park Avenue South,
New York, NY 10016-8810

A CIP catalogue record for this book is available
from the British Library.
ISBN 13: 978-1-844034-47-5
ISBN 10: 1-84403-447-X
10 9 8 7 6 5 4 3 2 1

Printed in China

● Site of Bankside Gallery, home to the Royal Watercolour Society

Royal Watercolour Society
Bankside Gallery
48 Hopton Street
London SE1 9JH
Tel. 020 7928 7521
Fax. 020 7928 2820

rws@banksidegallery.com
www.royalwatercoloursociety.com
Registered Charity 293194